ARTISTS AND THE AVANT-GARDE THEATER IN PARIS 1887–1900

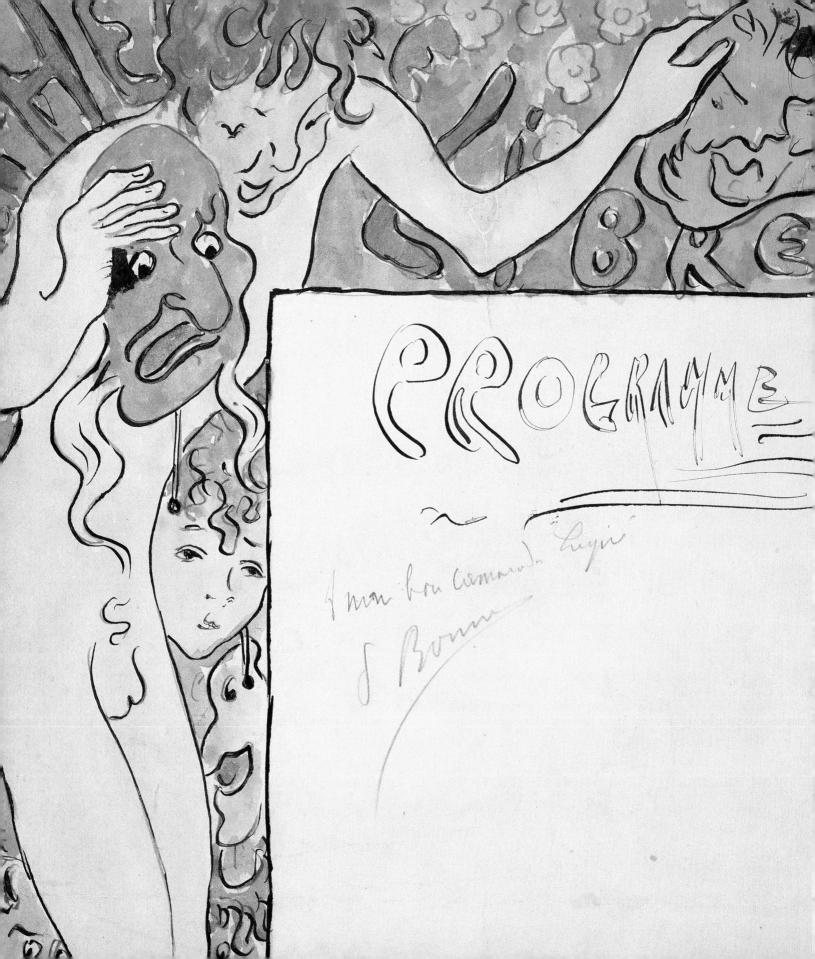

ARTISTS AND THE AVANT-GARDE THEATER IN PARIS 1887–1900

The Martin and Liane W. Atlas Collection

Patricia Eckert Boyer

National Gallery of Art, Washington

EXHIBITION DATES

National Gallery of Art, Washington
7 June – 7 September 1998

National Academy Museum, New York
1 October 1998 – 3 January 1999

This publication was produced by the Editors Office,
National Gallery of Art.
Editor-in-chief, Frances P. Smyth
Editor, Tam Curry Bryfogle

Designed by Watermark Design Office, Alexandria, Virginia
Text type is Goudy, display type is Eras, cover type and
initial capitals are Willow
Printed on Gardamatt Brillante
Printed and bound by Milanostampa, Farigliano, Italy

Cover: Detail of Henri de Toulouse-Lautrec's program
for *L'Argent*, 5 May 1895 (pl. 27)

Inside cover: Detail of George Auriol's program for *Ménages
d'artistes* and *Le Maître*, 21 March 1890 (pl. 6)

Frontispiece: Detail of Pierre Bonnard's program design
for the Théâtre Libre, 1890 (pl. 8)

Page 6: Detail of Edouard Vuillard's program for *Monsieur
Bute*; *L'Amant de sa femme*; and *La Belle Opération*,
26 November 1889 (pl. 7)

LIBRARY OF CONGRESS CATALOGING-IN-PUBLICATION DATA

Boyer, Patricia Eckert.
 Artists and the avant-garde theater in Paris, 1887–1900 / Patricia Eckert Boyer
 p. cm.
 Catalog of an exhibition held at the National Gallery of Art, June 7–Sept. 7, 1998.
 Includes bibliographical references.
 ISBN 0-89468-274-1
 1. Theater programs—France—Paris—Exhibitions. 2. Printed ephemera—France—
Paris—History—19th century—Exhibitions. 3. Artisits and the theater—France—
Paris—Exhibitions. 4. Experimental theater—France—Paris—Illustrations—
Exhibitions. 5. Atlas, Martin, 1914– —Art collections—Exhibitions.
6. Atlas, Liane W.—Art collections—Exhibitions. 7. Theater programs—Private
collections—Washington, (D.C.)—Exhibitions. 8. Theater programs—Washington, (D.C.)—
Exhibitions. 9. National Gallery of Art (U.S.)—Exhibitions. I. National Gallery of Art (U.S.)
II. Title.
NC1002.P7B68 1998
792'.09443'6109034—dc21 97–44775
 CIP

CONTENTS

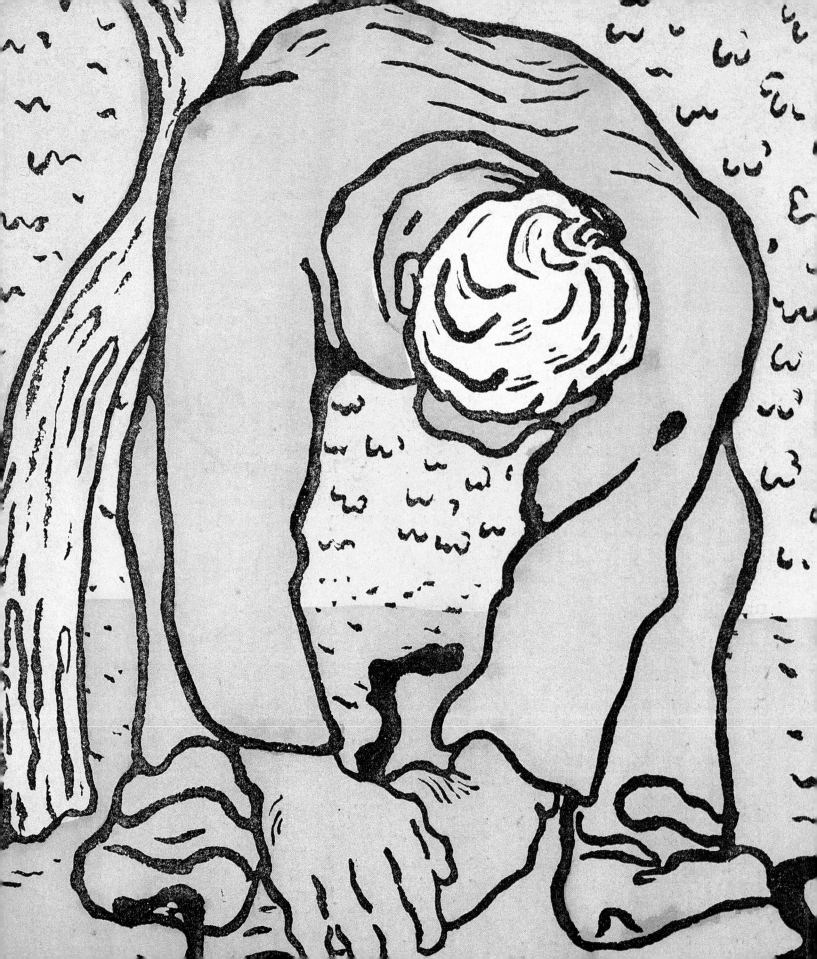

A unique relationship between the visual and performing arts developed in fin-de-siècle Paris, bringing together from throughout Europe many of the most talented writers and artists of the period with printers and publishers, theater entrepreneurs, and their patrons. This dynamic conjunction of imagination and energy led to the commissioning of original prints to decorate the covers and pages of programs, documenting performances at the city's small avant-garde theaters.

Over a period of more than three decades Washington collectors Martin and Liane W. Atlas collected these illustrated French theater programs along with related drawings, correspondence, and ephemera. Their collection became the first comprehensive representation in America of these playbills, including almost complete sets of programs from André Antoine's Théâtre Libre and Aurélien Lugné-Poe's Théâtre de L'Oeuvre. Indeed, the Atlases were among the first private collectors internationally to recognize the broad cultural significance of these programs, and in their prescient collecting they were themselves avant-garde.

This exhibition of sixty-seven theater programs and related objects celebrates the gift of some 130 works on paper and bound volumes to the National Gallery of Art from Mr. and Mrs. Atlas and from the Atlas Foundation. The selection offers an extraordinary range of artistic styles, from realism to symbolism, as well as varied portrayals of the Parisian milieu, from politics and labor relations to family life and entertainment for the masses. Renowned artists such as Pierre Bonnard, Edvard Munch, Henri de Toulouse-Lautrec, and Edouard Vuillard are included, along with lesser-known practitioners such as Maurice Dumont, Henri-Gabriel Ibels, and Paul Sérusier.

Prints in the Atlas gift include rare color trial proofs and proofs before the program texts were added. A further distinguishing aspect of the gift is the material related to the Théâtre Libre that Rodolphe Darzens assembled between 1887 and mid-1891 during his tenure as secretary and archivist of the theater. He brought together several volumes of programs, letters, stage layouts, articles related to the theater, menus for special dinners, and other unique documents.

Our great sadness is that Martin Atlas died before this exhibition was installed, although he shared in its initial planning stages. To Lanny Atlas, however, we extend our deepest appreciation for their generous joint support of the National Gallery, its collections, and programs.

Andrew Robison, Andrew W. Mellon Senior Curator, was closely associated with the Atlases as they built their collection, and he introduced the idea of this exhibition. Its organization has been coordinated by Ruth E. Fine, the Gallery's curator of modern prints and drawings, aided by assistant curator Carlotta J. Owens. We are grateful to Patricia Eckert Boyer, an independent scholar of nineteenth-century art, for her participation in the exhibition's planning and for her thoughtful catalogue essays, which make an important contribution to the study of late nineteenth-century French theatrical productions and the original prints that served to decorate their programs.

Earl A. Powell III
Director
National Gallery of Art

n this catalogue I discuss three essentially synchronous avant-garde theaters—the Théâtre Libre, the Théâtre d'Art, and the Théâtre de L'Oeuvre—in the context of the larger avant-garde movement within which they functioned at the end of the nineteenth century. André Antoine at the Théâtre Libre was the first to stage naturalist drama performed in a realistic manner, and I consider his contributions and their sources—both dramatic and artistic—in relation to existing conventions in theater and to popular avant-garde activity already taking place in Montmartre. I then discuss Paul Fort's Théâtre d'Art and the way in which symbolist literary theories were manifest in dramatic presentations with the collaboration of leading artists of the day. Finally, I turn to Aurélien Lugné-Poe's Théâtre de L'Oeuvre and examine the realization of symbolism as a dramatic style and the interrelationships—personal and professional—that characterized this joining of creative advances.

I have singled out programs for discussion based on the availability of information about the circumstances under which they were created; the degree to which the program illustrates the theater's interaction with other facets of the avant-garde; and the goal of giving an accurate historical overview of the evolution of the avant-garde theater. I include a summary of the plot of a play when it relates to and explains an artist's image decorating the program. Unfortunately, none of the painted backdrops has survived, and contemporary reviews of particular productions are uneven in informative quality and unequal in number from show to show. Therefore our knowledge of the details of staging and artists' contributions varies considerably. Still I hope that the catalogue will shed light on the issues raised by performances at these avant-garde theaters and the collaboration of painters in the productions.

I must begin by acknowledging the great foresight shown by Liane and Martin Atlas in compiling their collection of late nineteenth-century theater programs. The Atlases also undertook research on the plays represented by these programs, enlisting the help of Eva Masur in translating the synopses of the texts published in *Le Théâtre Libre illustré*. In 1972 the collection was circulated by the Smithsonian Institution Traveling Exhibition Service, with a catalogue by Daryl Rubenstein. The Atlases, who have been generous lenders to many exhibitions over the years, have now ensured that their collection, by its donation to the National Gallery of Art, will be available to scholars for years to come.

I wish to thank a number of individuals at the National Gallery. In addition to director Earl A. Powell III and deputy director Alan Shestack, I am especially grateful to curator Ruth E. Fine for her guidance, acumen, and sensitivity as a professional in the world of modern prints and drawings and for her inspiration and friendship. Assistant curator Carlotta Owens has been involved with many aspects of the exhibition and publication, and I have greatly appreciated her help. Mellon Senior Curator Andrew Robison offered encouragement and leadership. In the library Ted Dalziel facilitated my access to interlibrary loans. Editor-in-chief Frances Smyth provided support and good counsel regarding preparation of the manuscript and production of the book. Editor Tam Curry Bryfogle paid scrupulous attention to

detail and offered fresh insights into the essay's arguments. Dean Beasom and Lee Ewing are responsible for the excellent quality of the photography of works in the Atlas Collection. Thanks also to Maria Tousimis, budget and project coordinator in the editors office, and Ann MacNary, assistant curator of old master drawings, for bringing smooth efficiency to the publication effort, and to Ava Lambert, secretary in the department of modern prints and drawings, for her assistance with library research. In the exhibitions office D. Dodge Thompson and Jennifer Fletcher Cipriano have overseen the administrative details of the project. The exhibition design and installation have been sensitively realized by Mark Leithauser and his staff, including Gordon Anson and John Olson.

This book exists in the form that it does thanks to many individuals. Geneviève Aitken has published extensively on the subject of artists and the avant-garde theater. In her dissertation, written in Paris in 1978, and in her text for the catalogue of Samuel Josefowitz' collection of theater programs, *Artistes et théâtres d'Avant-Garde* (1991), she was the first to catalogue the programs commissioned by the Théâtre Libre, Théâtre d'Art, and Théâtre de L'Oeuvre and to identify the plays depicted in the images. Mme. Aitken kindly responded to my queries during the preparation of this manuscript, and in many ways her work served as the foundation for what I have written here.

I am very much indebted to Antoine Salomon, who was most generous with his vast knowledge of and documentation on Edouard Vuillard, an artist who was integrally involved in all aspects of the avant-garde theater. I would also like to thank Mme. Salomon for providing a gracious and comfortable atmosphere for my work. And I would like to express my gratitude to Samuel Josefowitz, for sharing his extraordinary collection, library, and documentation as well as for his guidance and friendship over many years. Waring Hopkins was also generous with his time and ideas, greatly aiding my research. Christian and Lana Neffe helped in tracking down documentation and photographs. Florence Arnoud shared with me unpublished correspondence to and from Paul Fort.

In Paris my work was facilitated by several museum professionals and librarians, including Guy Cogeval, director of the Musée des Monuments Français; Mme. M. Odile Gigou, at the Bibliothèque de la Regie Théâtrale, Bibliothèque Historique de la Ville de Paris; J.-C. Garreta, Bibliothèque de L'Arsenal; Françoise Viatte, conservateur, département des arts graphiques, Musée du Louvre; Françoise Heilbrun, conservateur-en-chef, Musée d'Orsay; Luce Abélès, section littéraire du Musée d'Orsay; Marie-Noëlle de Grandry, Musée des Arts Decoratifs; Mme. Cohen, conservateur, and Sylvie Juvénal, Musée de La Monnaie. I want to extend a special thanks to Florence Roth, librarian at the Société des Auteurs et Compositeurs Dramatiques. She introduced me to Jean-Jacques Lefrère, who had recently written a thesis on the poet Rodolphe Darzens, the secretary and archivist of the Théâtre Libre. Mr. Lefrère generously shared his manuscript with me, and it provided much valuable and new information.

Elizabeth Prelinger, associate professor of art history at Georgetown University, and Phillip Dennis Cate, director of the Zimmerli Art Museum, Rutgers University, offered critical readings of the

manuscript and made suggestions that improved it greatly. Also at the Zimmerli Art Museum, curator of prints and drawings Trudy Hansen and registrar Barbara Trelstad aided my research and obtained photographs. At the Art Institute of Chicago, Gloria Groom helped me locate resource materials not easily available. I also want to express great appreciation to Stephen L. Peterson, librarian at Trinity College, Hartford, Connecticut, who allowed me to use this private college library and all of its resources; and Mary Curry, the interlibrary loan librarian, who obtained for my use many obscure nineteenth-century French books and journals. Managing director of the Hartford Stage, Steve Albert, was a great resource on the theater. Lory Frankel provided accurate and sensitive translations of the French.

Finally, I want to acknowledge some of the many contributions made by family and friends. Chantal and Christian Kiener served as welcoming hosts and encouraging compatriots during my periods of research in Paris. I am continually inspired by my two sons, Ryan and William. My husband, John, altered his schedule to become museum director/soccer dad to accommodate my research and travel and then supported me through the pleasures and pains of writing. He is always a discerning reader of my manuscripts, and I am deeply grateful to him. This book is dedicated to William.

Patricia Eckert Boyer

NOTE TO THE READER

Works in the exhibition are illustrated within the text in full-page plates, numbered separately from the comparative figures. Captions for the plates generally include the artists' names, the French titles of plays represented by the programs, and the dates of the performances. For translations of titles, media, dimensions, and credit lines, please consult the comprehensive checklist of the Atlas Collection at the National Gallery of Art in the back of this catalogue. Full captions are given for comparative figures.

Dimensions appear in centimeters followed by inches in parentheses; height precedes width.

Prior to 1887, the year in which the Théâtre Libre was founded by André Antoine (1858–1943), traditional theater was controlled by the taste of the bourgeoisie, who wanted entertainment that was moralistic and comforting. Plays were written according to an accepted formula that met these expectations, and the result was called a *pièce bien fait* (well-made play). This formula was perfected in the first half of the century by Eugène Scribe and perpetuated by his followers so that it dominated conventional theater until the late 1880s. Although the fight for naturalism had long been won in literature and painting, and the literary avant-garde was already focused on symbolism, theater remained aloof from modern artistic trends before the late 1880s.

The prevailing "star system" and education in the theater also discouraged innovation. The few actors most admired by the public, such as Sarah Bernhardt, were guaranteed the best roles, which gave them the power to control the fate of new plays and severely limited the opportunities for emerging actors. Stars often abused their popularity and determined the success of a production merely by accepting or declining a role in it. And the stale quality of traditional theater was certainly not challenged at the Conservatoire de musique et de déclamation, the official training ground for French actors. The Conservatoire was rigid in its choice of actor-members and in its decision of which pupils to admit. It taught a conventional style of acting, combining aspects of melodrama with classical declamation. And every student, in order to graduate, had to pass an examination on the principles of declamation.[1]

Antoine, in his Théâtre Libre, initiated an era of change and experimentation. The impresario vowed to embrace all types of drama, including the new naturalistic plays and the work of foreign authors, and to employ amateur actors. Although he produced an eclectic mix of plays and would eventually explore symbolism as well, Antoine's great contribution to theater was as the first to bring naturalism to the stage.[2] He introduced subjects that Edouard Manet had developed in painting and Emile Zola in literature for the previous twenty years: the lives of the poor, the working classes, the sordid underside of belle-époque society. Rather than performing according to old conventions, with actors winking at the audience and speaking in declamatory rhetoric, Antoine's actors performed in a new, direct way. They spoke and gestured naturally, and they talked to each other—not to the audience—even if it meant turning their backs to the viewers. In fact, Antoine came to encourage his actors to perform as if they were at home, almost as if they were unaware of the audience, or to pretend that there was an invisible fourth wall across the proscenium opening, separating the stage from the audience.[3] This practice was a revolutionary departure from the entirely audience-oriented performances perpetuated by traditional theater. Antoine also initiated the practices of darkening the auditorium and using real props. Of course, these innovations were not uniformly well received by critics, many of whom wrote consistently damning reviews.

Antoine embraced the work of naturalist playwrights such as Oscar Méténier, whose dialogue reflected an honest portrayal of the lowest social classes—prostitutes, pimps—as well as laborers and the urban poor. Early in his career Méténier had earned a living as the secretary to a police commissioner, and in that position he had a firsthand view of this element of society. He and other writers of the *comédie rosse* genre (biting humor) recreated the coarse, occasionally obscene vernacular spoken by various types existing in the seamy margins of French society. They believed that their portrayal of such situations would expose what they considered to be society's hypocritical pretensions.[4] At the Théâtre Libre, for the first time, the language of uneducated working-class characters was heard on stage, and such presentations crossed into forbidden dramatic territory with their uncensored dialogue

Detail of pl. 12.

and candid treatment of sexual matters. Yet Antoine avoided censorship by selling tickets through subscription; his theater was technically a private one and thus not subject to censure.

As Antoine recalled in his memoirs, his initiation of a great period of experimentation in French theater was unintentional: "The battle, already won by the naturalists in the novel, by the impressionists in painting, and by the Wagnerians in music, was about to move into the theater. This, then, was the battlefield; these, the defenders and the attackers of the fortified position. The time for an assault had come, but who was to give the signal? Chance alone decided. Without having the least suspicion in the world of it, I was going to be the one to unleash forces of which I was quite unaware."[5]

A few years after the birth of the Théâtre Libre the forces unleashed by Antoine led to a movement in theater to embrace symbolism, which was by then current among the literary avant-garde. In 1891 Paul Fort in his Théâtre d'Art and in 1893 Aurélien Lugné-Poe (who began his career as an actor at the Théâtre Libre) in his Théâtre de L'Oeuvre began to stage symbolist poems and "cerebral dramas" by young writers. In contrast to the realistic depictions of life for which the Théâtre Libre was known, the productions of the latter two theaters dealt with psychological states of the characters and with thoughts and emotions. Almost from the outset avant-garde painters and printmakers participated in the production efforts of Antoine, Fort, and Lugné-Poe. In fact, all three theater directors were important patrons for the young artists whose imagery was too bold to appeal to the bourgeois market, which still preferred the more formulaic paintings of the Académie française, just as it preferred the predictable dramas presented at established theaters. They hired artists to create original images to adorn the program for an evening's performances, and thus they exposed audiences not only to daring new theatrical presentations but also to

new aesthetic concepts in the visual arts. And the idea of having artists design stage sets and costumes, introduced at the Théâtre d'Art and taken up at the Théâtre de L'Oeuvre, became as integral a component of theater as the contributions of actors and others involved in the productions. Antoine, too, experimented with the practice, hiring Henri Rivière to paint sets for the Théâtre Libre.

The engagement of artists to design original theater programs was part of a larger movement among the artistic avant-garde to reinvigorate the decorative, or applied, arts, which avant-garde theaters supported from the beginning. Most of the artists selected to create illustrations for programs were active participants in the revival of color printmaking, which itself was part of the larger renewal of decorative arts and crafts.[6] By the late 1880s it had become clear that France had lost its preeminence in the production of applied arts, and concerned observers—including the critics Maurius Vachon and Claude Roger Marx—began to call for efforts to reestablish the country's leadership in this area. Their appeal for a revival of the decorative arts was linked to prevailing concerns about the lack of patronage for young French artists and the need to expand the market for art. It was hoped that the application of art to everyday objects would educate the taste of the bourgeoisie—which had great buying power— and create a better market for art.

Prints were seen as an especially effective way of attaining wider distribution of art, since in printmaking an artist's original image is produced in multiples. The color lithographic posters by Jules Chéret, advertising innumerable products, were visible on the walls around Paris beginning in the 1870s and were thought by some to exemplify the best decorative art of the day. Because of his inventive use of the medium, Chéret was credited with elevating the poster to the status of true art.[7]

Antoine was among the earliest to follow Chéret's example in demonstrating that ephemera

(such as posters or theater programs) could also be art. Beginning with the Théâtre Libre, programs illustrated by Chéret and other artists were meant to be collected—taken home and hung on the wall. In selling subscriptions to his seats along with the original prints adorning his programs, Antoine offered patrons the opportunity to build a collection of original prints in installments. In this way, he anticipated the later efforts of publishers such as the Natanson brothers, who included original lithographs within issues of their artistic and literary magazine *La Revue blanche* beginning in 1893, and André Marty, who published and sold subscriptions to quarterly albums of original prints called *L'Estampe originale* between March 1893 and the spring of 1895.[8]

Popular culture may have nurtured more than one of the contributions made by the Théâtre Libre. If the seeds for Antoine's application of art lithography to a functional purpose can be found in the commercial "street-art" of Chéret, part of the impetus for his taking a realistic direction in dramatizations might stem from avant-garde performance activity in Montmartre cabarets. In particular, the Chat Noir, founded by Rodolphe Salis in December 1881, became the meeting place of avant-garde artists, literary figures, and musicians soon after it was established.[9] It offered an alternative to the highly institutionalized traditional theater and may have encouraged the revolution begun in 1887 by Antoine. Aristide Bruant, who performed often at the Chat Noir, had explored life in the poor districts of Paris, observing criminals, prostitutes, and pimps, with Oscar Méténier as his guide and teacher. He recorded the argot he had heard with Méténier and incorporated it into his lyrics, sung in a unique, abrasive, and rude style before mostly working-class audiences.[10] In June 1885 Salis moved the Chat Noir to larger quarters, and Bruant, whose crude dialogue did offend some of Salis' clients, stayed behind at the old location and established his own cabaret, Le Mirliton, where he continued to perform his own genre of

songs and monologues in the slang of the lowest and poorest social classes of Paris.

In addition to any inspiration Antoine might have derived from Bruant's assimilation of street slang into his performances, theatrical developments at the Chat Noir's new location may have provided some stimulus for exploring other directions in theater. In 1886 Salis established a shadow theater that immediately became the rage of Paris. It was created and directed by the artist Henri Rivière, followed by other Montmartre artists, including George Auriol, Carand'ache, and Adolphe Willette, who were habitués of the café. At first Rivière and his friends used backlighting to project solid black silhouettes of zinc cutouts onto a white screen. Then beginning in December 1887, with Rivière's adaptation of Gustave Flaubert's *La Tentation de Saint Antoine*, complex overlapping color silhouettes were projected through transparent color paper inserted into zinc "outlines" or affixed to a transparent surface (fig. 1). For some plays Rivière hung a sheet of gauze behind the screen to suggest atmospheric effects.[11]

It was not long before these elements appeared in other contexts. A gauze curtain would be incorporated into the staging methods of the symbolist theater as a means of distancing the action on stage from contemporary reality. Painters also responded to the visual effects produced at the shadow theater. Artists of the "new school," such as Emile Bernard, Pierre Bonnard, Henri-Gabriel Ibels, Henri de Toulouse-Lautrec, and Edouard Vuillard, used silhouettes in their paintings and prints. And all of these individuals with the exception of Bernard would become involved with avant-garde theater.[12] The shadow plays and monologues recited at the Chat Noir were steeped in the Montmartre style of humor called *fumisme*, which involved puns, general irreverence, and bourgeois-bashing.[13] Antoine was accustomed to visiting the Chat Noir in the evenings, and a few months after he produced Méténier's *En Famille* at the Théâtre Libre in May 1887, Salis invited him to restage it

1. Henri Rivière, *Avarice—The Golden Calf,* from *The Temptation of Saint Anthony,* 1887, stencil-colored photo-relief on paper, 19.5 x 19.0 (7 5/8 x 7 1/2), Zimmerli Art Museum, Rutgers University, Norma B. Bartman Research Library Fund.

in a basement salon of the cabaret.[14] The Chat Noir and its special brand of humor were important catalysts for change at the Théâtre Libre, as were such literary figures as Zola, Honoré de Balzac, Henri Becque, and Alfred de Musset. According to a seminal history of the theater: "However insignificant the influence of the Chat Noir may have been on the destinies of the Théâtre Libre, it is none the less true that the clan from the rue Victor Massé exercised a serious pressure on the contemporary theater movement.... The famous cabaret of *Gentleman Rodolphe Salis* was the cradle of a manner which, very much in vogue today, can count more than one masterpiece: the *Parisian* manner—light, skeptical, joking, good-natured."[15]

André Antoine (fig. 2) was a twenty-nine-year-old amateur actor working at the Paris Gas Company when he founded the Théâtre Libre in the spring of 1887. The theater's first presentation took place on 30 March 1887 in a rented space at 30 passage des Elysées des Beaux-Arts (just off the place Pigalle) (fig. 3). It featured a mix of one-act plays belonging to the naturalist genre: *Jacques Damour,* adapted by the writer Léon Hennique from a short story by Zola; *Un Préfet (The Prefect)* by Arthur Byl; *Mademoiselle Pomme (Miss Apple)* by Paul Alexis, based on a story by Edmond

Duranty; and *Cocarde (The Vain One)* by Jules Vidal. The second program, which took place on 30 May, was more eclectic. It included *La Nuit bergamasque (The Bergamasque Night)* by the Parnassian poet, dramatist, and journalist Emile Bergerat, and the *comédie rosse* by Méténier, *En Famille.* The latter focuses on a drunken family gathering that involves the father, a receiver of stolen goods; the daughter, a prostitute; and the son, a pimp who recalls, in lurid detail, his criminal friend's execution by guillotine (fig. 4).[16] The play was considered to be morally offensive, so theaters were forbidden from performing it publicly, but because Antoine sold tickets through subscription and was therefore technically running a private theater, he could produce it. Among those attending the opening night were the actor Coquelin *cadet* (*cadet* signifies that he is the younger of two Coquelin brothers), poets Catulle Mendès and Jean Richepin (whose verse also focused on the dispossessed in French society), artists Pierre Puvis de Chavannes and Auguste Rodin, and Rodolphe Salis, who quickly invited Antoine to perform *En Famille* at the Chat Noir. Although it would have been financially rewarding for the perpetually impoverished Antoine to accept the offer, he declined it, fearing that direct early association with the cabaret would compromise his burgeoning literary and artistic reputation.[17]

Rodolphe Darzens, Secretary and Archivist

Sometime prior to September 1887 the young poet Rodolphe Darzens (1865–1938) became officially associated with the Théâtre Libre. And as Antoine wrote in his memoirs for 5 September: "Rodolphe Darzens, a poet who has become the fencing master and archivist of the Théâtre Libre, has obtained from Villiers de l'Isle-Adam a one-act play, *The Escape,* which we are rehearsing with *Sister Philomène* each evening in the Rue Blanche."[18]

Darzens was a fascinating and well-connected figure, who seems to have aided Antoine tremendously not only in collecting press clippings on Théâtre Libre performances and handling other administrative matters but in securing material from writers and at times perhaps even artists for the director's consideration. Darzens' friends and associates were among those whose creative talents would figure prominently in Antoine's theater and in the symbolist theaters that followed it. During Darzens' years of affiliation with the Théâtre Libre, he was one of the individuals on whom multiple facets of the avant-garde converged. While working with the naturalist theater, he was writing and publishing poetry and was entirely immersed in the world of symbolist literature. He knew artists and frequented the cabarets and cafés of Montmartre that were their haunts as well.

Correspondence from Antoine to Darzens in the Atlas Collection reveals the director's affection for the younger man and the closeness of their relationship. Antoine addressed Darzens in the familiar *tu* form and frequently wrote to him of small, personal matters. He clearly trusted his associate completely and requested his help in finding solutions to the theater's financial problems, at times admonishing him not to tell even the theater's administrator, Chastanet (Ferdinand Chastan), of certain difficulties. As late as July 1891, toward the end of Darzens' official association with the Théâtre Libre, Antoine continued to express his admiration for the poet's talent.[19]

Although of French nationality, Darzens' family lived in Russia at the time of his birth and periodically thereafter.[20] The young Rodolphe attended the Lycée français in Moscow and spoke Russian as fluently as he did French. During his youth he also learned German, English, and Norwegian. Between 1882 and August 1883 Darzens attended the Lycée Fontanes in Paris, which changed its name to the Lycée Condorcet in January 1883. The school was liberal and encouraged its pupils to explore progressive literary and artistic trends in

Paris. At the Lycée Condorcet Darzens met and became part of a circle of important figures in the emerging literary avant-garde: Camille Bloch and Pierre Quillard became his lifelong friends as well as literary associates; Réné Ghilbert (the future Réné Ghil), Stuart Merrill, and Georges Michel (who soon changed his name to Ephraim Mikhaël) also became his friends and together published a small literary journal titled *Le Frou*. Even though they did not meet at the Lycée Condorcet, Darzens developed close ties at approximately this time with the writers Catulle Mendès and Jean Ajalbert, who was a good friend of the painters Maximilien Luce, Georges Seurat, and Paul Signac. He also became acquainted with the literary avant-garde in Belgium, specifically Maurice Maeterlinck and Charles Van Lerberghe, whose work, like that of nearly all of Darzens' associates, would be performed at the avant-garde theaters in the years ahead. The matriculation of the young artists and future Nabis, Bonnard, Vuillard, Maurice Denis, Ker-Xavier Roussel, and Paul Sérusier at the Lycée Condorcet overlapped with that of Darzens, as did that of Aurélien Lugné (later Lugné-Poe), Thadée Natanson, future publisher of *La Revue blanche*, and his brother Alfred. Vuillard entered the lycée in 1879 and established friendships with Denis, Lugné-Poe, and Roussel in 1884. Unfortunately, there does not seem to be any record of their having met Darzens during those years, but it seems reasonable to imagine that their paths would have crossed. All of these individuals would interact in many ways in future years, and all would be deeply involved in avant-garde theater.

Darzens' poems began to be published in *La Revue moderne* in 1885, and until about 1890 he attended dinners sponsored by the magazine, where he met such literary figures as Rachilde, Richepin, Jean Moréas, and Villiers de L'Isle Adam, who became his friend and mentor. In 1885 Darzens became the co-secretary of *La Jeune France*, a literary periodical devoted to publishing the work of young writers, and there he tried to gain exposure

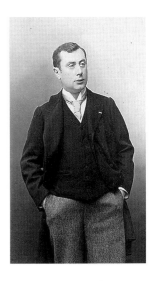

2. Photograph of André Antoine, Bibliothèque de L'Arsenal, Paris, Rondel Collection.

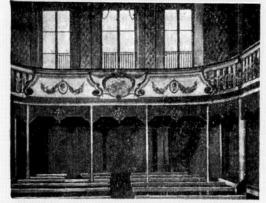

Ce que fut la soirée du 30 mars 1887

au passage de l'Élysée-des-Beaux-Arts

par **LUCIEN DESCAVES**, de l'Académie Goncourt

La salle du Théâtre Libre, passage de l'Elysée-des-Beaux-Arts

for his own poems and the work of his friends Ajalbert and Mikhaël.

At about the same time Darzens attended the *lundis* (Monday receptions) of Robert Caze, a naturalist and friend of Zola's and Edmond de Goncourt's.[21] The gatherings attracted writers and artists of various schools, including the symbolists. Among those who attended were Alexis, Hennique, Mikhaël, Moréas, Paul Adam, Félix Fénéon (critic and future literary secretary of *La Revue blanche*), Joris-Karl Huysmans, Henri de Régnier, and Maurice Rollinat; many of these writers would later have works performed at the Théâtre Libre and at the symbolist theaters. Other participants in Caze's *lundis* included Luce, Seurat, and Signac as well as the painters Albert Dubois-Pillet, Armand Guillaumin, Camille Pissarro, and Jean-François Raffaëlli. Of these, Luce, Raffaëlli, and Signac would illustrate programs for the Théâtre Libre. Recalling these evenings, Ajalbert wrote:

The Salon of Robert Caze was an intersection of a greatly varied group of developing talents, highly representative, like a train station, of the departure of travelers, gathered for a moment in the station restaurant from every direction and who will never meet again....At Robert Caze's *lundis*, people came from every quarter, still lacking labels except for the group of "neo-Impressionist" painters, just then at the point of adopting pointillism, the division of tints, under the unflappable lead of Félix Fénéon....The atmosphere heated up quickly, as at a café or an editorial meeting—with lively discussions, amid much pipe smoke.[22]

Caze's *lundis* ended prematurely in 1886 when he was mortally wounded in a duel. Ajalbert, Darzens, de L'Isle Adam, Dubois-Pillet, and Signac all attended the match in February in support of Caze, who died from his injuries the following month.[23]

By December 1884 Darzens and his friends had begun to frequent the *vendredis* (Friday receptions) at the Chat Noir on the boulevard Rochechouart. In 1885 the cabaret's journal, *Le Chat noir*, published some of his poems, which later appeared in his book of poetry *La Nuit*. Two of these were dedicated to Albert Tinchant, the secretary of *Le Chat noir*. (More of Darzens' poems were published there on 31 August 1889.) Other favorite haunts included the Montmartre cafés La Nouvelle Athènes and Le Tambourin, where in 1886–1887 Van Gogh organized an exhibition of his work together with that of Lautrec, Louis Anquetin, and Albert Besnard.

Although Darzens never participated in the symbolist theater himself, he was in the center of the movement that gave rise to it. For several months in 1886 he served as director of *La Pléiade*, a "literary, artistic, musical, and dramatic review," where he published the work of many friends who were emerging as important members of the literary avant-garde and who would become involved with the Théâtre Libre or the Théâtre d'Art. In the frontispiece to the first issue of *La Pléiade*, which

appeared in March, Darzens advertised his own published volumes of poetry and those of his friends Ajalbert, Mikhaël, Quillard, and Paul Roux (later Saint-Pol-Roux). Roux and Mikhaël contributed poems to this issue, as did Darzens, who also reviewed exhibitions, theater, and literature. The second issue, which appeared in April, included contributions by the same writers, including the entire text of Quillard's *La Fille aux mains coupées* (*Girl with the Cut-Off Hands*) (which gained real fame in 1891 when it was the first play to be staged in a symbolist manner at the Théâtre d'Art). The first work by Maeterlinck to be published in Paris appeared in the May issue of *La Pléiade*—it was his first short story, "Le Massacre des innocents." Six of Maeterlinck's poems appeared in the June 1886 issue, along with several by Van Lerberghe.[24] Maeterlinck's dramas, which focused on the life of the soul rather than external realities, would be of supreme importance to the symbolist theater: Paul Fort produced *L'Intruse* (*The Intruder*) and *Les Aveugles* (*The Blind*) at the Théâtre d'Art in 1891, and Lugné-Poe's symbolist production of *Pelléas and Mélisande* in 1893 led directly to the creation of the Théâtre de L'Oeuvre.

The last few issues of *La Pléiade* created under Darzens' directorship reveal still more early connections to figures and concepts that would soon appear in the theater. In May 1886 Darzens reviewed the Exposition des Impressionnistes, admiring Signac's paintings in particular. Ajalbert dedicated his poem "Drapeaux" to Signac in the same issue.[25] Darzens also reviewed the paintings in the Salon of 1886 and singled out a painting by the Chat Noir artist Adolphe Willette, titled *La Veuve de Pierrot* (*Pierrot's Widow*), for strong praise, noting how discordant it was in an exhibition of otherwise heavy and highly varnished paintings. Among the other works he admired were those by Raffaëlli.[26] His emphasis on the work of these three artists is significant, since Willette would receive the commission for the first illustrated program for the Théâtre Libre in October 1888, Signac for the

second in December of the same year, and Raffaëlli for the third in March 1889.

In July 1886 Darzens published Réné Ghil's article "Traité du verbe," in which Ghil discussed theories of Richard Wagner that were of great importance to the symbolists. These theories—including notions of the musicality of language and the correspondence between color and sound[27]—as well as Ghil's interpretation of them, would be clearly manifest in the symbolist productions at the Théâtre d'Art.

Although Darzens was primarily situated among the emerging symbolist writers during the mid-1880s, his literary contacts were diverse and aided Antoine in developing his naturalist theater. As Antoine recalled in his memoirs, Darzens obtained for the Théâtre Libre Villiers de L'Isle Adam's *L'Evasion* (*The Escape*), which was performed on the premiere evening of the 1887–1888 season. The rest of the season featured the work of other literary associates of Darzens such as Léon Hennique and Catulle Mendès. From the outset Antoine's offerings were eclectic, and before long this diversity elicited commentary in the form of a caricature of Antoine flanked by figures representing naturalism/realism on one side and romanticism/idealism on the other (fig. 5). Antoine also opened his theater to foreign writers and in February gave the first performance in Paris of Leo Tolstoy's *La Puissance des ténèbres* (*The Power of*

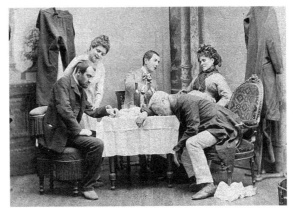

4. Performance of Oscar Méténier's *En Famille* at the Théâtre Libre, 30 May 1887, Darzens scrapbook, vol. 2, National Gallery of Art, Washington, Gift of the Atlas Foundation. Left to right: Auguste (Mévisto); Amélie (Luce Colas); Albert (Paul Alexis); Mère Paradis (Barny); Père Paradis (André Antoine) (see Jean Chothia, *André Antoine* [1991], 13).

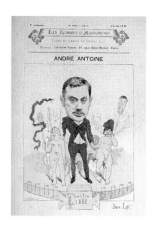

5. Charles Descaux after Désiré Luc, *Les Hommes d'aujourd'hui: André Antoine*, c. 1888, photo-mechanical illustration, 28.5 x 29.9 (11 ⅝ x 7 ⅞), Darzens scrapbook, vol. 1, National Gallery of Art, Washington, Gift of the Atlas Foundation.

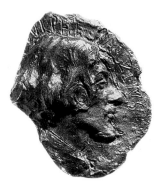

6. Alexandre Charpentier, *Rodolphe Darzens*, bronze bas-relief plaquette, 16.0 x 12.1 (6 ¼ x 4 ¾), Musée de la Monnaie, Paris.

Darkness). As an early biographer of the Théâtre Libre noted, in 1886–1887 the press had focused on the shadow theater at the Chat Noir; in 1887–1888 the Théâtre Libre received most of the attention.[28]

Although the practice of inviting artists to design programs was not initiated until the following year, sculptor Alexandre Charpentier, who had long been active in the design of decorative arts, devoted his energies during the 1887–1888 season to a series of bronze medallions and plaques of figures working at the Théâtre Libre and authors whose plays were produced there. Apparently Charpentier had come to the inaugural performance of the Théâtre Libre with Zola and had been so favorably impressed that he was inspired to begin the series.[29] The collection grew over the years to include many portraits, such as those of Antoine, theater administrator Chastanet, Darzens, writers Hennique, Mendès, Georges Ancey, Théodore de Banville, and Jean Jullien, and artists Luce and Signac. The medals were applauded for capturing not only the subjects' physical likeness but their character and "intellectual physiognomy" as well. Charpentier exhibited them at the Salon, apparently with great success (see fig. 6).[30]

The year 1887 was a busy one for Darzens. By March, when he was installed as secretary and archivist for the Théâtre Libre, he had had a falling out with his good friend, the symbolist poet Jean Moréas, over a woman. She had been Darzens' lover, but while he was in Moscow to attend his ailing father, she turned her affections to Moréas. Darzens received a letter from Villiers de L'Isle Adam informing him of the situation, and when he returned to Paris, Darzens, who was a skilled swordsman, challenged Moréas to a duel. The event occurred a few months later, with neither man being seriously injured.[31] That same year Darzens wrote the play *L'Amant du Christ* (*Christ's Lover*) and asked his friend Quillard to help him with the production, which was presented at the Théâtre Libre in October 1888.[32] In contrast to much of

what Antoine had produced thus far, Darzens' play was not a naturalist work but a somewhat erotic "evangelical verse play" or mystery about the conversion of Simon Peter and Mary Magdalene's love for Jesus.[33] (One wonders whether the subject might relate to Darzens' betrayal by his lover.)

Introduction of Illustrated Programs: Willette, Signac, Raffaëlli, Charpentier, Rivière, and Auriol

The production of Darzens' play was also the occasion for the creation of the first illustrated program for the Théâtre Libre, and Adolphe Willette was given the commission. Antoine credited himself with the idea of hiring artists to illustrate programs, writing in his memoirs: "It occurred to me to have a different painter or designer illustrate each of our programs. This time Willette sent me a marvelous design which I hope will be the first of a most interesting collection."[34] Antoine probably met Willette during evenings at the Chat Noir, yet it is curious that he makes little further mention of interaction with artists; and despite the wealth of correspondence he sent to literary figures, there are no published letters to the many artists involved with the Théâtre Libre over the years.[35] Antoine clearly embraced the idea of hiring artists to illustrate programs, continuing the practice for several years. Yet the lack of documentation on the one hand and the obvious links between Darzens and the artists who received the earliest commissions on the other lead one to consider the possibility that it may actually have been Darzens who initially proposed hiring artists to illustrate programs. For the Théâtre Libre program Willette drew a white Pierrot being stabbed in the heart by a worker (pl. 1). The image does not relate to the content of the play, but the theme of the artistic spirit thwarted by obstinate reality is one that Darzens reinforced in the legend he wrote to correspond with the illustration:

1 Adolphe Léon Willette, *Chevalerie rustique; L'Amant du Christ; Marié; Les Bouchers,* 19 October 1888

The murdered white Pierrot—
Is he not the immaculate Ideal
Which Reality persists
In dealing a stubborn blow?

To no avail! Pierrot lives on,
From the purest blood of his heart
Springs eternally victorious Hope,
The royal flower that adorns him.[36]

Darzens' *L'Amant du Christ* was performed with *Chevalerie rustique (Rustic Chivalry)* by Giovanni Verga and *Les Bouchers (The Butchers)*, a naturalist drama by Fernand Icres. Antoine's staging of the latter outraged most critics because he hung a real side of beef on the stage to make the setting more realistic. To the premiere performance Darzens invited his literary associates Mendès, Georges Rodenbach, Léo Tréznik, Paul Verlaine, and Rachilde, who would also become an important advocate for young poets and writers.[37] Lugné-Poe, future director of the Théâtre de L'Oeuvre, performed in *L'Amant du Christ* and in the two other plays that evening.[38] He later recalled Darzens and his role at the Théâtre Libre: "Sometimes Rodolphe Darzens showed up, young, handsome, feisty, and his Parisian adventures, which he recounted at high pitch, enchanted us. His tangle of intrigues astounded Antoine as much as the friendship that Catulle Mendès seemed to lavish on Darzens. Had not Darzens collaborated on projects with the poet-critic? At [the Théâtre] Libre, Darzens made overtures to the poets, to Mendès, to Bergerat, to Mikael [*sic*], to Quillard. He was the poet of place, he was the verse, which amused Antoine, with whom he took on an entirely different tone than that he affected with the naturalist writers."[39]

From this performance on, as finances permitted, the Théâtre Libre hired artists to create images for its programs. In the beginning the illustrations often had nothing to do with the plays represented on the program but were simply original artistic designs. Signac's commission for the second program led to works by Jean-François Raffaëlli, Alexandre Charpentier, Henri Rivière, and George Auriol. The sixth program was done by the Nabi artist Edouard Vuillard, who was a close friend of Lugné-Poe's (both, like Darzens, had been pupils at the Lycée Condorcet).

Signac's program was for the 10 December 1888 performances of Georges Porto-Riche's *La Chance de Françoise (Françoise's Luck)* and works by two other acquaintances of Darzens: Hennique's *La Mort du duc d'Enghien (The Death of the Duke of Enghien)* and Mikhaël's *Le Cor fleuri (The Flowered Horn)*. Like Antoine, Darzens, Willette, and many young artists and writers of the day, Signac frequented the Chat Noir. He participated in the humorous, *fumiste* activities organized by habitués of the café, including a fake funeral to which he came dressed as a nun. And like Darzens, he had published works in *Le Chat noir:* in 1882, at the age of nineteen, he contributed two articles, one of which, "Une Trouvaille," was an imitation of the work of Zola.[40] Signac had also been following developments at the Théâtre Libre. When the play *La Fin de Lucie Pellegrin (Lucie Pellegrin's End)* by Paul Alexis was produced the preceding June, Signac and Seurat contributed drawings for the review published in *La Vie moderne.*[41]

Signac's image for the program (pl. 2) does not relate to the content of any of the plays; it represents spectatorship—showing the back of the head of a man viewing a performance. In addition, as its caption suggests, the image is an "Application du Cercle chromatique de mr. Ch. Henry." It publicizes both the Théâtre Libre ("T-L") and the work of scientist Charles Henry, who had developed highly influential theories about the symbolism of lines and color in art. Henry believed that rising lines suggested gaiety, while descending lines evoked sadness. He had also conceived a system for dividing color and opposing complementary colors that resulted in a truer optical impression for the viewer. These theories influenced

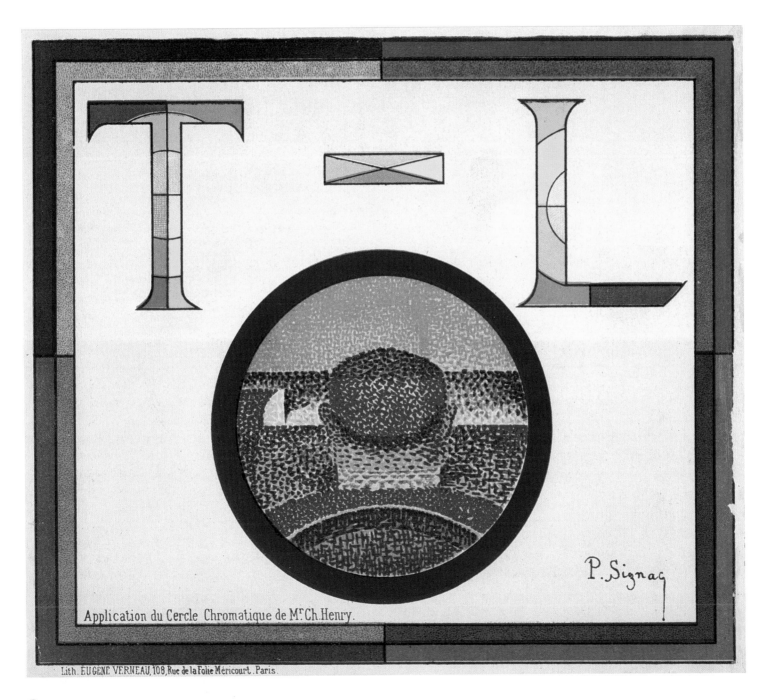

2 Paul Signac, *La Chance de Françoise; La Mort du duc d'Enghien; Le Cor fleuri,* 10 December 1888

3 Jean-François Raffaëlli,
La Patrie en danger,
19 March 1889

Seurat, Signac, and other painters working in the pointillist technique.

Signac collaborated closely with Henry. In the same year that he illustrated the Théâtre Libre program, he also created drawings to illustrate Henry's theories and made color samples for pamphlets advertising *Le Cercle chromatique* and *La Rapporteur ésthétique*. Signac, who was very sympathetic to the mutual plight of the worker and artist of his time, and who was, in fact, an anarchist, believed that Henry's theories would be useful in educating taste and in training artists who worked in applied art.[42] And his Théâtre Libre cover sought to do just that. Printed on a heavy card stock, with the program information on the verso, his color lithograph illustrates recent theories in the visual arts and at the same time serves as an original work of art, collectible by the subscriber. Signac's lithograph was reused for the 15 January 1889 performance of *La Reine Fiammette (Queen Fiametta)* by Mendès and the 31 January performances of *Les Résignés (The Resigned)* by Henri Céard and *L'Échéance (The Day of Reckoning)* by Jean Jullien. Signac's image illustrates some of Henry's principles:

Starting at the bottom of the right side of the 'T,' rising up to the top and down the other side, one has the colors in the order Henry placed them on his wheel. The 'L' repeats the first portion of this sequence, but upside-down. In the tondo, the hair of the spectator turns bluish green to oppose the red-orange of the stage; the central portion of his hair is purple, and therefore flanked by the yellow of the footlights; the base of his hair again becomes bluish green as it meets the ruddy flesh tones of his neck. The outside border pairs color opposites and then echoes them in reversed order across the square. In the lower left, the outside is dark green next to the red inner band; in the opposite corner, the outer band is dark red and the inside, green.[43]

For the evening of 19 March 1889 Antoine staged *La Patrie en danger (The Nation in Danger)* by

Edmond and Jules de Goncourt, a drama based on episodes from the French Revolution. A photolithographic reproduction of a drawing by Raffaëlli, who was known for his depictions of the lower social classes in the suburbs of Paris, decorated the playbill (pl. 3).

Also in 1889 Darzens published a group of essays with Mendès on dancers at the Exposition Universelle. He contributed a poem on "Sénégalises" for a tourist brochure that provided background on this particular national dance tradition. Through Mendès, Darzens met the poet Jules Bois, whose *Noces de Sathan (Satan's Wedding)* would be performed at the Théâtre d'Art a few years later. Also through Mendès he met the illustrator Lucien Métivet, who began to collaborate with him in producing a short-lived publication for Antoine, *Le Théâtre Libre illustré*.[44] Each issue, distributed on the evening of a performance, included a discussion of the piece being presented, often the text of the play, and a portrait of and biographical information about its author. The booklets first appeared in October 1889 and continued for two seasons. They were later reissued by the publisher E. Dentu in two volumes that corresponded to the 1889–1890 and 1890–1891 seasons.

In January 1890, while still serving in his official capacities at the Théâtre Libre, Darzens began to branch out in other directions. He became the chief editor of a new literary periodical, *La Revue d'aujourd'hui*, which also reproduced visual likenesses of the writers discussed; Raffaëlli drew a portrait of Ajalbert, and Frédéric-Auguste Cazals did one of Verlaine. At the same time Darzens attempted to create a publication called *Journal libre* to support the work of the young symbolist writers, inviting other publishers to participate in the effort. Thadée and Alexandre Natanson, who were just beginning their involvement with *La Revue blanche* (founded in December 1889), and Alfred Vallette, publisher of the symbolist journal *Mercure de France* (founded in January 1890), discussed with Darzens the feasibility of this new

publishing venture. In the end, however, it was decided that the *Journal libre* was an excellent but impractical idea.[45]

Alexandre Charpentier, who had already begun the series of medallions of authors whose works were performed at the Théâtre Libre, created a bas-relief print to adorn the program for the evening of 21 October 1889, featuring *Dans Le Guignol (In the Puppet Show)* and *Le Père Lebonnard (Father Lebonnard)*, both by Jean Aicard. His design was reused on 27 November, which included the plays *L'École des veufs (School for Widowers)* by Georges Ancey and *Au Temps de la ballade (In the Time of the Ballads)* by Georges Bois (pl. 4). Charpentier, as a sculptor and furniture maker, had long advocated applying art to the decoration of everyday objects. He was also one of the first to experiment with making three-dimensional prints, introducing the bas-relief aesthetic of his medals and sculpture into printmaking. In making these prints, Charpentier adapted a technique from Japanese printmaking called *gaufrage*, which involves using a matrix made up of cigarette wrappers that is flexible enough so that the mold does not tear the paper during printing.[46] For these programs, he did not apply ink; the image was simply embossed into the plain paper.

Henri Rivière, the genius behind the shadow theater at the Chat Noir, was invited to design a program cover for the 10 January 1890 performances of *Le Pain d'autrui (The Bread of Others)* by Russian novelist Ivan Turgenev and *En Détresse (In Distress)* by Armand Ephraim, Henry Fèvre, and Willy Schute. Rivière's image was reused both for the 25 February performances of *Les Frères Zemganno (The Brothers Zemganno)* by Edmond de Goncourt and *Deux Tourtereaux (Two Turtle Doves)* by Paul Ginisty and Jules Guérin and for the 30 May presentation of *La Pêche (Fishing)* by Céard and *Les Revenants (Ghosts)* by Ibsen (pl. 5). The latter was the first performance in Paris of a work by this Norwegian playwright, and the script had been translated into French by Darzens.

Rivière's image does not relate to the content of any of the plays but depicts a winter street scene in Paris. This design, and the one by George Auriol that followed it, are especially clear indications of how thoroughly "artistic" these playbills were: they provide information on an evening's performances but also function as original, noncommercial art to be hung in the home of the subscriber. Like the earlier designs by Signac and Willette, these were all-purpose images, used for more than one program, undoubtedly as a means of economizing. Like Signac's design, Rivière's composition limits the text to one side of the paper, but in this case the program was folded so that the image was protected on the inside and the text appeared on the front and back "cover." Prominent in Rivière's image is a Morris column, onto which is pasted an advertisement for the Théâtre Libre. Morris columns had been invented twenty-two years earlier in response to the long-recognized need for a more orderly way to display posters—particularly theater posters, which were so numerous. Finally, in 1868 the Morris Company was commissioned to construct 150 columns exclusively for this use, and they quickly became one of the most characteristic features of the Parisian sidewalk.[47]

Rivière's division of the image into two halves and his use of a strong diagonal to define the curb reflect his admiration of Japanese prints. And black silhouetted forms, like those he was creating in the shadow theater at the Chat Noir, are scattered in the background. Prior to this he had made only color woodblock prints and etchings. This commission inaugurated his exploration of color lithography and his lasting friendship with Eugène Verneau, who printed all of Antoine's programs after 1888.[48] Later Rivière and Verneau further developed the concept of prints as decorative art in a series of large-scale color lithographs specifically intended "for the decoration of apartments—dining rooms, vestibules, children's rooms—and school rooms."[49]

LE THÉATRE LIBRE

Saison 1889-1890

L'ÉCOLE DES VEUFS

Comédie en cinq actes, en prose.

Mirelet	M.M. ANTOINE
Henri	MAYER
Marguerite	M^lle HENRIOT

Invités, gens de service

MM. PHILIPON, JANVIER, DARNEY, ARQUILLIÈRE, PINSARD, AMYOT, DORVAL, DUJEU, TINROT, MORITZ, MORIÈRE, SÉVÉRINO, DUBARRY, FECHTER, FRÉDÉRICK.
M^lles LUCE COLAS, MARLEY.

Décor de M. P. CHAPUIS. Meubles de M. LE HOUSSEL

ON COMMENCERA PAR

AU TEMPS DE LA BALLADE

Pièce en un acte, en vers.

Charles d'Orléans	MM. LAUDNER
François Villon	PHILIPON
Galuet	ARQUILLIÈRE
Guillemette	M^lle AUBRY

2^me SOIRÉE.

Mercredi 27 Novembre 1889.

LEVER DU RIDEAU A 8 H. 1/2

De la part de MM. GEORGES ANCEY ET GEORGE BOIS.

Paris. — Imp. Eugène VERNEAU, 108, rue de la Folie-Méricourt.

4 Alexandre Charpentier, *L'École des veufs; Au Temps de la ballade*, 27 November 1889

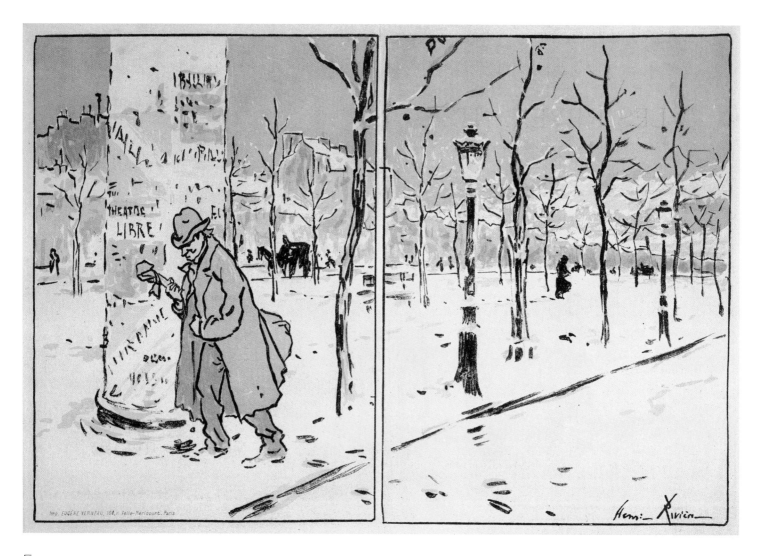

5 Henri Rivière, *Les Revenants; La Pêche,* 30 May 1890

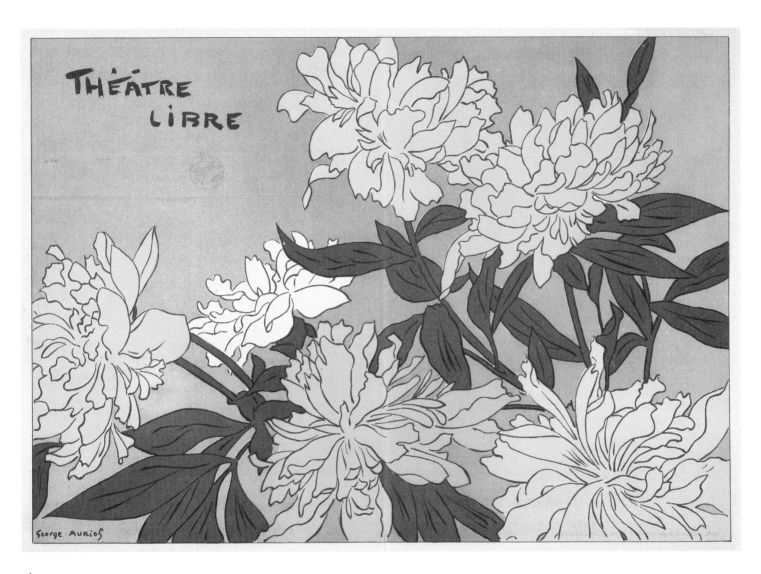

6 George Auriol, *Ménages d'artistes; Le Maître,* 21 March 1890

Auriol's color lithograph of chrysanthemums for the Théâtre Libre (pl. 6) is closely related in format to programs he had designed for the shadow theater performances at the Chat Noir, which all reflect his admiration of Japanese art. His chrysanthemums decorated the program for 21 March 1890 performances of *Ménages d'artistes* (*Artists' Households*) by Eugène Brieux and *Le Maître* (*The Master*) by Jean Jullien, and it was reused for the programs of 2 May and 13 June. Like Rivière's earlier design, Auriol's layout relegated program information to the verso, which underscores the preciousness of the lithographic image and enables the object to evolve from functioning as a theater program to existing solely as a work of art. In addition to collaborating with Rivière on the shadow theater between 1887 and 1889, Auriol served as the editor of *Le Chat noir* for several years and contributed many articles and drawings.[50]

By early 1888 the headquarters for the Théâtre Libre at 96 rue Blanche in Montmartre was becoming a gathering place for artists and literary figures. Antoine decorated the walls with works of art, and one surviving description offers a sense of what it was like: "It was a large square salon with divans. On the walls were canvases by young realistic painters. They give the note to the establishment which has a youthful atmosphere. Antoine is the general-in-chief of this army of volunteers. He insists that everyone, like him, shall take his mission seriously. And from nine o'clock in the evening until midnight these young people maneuver with admirable discipline, reciting dialogues or monologues with fury, until they find the right note or the true gesture."[51]

In 1889 Antoine was offered a painting by Henri-Patrice Dillon that recorded this activity, *Rehearsal of "La Sérénade" by Jullien at the Théâtre Libre* (fig. 7). As he wrote in his memoirs: "A painter whom Jean Jullien brought to the theatre did a painting...which he has shown me and which I find most interesting. I would have liked to buy it, but alas, I don't have a cent."[52] Dillon's picture portrays many of the actors and writers closely associated with the theater at this time, including Ancey, Jullien, Alexis, Hennique (with the cane), and Darzens, all seated to the right of the door; and Antoine, standing with his back to the viewer reading the text of a play.[53] A photograph from around 1892 reveals that at that time a design by Henri-Gabriel Ibels for a fan depicting circus performers was among the objects that hung in the theater's salon (fig. 8).[54]

In the fall of 1888, while Lugné-Poe was acting in Darzens' *L'Amant du Christ* and other Théâtre Libre productions, Bonnard, Denis, Ibels, and Paul Ranson were absorbing the artistic theories that inspired a painting made by Sérusier under the supervision of Paul Gauguin. It was a landscape painting called *Bois d'amour* that was far less a representation of nature than it was the decorative arrangement of patches of color on a flat surface. Form and color were expressive, independent of the subject depicted, a theory that became known as synthetism. As Denis later

7. Henri-Patrice Dillon, *Rehearsal of "La Sérénade" by Jullien at the Théâtre Libre*, 1889, oil on canvas, 97.0 x 126.0 (38 1/4 x 49 5/8), Musée Carnavalet, Paris.

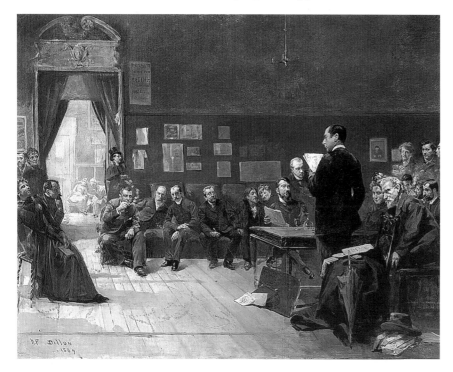

recalled, this experience changed the way he and his friends thought about image-making: "And so we were introduced, in a paradoxical and unforgettable form, to the fruitful concept of the 'flat surface covered with colors assembled in a certain order.' And so we learned that any work of art was a transposition, a caricature, the impassioned equivalent of a sensation experienced."[55]

Early in 1889 these young men banded together as an artistic fraternity called the Nabis (prophets, or seers), devoted to exploring the theories espoused by Gauguin. Within a few months others, including Vuillard and his brother-in-law Ker-Xavier Roussel, joined the group of converts. They experimented with the new symbolist concepts, searching for a more decorative, expressive way of painting. They created bold images that did not appeal to the traditional buyers of art. As Lugné-Poe pursued his acting career, he worked tirelessly to find patrons for his friends' art; and they, particularly Vuillard, were very supportive of his efforts in the theater. Lugné-Poe had been admitted into the Conservatoire to study traditional declamation and rhetoric in the fall of 1888 and continued to take acting classes there while performing regularly with Antoine's quite untraditional Théâtre Libre. In July 1890 he competed in the *concours* at the Conservatoire and shared the first honorable mention in comedy with two other students.[56] He participated in the competition again in 1891 together with the young actress Marthe Mellot. Vuillard often accompanied Lugné-Poe to the Conservatoire, and he recorded the frenzied activity of the 1891 *concours* in a lively watercolor (fig. 9) that shows Lugné-Poe onstage with Mellot, who would perform often with him a few years later.[57] She would also marry Alfred Natanson, drama critic for *La Revue blanche*, and brother of its publishers, Thadée and Alexandre.

Antoine's 1890–1891 season began with the performance of Henry Fèvre's *L'Honneur* (*Honor*), a five-act play in prose that was meant to address the prejudices in French society about "feminine

8. Photograph of André Antoine seated in the rehearsal room at the Théâtre Libre, from an undated article, Darzens scrapbook, vol. 1, National Gallery of Art, Washington, Gift of the Atlas Foundation.

honor." The play is about the young daughter of a bourgeois couple who hope to find a favorable match for her. She is pretty and healthy, and although she has had an offer of marriage from her cousin, the parents have refused it, hoping to find better. Their wealthy neighbors, the Bagréants, promise to help in finding a suitable young man. But M. Bagréant, a womanizer, forces himself on the girl. She becomes pregnant and admits what has happened, but Mme. Bagréant and her parents side with M. Bagréant. Her young cousin again asks to marry her. This time the family agrees to the union, but at the last minute the father, who is ashamed, tries to cancel the wedding by explaining to the young man what has transpired. When told, the young man claims that he is the father of the unborn child, and the wedding takes place. Carlos Schwabe, a symbolist artist and illustrator, was given the commission to illustrate the program (fig. 10), and while the meaning of his image is not clear, it seems to include symbols referring to the issues of love and feminine honor explored in the drama: the woman is weighing hearts, surely symbolizing love, against a branch, perhaps palm, that might symbolize victory in regaining her lost

9. Edouard Vuillard, *Concours de déclamation Conservatoire*, 1891, brush and ink with watercolor on paper, 39.0 x 34.0 (13 3/8 x 11 1/2), Victoria and Albert Museum, London.

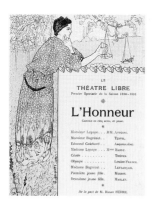

10. Carlos Schwabe, *L'Honneur*, 22 October 1890, photorelief with watercolor stenciling (*pochoir*) on paper (recto); photomechanical reproduction of drawing by Jean-Louis Forain (verso), 21.0 x 31.6 (8 1/4 x 12 3/8), National Gallery of Art, Washington, Gift of The Atlas Foundation, 1995.76.134.

honor. Balances and similar branches also appear on her skirt, and hearts with notes pinned onto them form a line across the text block.[58]

On 26 November 1890 the Théâtre Libre offered three plays: Maurice Biollay's *Monsieur Bute*, Aurélien Scholl's *L'Amant de sa femme* (*His Wife's Lover*), and Jean Serment's *La Belle Opération* (*The Fine Operation*). Vuillard received the commission to design the program (pl. 7), thanks to Lugné-Poe, who must not have seen the performance, since he left Paris to perform his military service on 10 November (serving through March 1891). Vuillard's stencil-colored photorelief print has been thought to relate to the character of M. Bute, although this may not be so, and it is surely unrelated to the other two plays given that evening.[59] In Biollay's drama, M. Fraulin, who is also known as M. Bute ("farrier's knife"), was an executioner for thirty years but has been forced to retire because the public thinks he is not cold-blooded enough. A widower, he lives with his daughter and a maid. He misses his work, however, and looks forward to attending an execution performed by his former assistant. But he is ill, and the doctor has advised his daughter and maid to prevent him from going out in the early morning hours to observe the event. In the final act he becomes enraged when the maid tries to stop him from leaving the house, and he beats her viciously with a candlestick, which breaks into pieces from the force of his attack, then he strangles her. By this point he is completely mad and kneels before her body pushing his hands and face into her blood.

Biollay's play was set indoors, and there is a literal illustration of the last act in Lucien Métivet's drawing published in the *Théâtre Libre illustré*. Although Vuillard's image for the program cover is set outdoors, the large, gnarled hands of the figure might bring to mind the author's description of M. Bute strangling the maid with his bare hands. It has been suggested that the three dark, twisted black forms at the man's feet symbolize rivulets of blood. Yet Vuillard reworked this image several

times, and in a series of preparatory drawings, the earliest of which is less abstract than the final printed one, these curving black forms are clearly some kind of plant or stalk emerging from the furrows in the ground (fig. 11) and the tree under which the figure stands is laden with naturalistically rendered fruit. The man is in a garden, a vineyard, or an orchard, and he is working the soil with his hands.[60] Furrows with stalks emerging from them recede into the distance. The components of the man's body, particularly his hands, are nearly in proper proportion to one another. In successively more abstract and more synthetist revisions of the image, Vuillard distorted shapes for expressive purposes, translating fruit into black and white orbs, exaggerating the size of the hands, and changing the words "Théâtre Libre" from block letters into undulating lines with an expressive potential of their own.

The interpretation of this figure as a peasant means that it does not relate to the content of any of the plays on the program for 26 November, nor does it seem to refer directly to any of the plays

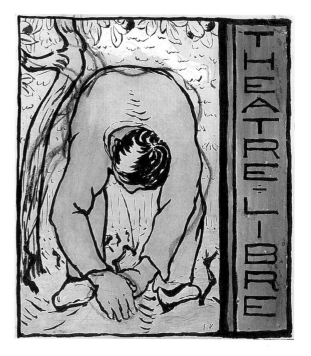

11. Edouard Vuillard, study for program for *Monsieur Bute*, 1890, pen and ink, brush and ink, watercolor, black crayon, and gouache on paper, 20.5 x 18.2 (8 1/2 x 7 1/8), Private Collection.

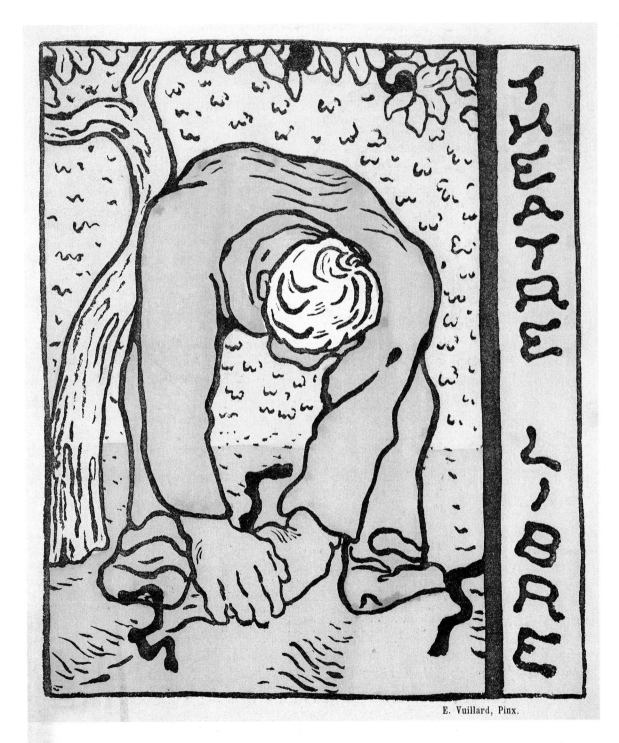

E. Vuillard, Pinx.

7 Edouard Vuillard,
Monsieur Bute;
L'Amant de sa femme;
La Belle Opération,
26 November 1890

12. Edouard Vuillard, untitled sketch, c. 1890, pen and ink on paper, 21.9 x 14.4 (8 5/8 x 5 5/8), Private Collection.

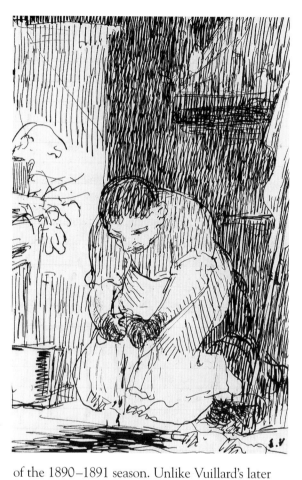

13. Edouard Vuillard, design for a program for the Théâtre Libre, 1890, pen and ink, brush and ink, and watercolor on paper, 17.2 x 24.5 (6 3/4 x 9 5/8), Private Collection.

of the 1890–1891 season. Unlike Vuillard's later lithographs for the Théâtre de L'Oeuvre, which obviously depict specific moments in particular plays, the earlier designs for the theater are difficult to ascribe to a single play. Perhaps this peasant was a generic image (like those by Auriol, Rivière, Signac, and Willette), broadly evoking the Théâtre Libre's renown for producing plays that dealt with the lower social classes. In early sketches for this program the artist pairs the figure of the bent-over peasant with the image of a nude pregnant woman, and it is remotely possible that she might relate to the slightly earlier performance of *L'Honneur*.[61] More directly connected to M. Bute perhaps is an intriguing and an approximately contemporary drawing by Vuillard that depicts a man in an interior,

kneeling to mop up some dark liquid (fig. 12), which suggests M. Bute's behavior following the bludgeoning of his maid.

Projects Related to the Theater: Vuillard, Bonnard, and Denis

Vuillard created several marvelous designs for programs for the 1890–1891 season that were never realized. Since the imagery often does not seem to correspond to a specific play, these too may have been generic images that could be applied to any evening's program at the Théâtre Libre. One example is his watercolor of a couple in a carriage receiving printed flyers from a fellow who is energetically distributing them (fig. 13).[62] Another design that could be applied to any play combines just a caricatural portrait (possibly of an actor) and the words "Théâtre Libre" (fig. 14). In a charming and perplexing example presumed to be a theater program design, Vuillard rendered all of the figures in bluish silhouettes (fig. 15), recalling the shadow theater performances at the Chat Noir. The soldiers on a distant hillside wear uniforms like those used during the Franco-Prussian War. In the foreground are the figures of a female Red Cross worker and a fellow worker or soldier drinking from a cup. The insignia of the Red Cross is prominent at the top of the drawing. Vuillard's

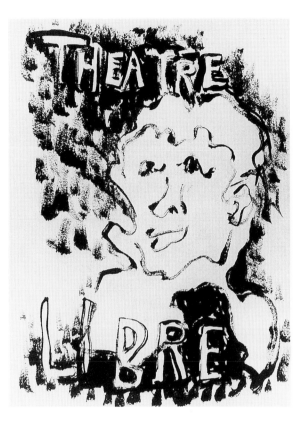

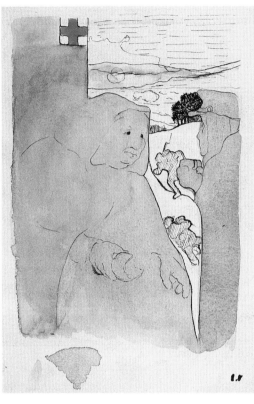

14. Edouard Vuillard, design for a program for the Théâtre Libre, 1890, brush and ink on paper, 27.5 x 20.0 (10 $^7/_8$ x 7 $^7/_8$), Private Collection.

15. Edouard Vuillard, design for a program for the Théâtre Libre, 1890, pencil, pen and ink, and watercolor on paper, 21.0 x 14.0 (8 $^1/_4$ x 5 $^1/_2$), Private Collection.

image may have evolved out of elements present in Lucien Descaves' and Georges Darien's one-act piece *Les Chapons* (*The Capons*), performed at the Théâtre Libre on 13 June 1890, which focused on the Prussian military arriving in Versailles in 1870 during the Franco-Prussian War. The Red Cross did play an important role in France during this conflict,[63] but Vuillard's drawing does not seem to have anything to do with Versailles and may have been offered as a design for this or any program.

Another indication of the apparently flexible nature of the imagery on some of these early projects for programs by Vuillard might be found in a watercolor drawing inscribed "T-L / 2e soirée" (Théâtre Libre / second evening) (fig. 16). It depicts two figures—one male and one female—in the center of an undulating red oval and encircled by flowing red forms that also encompass the text. If it was intended for the Théâtre Libre's second

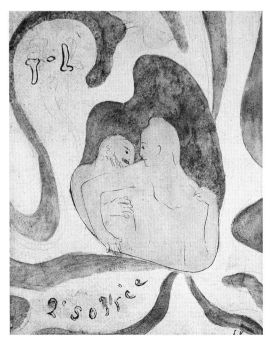

16. Edouard Vuillard, design for a program for the Théâtre Libre, "2e soirée," c. 1890, pen and ink, brush and ink, and watercolor on paper, 20.7 x 16.2 (8 $^1/_8$ x 6 $^3/_8$), Private Collection.

evening of the 1890–1891 season, 26 November, the image of the man and woman could be loosely related to Scholl's *L'Amant de sa femme*, which dealt with a husband who decides to keep his wife faithful to him by treating her as his mistress. Although the design was never used by Antoine, a slightly altered version was reincarnated in December 1891 for the Théâtre d'Art and printed as an illustration for Jules Laforgue's symbolist poem *Le Concile féerique* (*The Fairy Council*) (see fig. 43).

Vuillard was not the only member of the Nabis who hoped to receive a commission from Antoine. Lugné-Poe tried to intervene on Bonnard's behalf as well, but none of the latter's drawings was published by the Théâtre Libre. As Lugné-Poe recalled: "At the Théâtre Libre, thanks to Chastanet, I tried to slip in a program by Vuillard, as I did one by Bonnard, which was rejected, and I have kept it."[64] Bonnard's lively program designs, like Vuillard's, seem to be general in nature. The example from the Atlas Collection, inscribed in Bonnard's hand "à mon bon comarade Lugné, P. Bonnard," shows a young male nude surrounded by theatrical masks (pl. 8). The face to the right of the figure's stomach resembles the artist's cousin, Berthe Schaedlin, who modeled for him often during this period. Masks lower in the composition seem to take on more caricatural and proletarian qualities, like the subjects of plays for which the Théâtre Libre had become famous.[65]

Maurice Denis also hoped to design programs for the Théâtre Libre. While Lugné-Poe was away fulfilling his military obligations, Antoine planned to stage Maeterlinck's *Princesse Maleine*, and Denis wrote to Lugné-Poe: "Good relationships and seniors go together: the Pissarros, father and son. We get along very well with Signac. Vuillard is making a program for the T.L....If Antoine produces *Princesse Maleine*, as the newspapers claim, I would be *very happy* to design the program. To my way of thinking, there would be all those who saw the drawings for *Sagesse*."[66] Unfortunately, the Théâtre Libre never staged the piece, and Denis

never received a commission from Antoine.

It must have been through Lugné-Poe that Vuillard developed contacts with other actors and actresses, including Félicia Mallet, who had appeared at the Théâtre Libre in *La Fin de Lucie Pellegrin* on 15 June 1888. In the same year she also regularly performed Aristide Bruant's monologues at Le Mirliton.[67] In June 1890 she debuted in the role of Pierrot *fils* in *L'Enfant prodigue* (*The Prodigal Son*) at the Théâtre Bouffes Parisiens. This enormously popular pantomime was put on by an amateur group called the Cercle Funambulesque, which was devoted to all styles of mime performance.[68] Vuillard took Denis to see it and also created numerous drawings of Mallet in this role.[69] Among them are designs for a poster (fig. 18) and several sketches of the actress in costume on stage, including a charming sketch of just her arm as she enters or exits a scene with a grand gesture (fig. 17). Lugné-Poe recalled that in 1891 he showed this series of watercolors to the critic Gustave Geffroy, who was so favorably impressed by them that he planned to visit the studio that Vuillard shared by then with Bonnard, Denis, and Lugné-Poe.[70] The drawings were slated to be reproduced in a publication by Paul Hugounet called *Pierrot et Pierrots*, but the book never appeared.[71]

Biana Duhamel performed as Phrynette in the Cercle Funambulesque's production of *L'Enfant prodigue* at the Bouffes Parisiens, and Vuillard created a painting of her in the role. In November 1890 she played the lead in the same theater's operetta, *Miss Helyett*, and Vuillard recorded this in a pastel drawing (fig. 19). The libretto describes the humorous circumstances arising as the daughter of a puritanical preacher endeavors to maintain her virtue despite temptations from the world of the senses. Vuillard conveyed her predicament—being pushed and pulled from both poles—through distortions of form and stark contrasts in color.[72]

Lugné-Poe had also introduced his friends to the popular comedian from the Comédie-Française, Coquelin *cadet*, who became an early and impor-

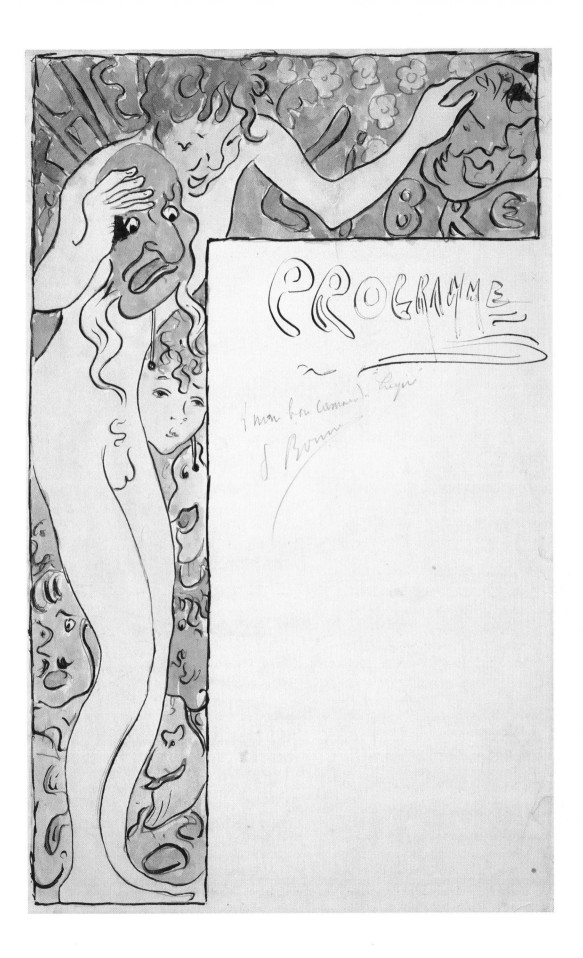

8 Pierre Bonnard,
*Program Design for
the Théâtre Libre,*
1890

17. Edouard Vuillard, *Félicia Mallet in "L'Enfant prodigue,"* 1890, brush and ink on paper, 11.7 x 8.0 (4 5/8 x 3 1/8), Private Collection.

18. Edouard Vuillard, design for a poster for Félicia Mallet in the role of Pierrot *fils* in *L'Enfant prodigue*, 1890, pencil, brush and ink, and watercolor on paper, 30.6 x 21.0 (12 x 8 1/4), Private Collection.

19. Edouard Vuillard, *Biana Duhamel in "Miss Helyett,"* 1890–1891, pastel on paper, 42.0 x 26.0 (16 1/2 x 10 1/4), Rosenthal and Rosenthal, Inc.

tant patron for the Nabis. While Lugné-Poe was absent from Paris during his military service, it was Coquelin who became the advocate for these young artists. Denis informed Lugné-Poe of this in a letter: "Coquelin apparently decided to replace you in our service."[73] And Coquelin *cadet* was among the first to buy Nabi works (he was Vuillard's first patron). British artist William Rothenstein recalled how he and others received such commissions from Coquelin *cadet* and his older brother, actor Constant Coquelin:

I made several drawings and pastels of both Coquelin *ainé* and his younger brother, the first commissions I got. These I made at the Comédie-Française, where I enjoyed the stir and bustle of the *foyer des artistes*, the glimpses of the actors and actresses making up in their dressing rooms and the excitement and confu-

sion of the rehearsals. The seeming miles of cupboards, in which hung the dresses for the whole repertory of the theatre, astonished me. Duvent, Royer, and Vuillard also worked much for both the Coquelins, for small sums, I think. But we were glad enough to be earning, Vuillard especially, for he was then very poor.[74]

Vuillard created a striking series of caricatural watercolors depicting Coquelin *cadet* in various roles at the Comédie-Française between 1890 and 1892.[75] Among these is one of the actor in the *Diable de Grisélidis* (fig. 20). In this highly abstract image Vuillard shows the stage through a metal grating, with Coquelin *cadet* as the devil at the upper left, his clawed hand echoing the lines of the grillwork as it arcs to the right around the figure of Grisélidis. In 1892 the Comédie-Française revived Boursault's

Mercure galant especially for Coquelin. He played five different roles in each of the nine performances given: Monsieurs Boniface, de Lamothe, La Rissole, Sagsue, and Beaugénie. One reviewer wrote: "The role of the 'mercure galant' offers a parade of an entire gallery of contemporary caricatures. Coquelin *cadet* himself takes on five of these caricatures, and he performs them to perfection. With the Gallic sonnet of the last act, he puts the whole theater in good mood."[76] Vuillard recorded this tour de force in a group of drawings, including one particularly strong image drawn in vivid colors on blue paper (fig. 21). All of the Coquelin drawings are marvelous examples of Vuillard's intentional distortion of form and audacious use of color to create synthetic images that evoke the spirit of the role and the actor's energy on stage. In addition to these watercolors, Coquelin purchased other works by Vuillard, including a pastel portrait of an actress, *Femme au peplum (Woman with a Cloak)* (fig. 22). Its juxtaposition of rich contrasting colors—burnt orange and teal blue—recalls the color oppositions in Signac's program for the Théâtre Libre and is evidence of Vuillard's exploration of diverse artistic

20. Edouard Vuillard, *Coquelin cadet in the role of the Diable de Grisélidis*, 1891, pen and ink with brush and ink on paper, 25.6 x 18.5 (10 1/8 x 7 1/4), Private Collection.

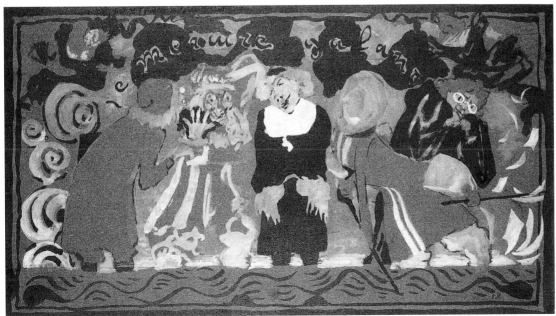

21. Edouard Vuillard, *Coquelin cadet in "Le Mercure galant,"* 1892, brush and ink watercolor, and gouache on blue paper, 22.5 x 40.9 (8 7/8 x 16 1/8), Private Collection.

22. Edouard Vuillard, *Woman with a Cloak*, 1890–1891, pastel, charcoal, and gouache on paper, 24.2 x 16.3 (9 1/2 x 6 3/8), Private Collection.

models and theories. As always, however, Vuillard assimilated external influences into his own extremely sophisticated and personal artistic statement. Coquelin also owned a painting by Vuillard of *Jane Avril with an Umbrella*, which documents the artist's broad theatrical interests (fig. 23). (Frequently depicted by Lautrec, Jane Avril was a well-known dancer at the café-concerts, including the Moulin Rouge and the Divan Japonais.) Paintings by Bonnard and Denis were also in Coquelin *cadet*'s collection, and he encouraged others to see and consider buying their art as well.[77]

While Lugné-Poe was away, the Nabis also received support from Rodolphe Darzens, who seems to have tried to help Denis find a publisher for drawings he had created in 1889 to illustrate Verlaine's *Sagesse*. Denis told Lugné-Poe about this

in the same letter in which he mentioned Coquelin's support, adding "I still await the promised visit of R[odolphe Darzens]: according to what I hear, he's fighting a duel!!!"[78] Darzens was not successful in getting the *Sagesse* illustrations published. Moreover, although he involved Vuillard in a potential book project, the only records are the artist's watercolor designs for a poster or book jacket inscribed *Phonographies, éditeur Rodolphe Darzens* (fig. 24) and *Phonographie, éditeur Darzens*. Thomas Edison had recently invented the phonograph and had traveled to Paris to present it at a special booth in the Galerie des Machines at the Exposition Universelle in 1889. Vuillard's marvelous designs explore various means of suggesting sound and the sense of hearing, including enormous ears and a decorative pattern of undulating line that implies sound waves.[79]

Before the Rise of Symbolism: Chéret, Forain, Willette, Charpentier, Rivière

The symbolist movement had been gaining momentum, and not long after Lugné-Poe's split with the Théâtre Libre in February 1890, a new theater emerged—the Théâtre d'Art—which would become the organ of the symbolists' interests. Its first performance took place in November 1890, the same month in which Lugné-Poe began his military service away from Paris. Antoine welcomed the new movement, writing: "A committee of poets has been formed to establish a Théâtre d'Art which will soon give plays by Pierre Quillard, Rochilde [*sic*], and Stephen [*sic*] Mallarmé....This is very good. The Théâtre Libre is no longer sufficient; other groups are becoming necessary to give certain works that we cannot present at our theatre. I do not feel that this new theatre will compete with ours, but rather will complement it in the accelerating revolution."[80] When Lugné-Poe returned to Paris from his military service, he and his Nabi friends devoted their

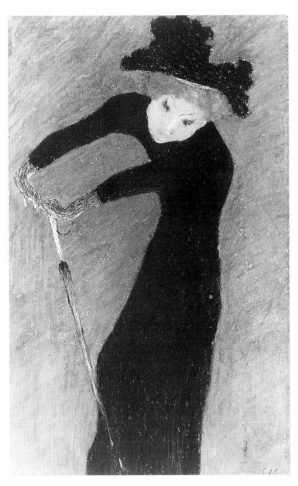

23. Edouard Vuillard, *Jane Avril with an Umbrella*, c. 1890–1891, pastel on paper, 39.5 x 25.0 (15$\frac{1}{2}$ x 9$\frac{7}{8}$), Private Collection.

24. Edouard Vuillard, *Phonographies, éditeur Rodolphe Darzens,* c. 1890, pen and ink with watercolor on paper, 20.8 x 14.2 (8$\frac{1}{8}$ x 5$\frac{5}{8}$), Private Collection.

energies to pursuing symbolist ideals— producing art and theater in which ideas, feelings, and sensations were evoked rather than explained directly. In May or June he and Bonnard, Denis, and Vuillard began to share a studio at 28 rue Pigalle, where they discussed and explored these issues in their art and in the theater.

As noted above, many of Darzens' friends had their works later performed at symbolist theaters. Not only Quillard and Rachilde but Mendès, Maeterlinck, Van Lerberghe, and Jules Bois were represented. It is difficult to understand why Darzens did not become more involved, but it seems that personal conflicts and a change in professional course kept him from it. Villiers de L'Isle

Adam had been a mentor to him, and when the writer died in 1889, Darzens assumed responsibility for helping his widow and protecting his estate. In that capacity he urged Paul Fort to stage *Axël* at the Théâtre d'Art. Fort kept Darzens waiting for a year, responding in June 1891 that he would indeed produce the play. But Fort had hired actors, ordered costumes, and begun rehearsals before informing Darzens of his decision, and Darzens was so angry that he withdrew the offer for Fort to stage the play. By 1892 Darzens had become a sports journalist, writing a daily column on bicycling for *Le Journal* under the pseudonym "Recordman."[81]

The influence of the growing symbolist movement was not immediately apparent at the Théâtre

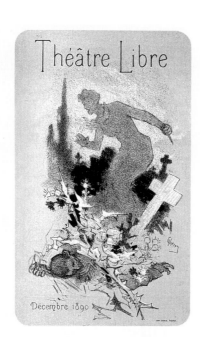

25. Jules Chéret, *La Fille Élisa; Conte de Noël*, 26 December 1890, lithograph in light brown and red brown on paper, 26.2 x 34.1 (10 ¼ x 13 ⅜), National Gallery of Art, Washington, Gift of The Atlas Foundation, 1995.76.17.

Libre. On 26 December 1890 Antoine's evening of performances included Ajalbert's *La Fille Élisa* (*Elisa the Whore*), which was adapted from a novel by Goncourt. Chéret, the father of the color lithographic poster, designed the program, with imagery corresponding to Ajalbert's play (fig. 25). The plot is typical of the naturalistic drama—focusing on, and sympathetic to, the underside of society. The prostitute Elisa is walking through a cemetery, reading a letter from her lover, when a young foot soldier attempts to "hire" her. She becomes enraged and kills the soldier out of feelings of loyalty to her lover. The jury finds Elisa guilty, and she is sentenced to death. While Elisa is in prison awaiting execution, her mother steals her savings and disappears; Elisa goes mad. Ajalbert was an anarchist, and his play was intended to illuminate the inequity in French society. Because Elisa is poor and uneducated, society has pushed her toward a life of prostitution; and when she defends her honor through actions that society would condone in a woman of a higher class, she is condemned as a criminal.

La Fille Élisa quickly became part of the controversy surrounding naturalist plays and their

different code of morality, and it was banned from public performance, which precipitated a heated debate in the Chamber of Deputies. The incident received much attention in the press and was taken up in an illustration by Jean-Louis Forain for the Montmartre journal *Le Courrier français* on 1 February 1891 (fig. 26). Antoine described "a fine cartoon by Forain....It shows censorship personified by a horrible old man [*sic*], armed with academic scissors, who is saying to Elisa: 'First go get dressed at Georges Ohnet's, then we shall see.'"[82]

On the back of the program for *La Fille Élisa* is an advertisement for *Le Courrier français*, also designed by Chéret. (It is tempting to wonder whether the comparison between the modeling knife in the sculptor's hand seen in the advertisement and the knife in Elisa's hand was intentional.) Both Chéret and the Théâtre Libre received support during this period from *Le Courrier français*, which was published by Jules Roques. It considered itself the most artistic of journals and devoted its efforts to supporting all aspects of Montmartre artistic life and interests. In February 1890 it announced that it would begin to include color lithographic reproductions of Chéret's posters as a supplement to the magazine, and an entire issue was devoted to Chéret the same month. In March 1891 the journal published a portrait of Antoine and a lengthy article on his theater, with an illustrated sequel in July.[83] *Le Courrier français* also produced some programs for the Théâtre Libre, probably as a means of assisting Antoine financially. Among these are the program for the evening of 6 July 1891, which featured three plays: *Coeurs simples* (*Simple Hearts*) by Sutter Laumann, *Le Pendu* (*The Hanged*) by Eugène Bourgeois, and *Dans Le Rêve* (*In the Dream*) by Louis Mullem. It is illustrated with reprints of drawings that had appeared in *Le Courrier français*, including one by Oswald Heidbrinck from the day before, showing a wealthy bourgeois type with sacks of money trying to buy his way into the Théâtre Libre, the

entrance to which is marked "reservée aux artistes." The illustration for the front of the program is by Forain, whose drawing prompted a hostile response from one critic: "I almost forgot to mention that the management of the Théâtre-Libre put out a fine collection of obscene designs in the guise of a program. This made the party complete." Antoine replied that the drawings had been given to them by *Le Courrier français*.[84]

The 30 November 1891 performances of *La Rançon (The Ransom)* by Gaston Salandri, *L'Abbé Pierre* by Marcel Prévost, and *Un Beau Soir (One Fine Evening)* by Maurice Vaucaire were also supported by a program published by *Le Courrier français*, with an illustration by Willette on the front cover dealing with censorship. It shows an academic soldier and a figure in a vaguely eighteenth-century costume from popular theater, who together represent the reign of academic traditions, attempting to prescribe what is "good" for everyone; the working-class woman rejects the artifice of their established traditions, however. Just as small literary reviews supported the work of new young writers, other journals that represented the interests of the Parisian artistic avant-garde would join *Le Courrier français* in supporting the bold efforts of these theater directors. In addition to providing reviews of plays, which other journals did as well, *Le Courrier français*, *Mercure de France*, *La Revue blanche*, and *PAN* embraced and supported the work of the artists, writers, directors, and all who participated in avant-garde theater, becoming true collaborators in the phenomenon.

On 25 May 1891 Antoine staged *Nell Horn* by Léon de Rosny, one of the leading young realist authors. The play was adapted from his book *Nell Horn of the Salvation Army: A Novel of London Manners*, which had been published in 1886. The embossed print that Charpentier had created for program covers in 1889 was reused for *Nell Horn*, but this time the bas-relief image was enhanced with color lithography (pl. 9). Charpentier also received the commission to design the program for

the 21 December 1891 performance of Ancey's *La Dupe* and Louis Marsolleau's *Son Petit Coeur (The Little Heart)* (pl. 10). In this instance Charpentier's molded paper is completely transformed from a two-dimensional surface into a bas-relief sculpture. Producing an original print for Antoine's subscribers, Charpentier fully realized the goal of making high art financially accessible to a broad range of people. He essentially turned ephemera into sculpture. In fact Charpentier may actually have used a bronze bas-relief sculpture as the matrix for the print—or in molding a matrix for the print—since a plaque of exactly the same dimensions and detail exists (fig. 27). The image of a nude man and woman in rather contrived poses may relate generally to the subject of *La Dupe*, a *comédie rosse* that was an extreme caricature of bourgeois marriage and wealth. In this story an unhappy young

26. Jean-Louis Forain, *Anastasie et Elisa*, illustration from *Le Courrier français*, 1 February 1891, photorelief on paper, Zimmerli Art Museum, Rutgers University.

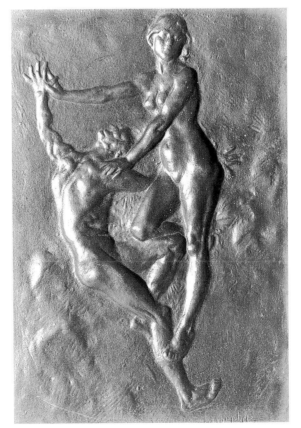

27. Alexandre Charpentier, untitled bronze bas-relief plaquette, 1891, 18.0 x 12.5 (7$\frac{1}{8}$ x 4$\frac{7}{8}$), Zimmerli Art Museum, Rutgers University, Class of 1937 Art Purchase Fund.

9 Alexandre Charpentier, *Nell Horn*, 25 May 1891

LE THÉATRE LIBRE
Saison 1890-1891

NELL HORN

Drame en quatre actes et six tableaux, en prose

MM.

Juste. GRAND
Michel. LAUDNER
Horn. DAMOYE
Willis RAYMOND
Le Vieux ANTOINE
Le Père de Willis ARQUILLIÈRE
Peacok DUJEU
Le Chrétien RENARD
L'Athée. DESMART
Le Gilet blanc. . . . PINSARD
Le Malthusien. . . . Henri DURTAL
L'Oiseau du Bagne. . GUICHARD
Le Nègre. VERSE
Le Capitaine PONS ARLES
Le Policeman Billy. . JANVIER
L'Homme aux Tracts. RICOUARD

Nell Horn. Mᵐᵉ NAU
Mistress Horn BARNY
Missis Carey. FRANCE
Jeune fille salvationniste. . . VERYNA

Deux vieilles femmes — Deux jeunes filles
Un gamin — Voisins et enfants
Rudes — Promeneurs — Chœur salvationniste
Totalisateurs de thé.

6ᵐᵉ SPECTACLE

Mardi 26 Mai 1891.

LEVER DU RIDEAU A 8 H. 3/4.

De la part de M. M. ROSNY

Paris. — Imp. Eugène VERNEAU, 108, rue de la Folie-Méricourt.

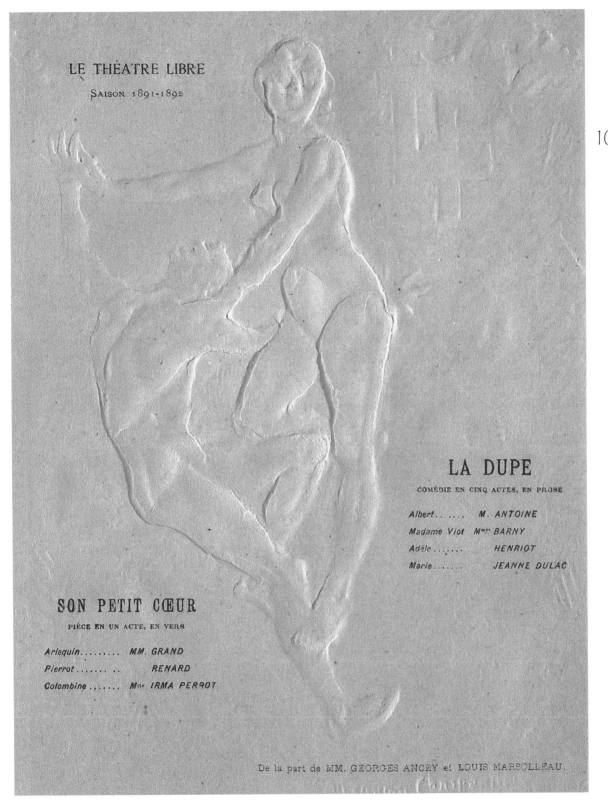

10 Alexandre Charpentier, *La Dupe*; *Son petit coeur*, 21 December 1891

woman, Adèle, has been pressured by her mother and older sister into marrying Albert. She finally agrees and in time grows to love him. Albert, however, has kept a mistress from the beginning, and he dupes Adèle into giving him a great deal of money, which he uses to keep this mistress. Eventually, he squanders her entire inheritance, and when this is discovered, Adèle's mother and sister coerce her to leave him, which she does, after much protest. Even then, Albert persuades Adèle to continue seeing him and giving him more money. The two figures on Charpentier's bas-relief are entwined in a forced and artificial way, not unlike the characters in Ancey's play.

Other programs continued to be adorned with all-purpose images. Henri Rivière designed his second program for the Théâtre Libre, an original color lithograph for the 8 June 1891 evening productions of *Leurs Filles (Their Daughters)* by Pierre Wolff, *Les Fourches caudines (The Caudine Forks)* by Maurice Le Corbeiller, and *Lidoire* by Georges Courteline (pl. 11). The image, depicting a boat on the Seine with the Eiffel Tower and smokestacks in the distance, is related to a color woodcut Rivière created the same year, *Du Viaduc d'Auteuil*. The artist's exploration of the quintessential Parisian landmark would culminate in 1902 in his publication of an album of color lithographs, *Les Trente-Six Vues de la Tour Eiffel*, printed by Eugène Verneau, the only lithographic printer with whom Rivière worked, and the one he had met through Antoine during his first commission for the Théâtre Libre.[85]

Rivière also collaborated with Antoine in the 30 November 1891 evening productions, but rather than designing a program, he painted the stage decor for *Un Beau Soir*. This may have been the first time an artist was involved in designing sets for the Théâtre Libre, although artists had been designing sets for Paul Fort's Théâtre d'Art since March of that year. Félix Fénéon described Rivière's decor in his review of the play: "In the distance, dominating a circular landscape, an avenue of lofty trees is ablaze in the dying sun-

light....But the lighting painted by M. Rivière should have been confirmed by real red-orange stage lights. M. Maurice Vaucaire's quartet shivers as it is obliged to frolic in an illogically cool late afternoon light."[86]

The Heyday of the Theater: Ibels

All of the programs for the 1892–1893 season were designed by Henri-Gabriel Ibels, who had been a member of the Nabi artistic confraternity since its inception in the fall of 1888. Antoine's commission provided an important early opportunity for public exposure of Ibels' work, displaying the striking distortions of color and simplifications of form that characterized the Nabis' art. Before working for Antoine, and indeed throughout his career, Ibels was an illustrator for the popular press, an activity that earned him the sobriquet "Le Nabi journalist." His images for the press, dating from as early as 1891, are more realistic, less bold and abstract, than his programs for Antoine. Indeed, for Antoine, Ibels reworked illustrations into colorful and very synthetic compositions.

Years later, recalling this commission and the effect it had on his career, Ibels wrote:

I explain[ed] to Monsieur Antoine that I want[ed] to illustrate the programs for the season with various lithographs, and having no relationship, naturally, with the plays being produced—with the sole purpose of making myself known to the press and the "in" crowd that subscribes to his Théâtre Libre....Six months later I was no longer an unknown. The subscribers, handling those freshly printed lithographs, soiled enough pairs of gloves so that the name of their creator remained imprinted in their memory. And I learn[ed], three years later, that this little incident cost Antoine the ten hundred francs that the advertising in his programs had brought him annually, the only commercial gain he drew from his first theatrical enterprise.[87]

11 Henri Rivière, *Leurs Filles*; *Les Fourches caudines*; *Lidoire*, 8 June 1891

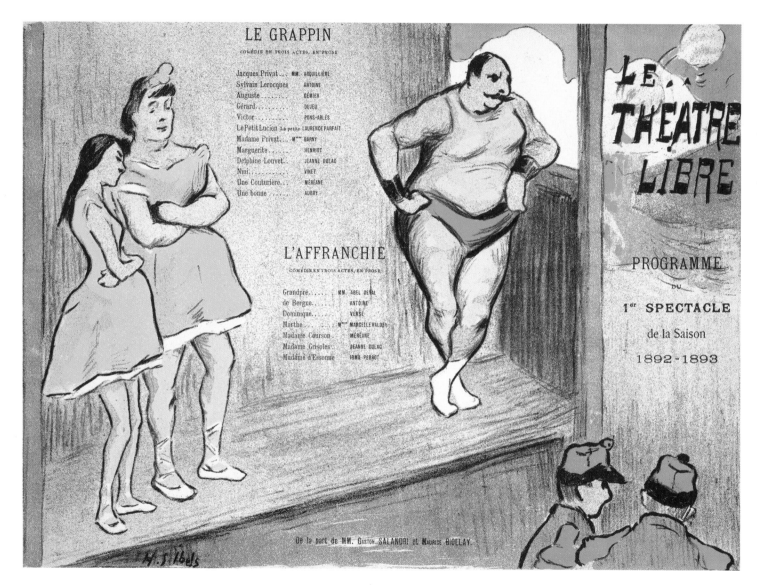

12 Henri-Gabriel Ibels, *Le Grappin*; *L'Affranchie*, 3 November 1892

13 Henri-Gabriel Ibels, *Le Grappin*; *L'Affranchie*, 3 November 1892 (proof before letters)

28. Henri-Gabriel Ibels, illustration from *Le Messager français*, 24 May 1891, Bibliothèque de L'Arsenal, Paris.

Apparently Ibels' decision to illustrate the programs with images unrelated to the content of the plays initially irritated some theater-goers. In January 1893, after the first three of Ibels' programs had appeared, the critic Charles Saunier wrote:

When it came to those programs, many people complained about the discrepancy between the play and its program. This was deliberate on the part of the artist, who defended himself thus: "The action is already illustrated by the actors developing it on a set loaded with anecdotal scenery. What more could a second interpretation offer?" M. Ibels simply wants to produce in their midst a series of types who would be called on to appear in the various plays that the Théâtre Libre puts on each year. This bather, that society swell are not Mme. or M.*** but rather the characteristic types of bather, of society swell. Similarly, the Théâtre Libre's programs are intended not to illustrate this drama or that comedy but rather to evoke the types who might have a role in all the plays performed.[88]

It is interesting that Ibels' divergence from the subjects of the plays produced complaints, since he was certainly not the first to illustrate programs with imagery unrelated to the dramas presented.

All of Ibels' designs for Théâtre Libre programs relate to illustrations and projects he had done before or would do later. Like Ajalbert, Signac, and many others, Ibels was sympathetic to the plight of the lower classes in Parisian society (he was affiliated with the anarchists), and his imagery reflects his concerns. His first program for Antoine, for the 3 November 1892 performances of Georges Salandri's *Le Grappin* (*The Grapnel*) and Maurice Biollay's *L'Affranchie* (*The Emancipated*), shows a family of *forains* (itinerant circus performers) who set up temporary street fairs in various quarters of Paris (pl. 12). He published a variation of this image, titled *Modestie Foraine*, as the cover illustration for *L'Echo de Paris* on 6 August 1893, and he created a portfolio of etch-

ings called *Les Forains* in 1895.[89] Ibels' lithograph for this theater program, like all of his prints for Antoine, was also printed in a separate edition before text was added—on off-white laid paper and intended for individual sale (pl. 13). In some cases Ibels reworked the image for the state to be printed with letters, as here, in the area to the right of the stage, which originally showed figures in the distance. In other cases the image was inked differently for each state.

Ibels' program for François de Curel's *Les Fossiles* (*The Fossils*), performed on 29 November 1892 (pl. 14), is the direct descendant of his illustration for the 24 May 1891 issue of the periodical *Le Messager français* (fig. 28).[90] Both share a steep, Japanese-inspired perspective, which results in the silhouetting of the figures against a background of sand. In the journal illustration the figures are modeled to a degree, but in the Théâtre Libre program any indication of three-dimensionality has been abandoned: the figures are drawn as black and flat color silhouettes, and natural elements are exploited for their decorative potential. His commission from the theater enabled Ibels to push the imagery he had explored in journalistic illustrations to new extremes.

On 16 January 1893 Antoine offered evening performances of *A Bas Le Progrès!* (*Down with Progress!*) by Edmond de Goncourt; *Mademoiselle Julie*, the first work by Swedish playwright Auguste Strindberg to be shown in Paris; and *Le Ménage brésile* (*The Brazilian Household*) by Romain Coolus, who was "discovered" by Antoine and would go on to have a strong literary career. Ibels' program for this evening (pl. 15) incorporates an image described in a contemporary article as "a regiment of foot soldiers re-entering the barracks."[91] It is related to the program that Ibels created for the 15 February performance of L. Bruyerre's *Le Devoir* (*The Duty*) (pl. 17), which depicts a café that also appears on Ibels' 1893 poster for *L'Escarmouche*, with foot soldiers outside the café windows (fig. 29), and in several

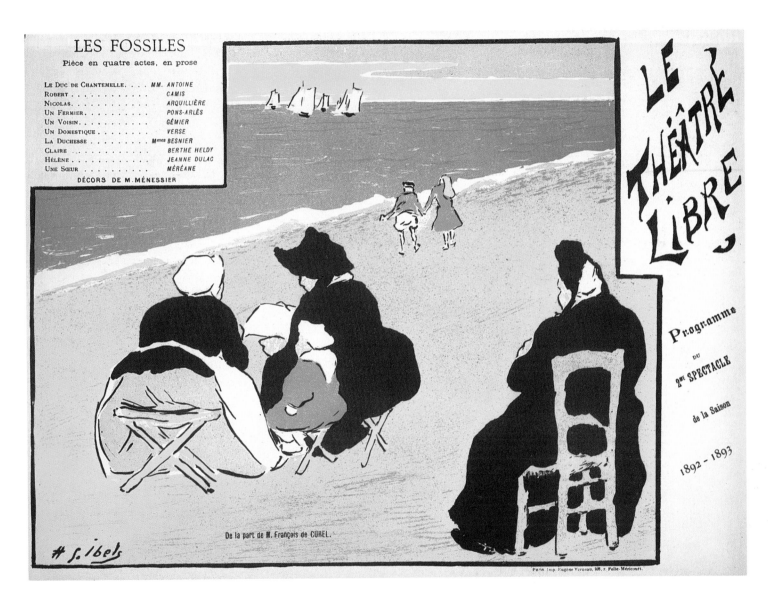

14 Henri-Gabriel Ibels, *Les Fossiles*, 29 November 1892

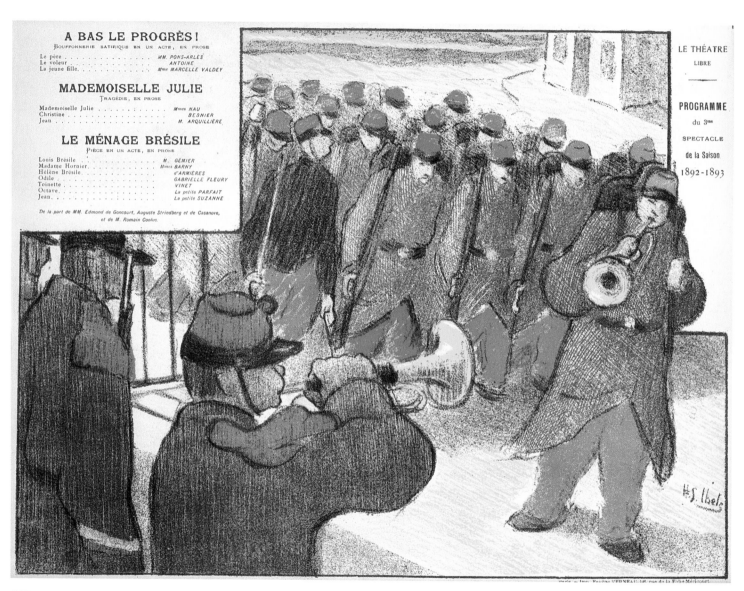

15 Henri-Gabriel Ibels, *A Bas Le Progrès!*; *Mademoiselle Julie*; *Le Ménage Brésile*, 16 January 1893

16 Henri-Gabriel Ibels, *A Bas Le Progrès!*; *Mademoiselle Julie*; *Le Ménage Brésile*, 16 January 1893 (proof before letters)

17 Henri-Gabriel Ibels, *Le Devoir*, 15 February 1893

other projects Ibels produced at this time. His illustration for a chapter on cabarets and pleasure spots in the book *Le Quartier latin* is accompanied by the caption "Foot soldiers at a bistro on the place Maubert."[92] It becomes clear that the café Ibels depicted was a specific one. Since offices for the anarchist journal *Les Temps nouveaux* were located just south of the place Maubert, cafés in the area would have been gathering places for anarchists and those like Ibels sympathetic to the movement. Furthermore, maps from the 1890s indicate that a military barracks was located just east of the place Maubert, which accounts both for the frequent appearance of foot soldiers inside and outside Ibels' bar on the place Maubert and for the reviewer's description of Ibels' design for the 16 January program.

For Georges Lecomte's *Mirages*, performed on 27 March 1893, Ibels had chosen to depict the café-concert, with figures in the audience rendered as purple silhouettes (recalling shadow theater), seen from behind as they look down on the performance (pl. 18). Onstage a couple is singing together, while dancers wait in the wings behind props for their entrance cues.

The imagery in Ibels' program for Georges Courteline's *Boubouroche* and Maurice Vaucaire's *Valet de coeur (Jack of Hearts)*, performed on 27 April 1893, may also be connected to his design for Gerhart Hauptmann's *Les Tisserands (The Weavers)* a month later (pls. 20, 22). Hauptmann's powerful play is about the downtrodden working class—specifically the poor, indeed starving, Silesian weavers, following their unsuccessful revolt against their oppressors in 1844. Audiences at the Théâtre Libre identified with the exploited weavers and cheered throughout the play. The founder of the French socialist party, Jean Juarès, wrote to Antoine following the performance, saying "such a production accomplished more than any political campaigns or discussions."[93] The play's focus on the troubles of the lower classes was also relevant to the artistic climates in Paris and

29. Henri-Gabriel Ibels, *L'Escarmouche*, 1893, color lithographic poster, 61.0 x 45.0 (24 x 17 3/4), Zimmerli Art Museum, Rutgers University, Gift of Herbert D. and Ruth Schimmel.

Belgium, where artists whose bold works were little appreciated by the wealthy and powerful bourgeoisie identified with the plight of the workers. It would have been particularly meaningful for Ibels and his anarchy-sympathizing friends.

The 1 May 1893 (Labor Day) issue of the French periodical *La Plume* was devoted to anarchy, and Ibels, Luce, Willette, and both Camille and Lucien Pissarro all contributed illustrations. Camille Pissarro's drawing (fig. 30), called *Débardeurs (Wharf Porters)*, depicts workers loading coal into bags that they then hoist onto their backs and carry to the ship in the background—literally backbreaking labor. The image seems related to Ibels' two theater programs, which depict workers towing the line from the barge to the dock (pl. 20) or shoveling coal into railroad carts (pl. 22). It is difficult to determine exactly which port or mines these prints were targeting, but it may be relevant

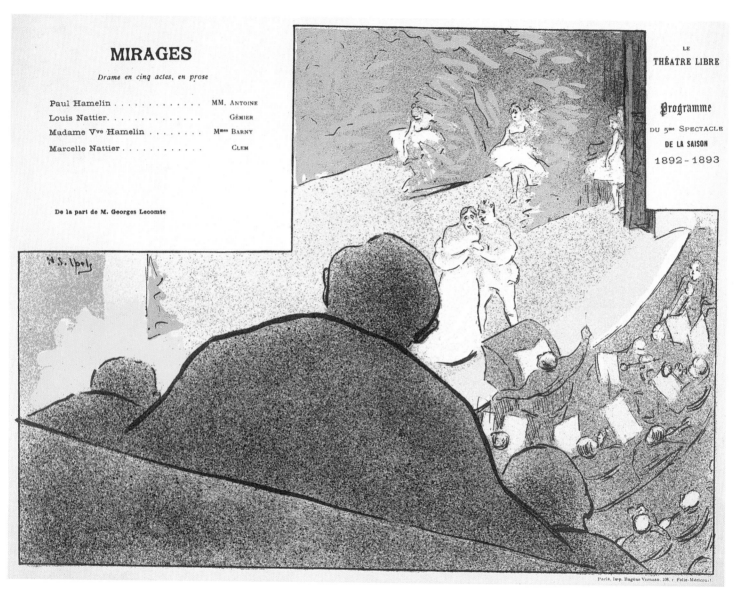

18 Henri-Gabriel Ibels, *Mirages*, 27 March 1893

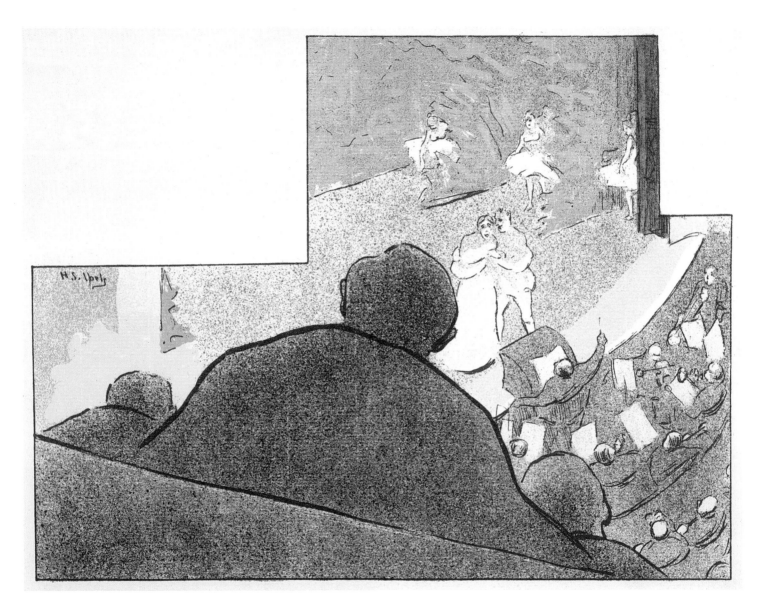

19 Henri-Gabriel Ibels, *Mirages*, 27 March 1893 (proof before letters)

20 Henri-Gabriel Ibels, *Boubouroche; Valet de coeur*, 27 April 1893

21 Henri-Gabriel Ibels, *Boubouroche; Valet de coeur*, 27 April 1893 (proof before letters)

22 Henri-Gabriel Ibels, *Les Tisserands*, 29 May 1893

that on Labor Day in Dunkerque five hundred port workers paraded through town with the national flag singing "La Marseillaise" and the hymn of Jean Bart, while in Saint-Chamont miners staged a strike, as was their habit every Monday.[94]

Ibels' own drawing for the Labor Day issue of *La Plume* (fig. 31) relates to his last program for the 1892–1893 season at the Théâtre Libre, featuring performances of *La Belle au bois rêvant (Dreaming Beauty)* and *Mariage d'argent (Moneyed Marriage)* (pl. 23). In contrast to his sympathetic portrayal of the lower classes of society, this journal illustration of two well-to-do gentlemen, titled *Entendu (Understood)*, was accompanied by the condemning caption, "But it is necessary, sir, to have some people who die of hunger! Because if everyone ate, the value of money would decrease, and that would be terrible, sir, TERRIBLE!!!"[95]

A year later Ibels created two lithographs pertaining specifically to *Les Tisserands*. One portrayed Antoine performing in the role of Old Hilse, and was intended as a portfolio cover for his Théâtre Libre programs (fig. 32), while the second depicted the actor Firmin Gémier in the role of the weaver Old Baumert.

Ibels' Théâtre Libre contacts may have encouraged commissions from actors themselves. During these years he designed many lithographs for song sheets and programs for actors performing at the café-concerts of Paris, including Antoine's good friend Mévisto (Auguste Wisteaux), who often acted at the Théâtre Libre. In 1892, for example, Ibels created illustrations for the published text to *L'Amour s'amuse (Love Amuses Itself)*, performed at La Scala by Mévisto and Camille Stéfani, and he designed a color lithographic poster for Mévisto (fig. 33). The imagery of the latter—including a foot soldier, workers, and a factory in the background—related as much to Mévisto's performances, which often focused on the plight of the working class, as to Ibels' own sympathy with such causes. Irma Perrot, who had acted in several plays during the 1892–1893 season at the Théâtre Libre,

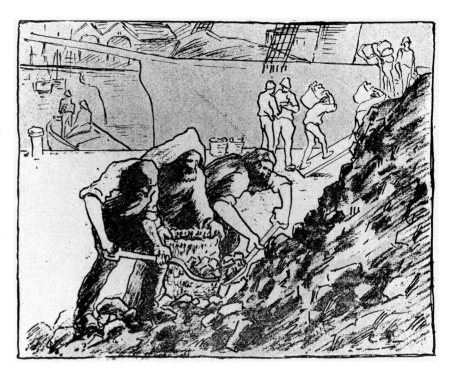

including *L'Affranchie*, *Les Tisserands*, and *Mariage d'argent*, also commissioned a poster from Ibels (fig. 34).

30. Camille Pissarro, *Wharf Porters*, illustration from *La Plume*, 1 May 1893, Zimmerli Art Museum, Rutgers University, acquired with the Herbert D. and Ruth Schimmel Library Fund.

Lautrec and Sérusier

Henri de Toulouse-Lautrec began his lasting affiliation with avant-garde theater when he received the commission for the Théâtre Libre program for its 8 November 1893 performances of *Une Faillite (The Bankruptcy)* by Norwegian writer Björnstjerne Björnson and *Le Poète et le financier* by Maurice Vaucaire (pl. 24). Lautrec may have received the commission through the recommendation of Ibels, with whom he had been closely associated since late 1892. His color lithograph might relate generally to *Le Poète et le financier*, depicting the Countess Gisèle, a character in the play, at her toilette. The lithograph was issued in two editions in 1893: one, published by Kleinmann, who sold many other prints by Ibels, Lautrec, and their associates; and this second edition, for the theater pro-

31. Henri-Gabriel Ibels, illustration from *La Plume*, 1 May 1893, Zimmerli Art Museum, Rutgers University, acquired with the Herbert D. and Ruth Schimmel Library Fund.

32. Henri-Gabriel Ibels, portfolio cover for *Les Programmes du Théâtre Libre*, 1894, color lithograph on paper, 47.4 x 39.0 (18 5/8 x 15 3/8), Josefowitz Collection.

gram. Lautrec also made a separate lithograph of Antoine and Gémier performing in *Une Faillite*.[96] Henri Rivière created the stage decor for the performance of *Le Poète et le financier*, and his design was described in a review of the play simply as "delicious."[97] He would return to design the sets for Antoine's production of François de Curel's *Le Repas du lion* (*The Lion's Meal*) in November 1897 at the Théâtre Antoine.

On 1 February 1894 Antoine staged a second play by Gerhart Hauptmann: *L'Assomption de Hannele Mattern*. Like *Les Tisserands*, it contained elements of naturalist drama and offered a sympathetic depiction of the downtrodden and impoverished. In the first scene it introduces a poorhouse and its inhabitants; in the last scene a doctor leaning over Hannele pronounces her dead. But much of the middle of the drama is a symbolist dream play that takes place in Hannele's febrile delirium. Although the Théâtre Libre's reputation was built on its presentation of naturalist works, and even *comédie rosse*, by this time symbolism had begun to influence Antoine's choice of plays and to increase the diversity of his repertoire. As early as July 1891 he had stated publicly that the symbolist works of the new school of writers interested him greatly and that he would like to produce some of them, with certain reservations: "Just as I have opened my doors widely, from the beginning, to the naturalist theater, so I will open them to the symbolist theater, provided that it is theater."[98] In staging *Hannele Mattern*, with its mystical ghostly apparitions, Antoine seems to have tried incorporating shadow effects similar to those found in Rivière's shadow theater, following techniques in use by this date at the symbolist Théâtre de L'Oeuvre. He used black curtains and green light on phosphorescent spirits, and he borrowed the symbolist theater's technique of a chorus of voices to convey meaning: in *Hannele* voices whispered the word "assassin" over and over.[99]

Paul Sérusier, a founding member of the Nabis, illustrated the program for *Hannele* (pl. 25).

By this date he had already gained much experience in the symbolist theater, working for Paul Fort's Théâtre d'Art between 1891 and 1892 and being very much involved with Lugné-Poe's Théâtre de L'Oeuvre from its inception in 1893. It is not surprising that Sérusier chose to depict the dream portion of *Hannele Mattern* for the program. The young girl Hannele, whose mother had died six weeks before, had been living alone with her abusive stepfather. Her misery was so great that she tried to commit suicide by drowning herself in a half-frozen pond but had been discovered, pulled out, and brought to the poorhouse. While in her bed, delirious with fever, she experiences a series of apparitions, including one of her mother, poorly clothed and aged before her time, at the foot of the bed, with long white hair reaching down. In Sérusier's print this ghostly figure hands Hannele a primrose (*Himmelschlüssel* in German, or "key to heaven"). Stage directions call for the room to be filled with a golden-green light, and Sérusier may have intended to reflect this in his lithograph, albeit the hue is green-blue in the print. The large iconic figure in the background of the print may be one of three bright figures of angels described by Hauptmann as having wings and wreathes of roses on their heads.

The program for the April performance of *Le Missionnaire* by Marcel Luguet was decorated with a color lithograph by Lautrec (pl. 26). Like the first of his lithographs for Antoine's theater programs, this one was printed in two editions. The first, issued in 100 impressions, was published by Kleinmann in 1893; the second, on smaller sheets and unsigned, but with letters added at the center left, was published by the Théâtre Libre the following year for use as the program cover.[100] Lautrec's image does not relate to the content of the play, but instead focuses on the theater audience. As was his habit, he depicted his friends: the elegantly dressed woman seems to be Jane Avril, a dancer at the Moulin Rouge and other cabarets frequented by Lautrec; to her left is the London-born artist

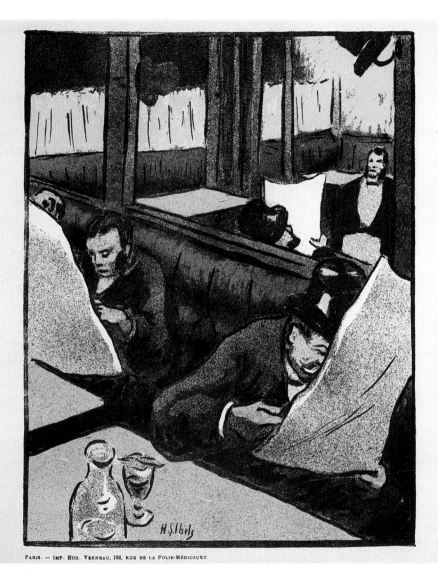

PROGRAMME DU 8ᵉ SPECTACLE DE LA SAISON 1892–1893

LA BELLE AU BOIS RÊVANT

Comédie en vers

Magali. Mˡˡᵉˢ CLEM
Sylvaïs. M. L. MIRAMON
Petrus MM. PONS-ARLÈS
Le Lieutenant. AMYOT

MARIAGE D'ARGENT

Pièce en un acte, en prose

Le père Baudruc. MM. ARQUILLIÈRE
Pierre. GÉMIER
Marie. Mᵉˡˡᵉ IRMA PERROT

AHASVÈRE

Drame en un acte, en prose

Karalyk MM. ANTOINE
Piotr le fils DEPAS
Le Pope GÉMIER
Un Paysan MICHELEZ
Le Chef des Cosaques ARQUILLIÈRE
La Mère Mᵐᵉˢ BARNY
La Grand'mère. REYNOLD
Kasja, servante. VINET

De la part de MM. Fernand Mazade, Eugène Bourgeois et Herman Heyermans.

PARIS. — IMP. EUG. VERNEAU, 108, RUE DE LA FOLIE-MÉRICOURT.

23 Henri-Gabriel Ibels, *La Belle au bois rêvant*; *Mariage d'argent*; *Ahasvère*, 12 June 1893

33. Henri-Gabriel Ibels, *Mévisto in "Concert la Gaité,"* 1892, color lithographic poster, 170.1 x 119.4 (66 7/8 x 46 7/8), Zimmerli Art Museum, Rutgers University, "Friends" Purchase Fund.

34. Henri-Gabriel Ibels, *Irma Perrot,* c. 1892, color lithographic poster, 118.0 x 83.0 (46 1/2 x 32 5/8), Zimmerli Art Museum, Rutgers University, Alvin and Joyce Glasgold Purchase Fund.

Charles Condor, who was raised in Australia and came to Paris in 1890, establishing himself in Montmartre, where he quickly became a part of the Parisian avant-garde and forged friendships with Lautrec, Bonnard, and many other artists in the quarter.[101]

Antoine's entry in his memoirs for 23 April 1894 looks back on his contribution to the visual arts in the waning days of his reign at the Théâtre Libre: "Toulouse-Lautrec has designed an admirable colored program for *The Missionary,* which collectors will fight over some day. I have succeeded in continuing this series of programs for several years, and it will be unique. All of the artists of the time will have contributed to it: Forain, Willette, Raffaëlli, Henri Rivière, Vuillard, Steinlen, Auriol, Signac, Luce, the sculptor Charpentier, and many others. I even had the pleasure of furnishing a

newcomer with the opportunity to show himself in an original way, by setting aside eight programs for H. G. Ibels last year."[102]

Larochelle and the End of the Théâtre Libre

Ironically, it was following the hugely successful performance of Hauptmann's *Les Tisserands* in May 1893 that Antoine realized that the Théâtre Libre was coming to an end: "Although I have almost decided to abandon the field and no one as yet suspects it, I feel a bitter regret this evening for all that we might yet accomplish. But I no longer have the energy or courage to continue. To get this far, I have utilized every talent and ability possessed by myself as well as my friends....but the one thing

25 Paul Sérusier,
*L'Assomption de
Hannele Mattern;
En l'attendant,*
1 February 1894

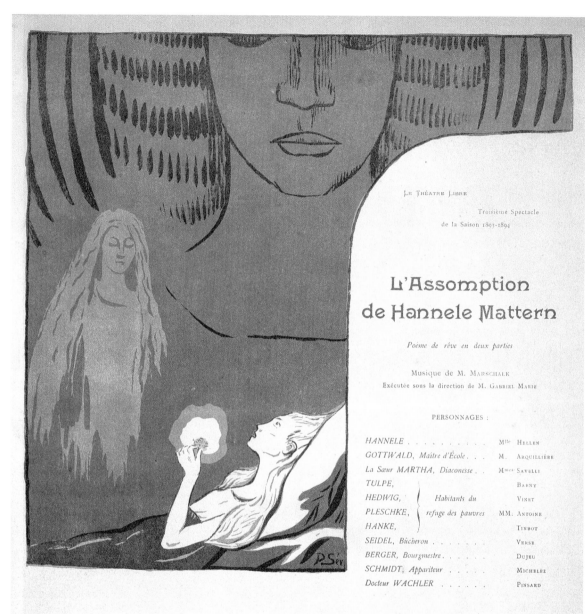

26 Henri de Toulouse-Lautrec, *Le Missionnaire*, 25 April 1894

we cannot create is money."[103] By the end of the 1893–1894 season he was at the end of his financial and emotional tether. In June 1894 he turned the Théâtre Libre over to the actor Paul Larochelle, on the condition that the four remaining productions promised to subscribers that year be presented. Antoine and some of his most devoted actors left Paris for a six-month tour abroad, performing pieces from the Théâtre Libre repertoire to generate funds to repay the theater's debts.

Larochelle finally presented the last four plays of the 1893–1894 season in the first months of 1895: Villiers de L'Isle Adam's *Elën*, Emile Fabre's *L'Argent (Money)*, Claude Berton's *Grand-Papa*, and Paul Lheureux's *Si c'etait (If It Were)*. Antoine continued to act with the Théâtre Libre, performing in *L'Argent* along with Gabriella Zapolska, the mistress of Paul Sérusier. Lautrec designed the theater program (pl. 27), which, unlike his other lithographs for the Théâtre Libre, was printed in only one edition. He depicted the two main characters from behind, in a perspective that perhaps recalls the naturalistic, anti-Conservatoire method of acting that Antoine had invented.

Productions for the remainder of the life of the Théâtre Libre, under the management of Larochelle, differed from Antoine's earlier repertoire in that symbolism, the now-prevailing style in avant-garde theater, was more fully represented. On 25 October 1895 Larochelle produced Joseph Caraguel's *La Fumée, puis la flamme (First Smoke, Then Fire)*, which contemporary reviews described as a play about *états d'âme* (moods or states of the soul). The plot involves a married couple, Michel and Clotilde Gélyès, who decide, after a decade of marriage and multiple infidelities on both sides, to forgive and forget and throw themselves into each other's arms. The public objected to the long realistic and psychological monologues that characterized the piece, but Alfred Vallette, publisher of *Mercure de France*, wrote that the monologues were just too intellectual for the public. He understood the message to be about a "living love that is

supremely lenient as it rises up over the protagonists and conceals them like waves of smoke in the lowlands."[104] Indeed the play explicitly compares love to smoke, both being ephemeral, and both having the ability to envelop a person.[105] And Abel-Truchet continued the theme in his design for the program (pl. 28), which seems to depict Clotilde leaping from dark, smoky obscurity—representing their joint decade of infidelity—into the bright, warm flames of true love. As a member of the Montmartre artistic avant-garde, Abel-Truchet was acquainted with many of the people involved with the Théâtre Libre. Along with Chéret, Lautrec, and Willette, he exhibited his work at the Quat'z'Arts cabaret, located at 62 boulevard de Clichy, where Théâtre Libre actors Mévisto and Marcel Legay performed as well.[106]

The next production for the Théâtre Libre, on 16 December, was Paul Adam's and André Picard's *Le Cuivre (Copper)*, also in the symbolist vein, a "drama of the souls" and of opposing forces representing war and peace.[107] Pierre-Eugène Vibert, a Swiss artist who arrived in Paris in 1893, created the illustration for the program (pl. 29), using lithography in a manner very similar to that used by Vuillard in his contemporary programs for the Théâtre de L'Oeuvre. Vibert densely applied lithographic crayon and tusche (grease-based ink) to the stone, then scratched it away to define a female figure emerging from mysterious darkness (where the crayon and tusche were scraped away on the stone, the white of the paper is exposed in the print). This is a depiction of Anne, a beautiful, highly intelligent, and manipulative femme fatale, who first masterminds a plot to lure the protagonist to his death, then just before his demise, seduces him. The role of Anne was played by Berthe Bady, who was one of Lugné-Poe's leading symbolist actresses at this time at the Théâtre de L'Oeuvre.

On 10 February Larochelle presented another play in the symbolist style, *L'Ame invisible (Invisible Souls)* by Claude Berton, along with *Mademoiselle*

28 Abel-Truchet, *La Fumée, puis la flamme,* 24 October 1895

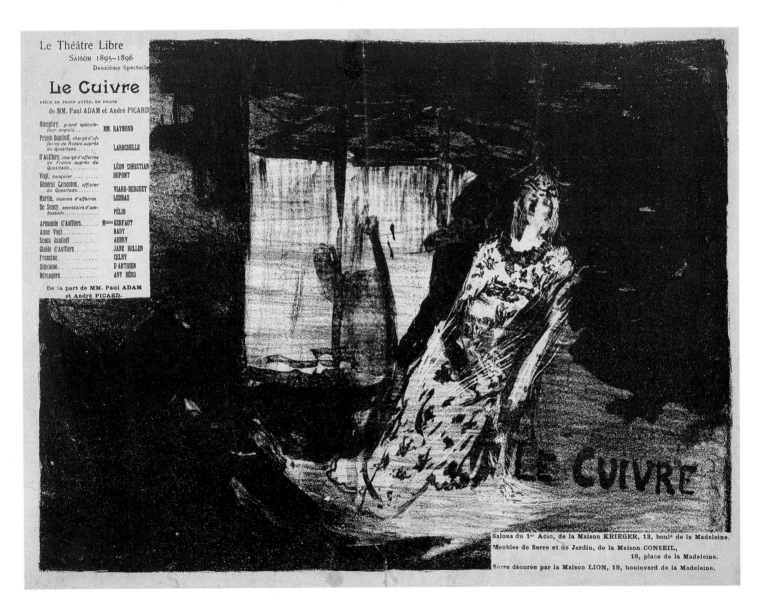

29 Pierre Eugène Vibert, *Le Cuivre*, 16 December 1895

30 Tancrède Synave, *L'Ame invisible; Mademoiselle Fifi*, 10 February 1896

Fifi by Oscar Méténier, creator of the *comédie rosse* genre. The little-known artist Tancrède Synave illustrated both dramas on the program (pl. 30). On the left are Pierre and his mistress Esther, characters from *L'Ame invisible*. On the right is the title character in *Mademoiselle Fifi* just before the dramatic climax. *L'Ame invisible* focuses on *états d'âme*. Pierre loves Esther passionately, but he senses her indifference toward him and is powerless to ignite in her the passion that he feels. Esther also flirts with other men, causing Pierre to become jealous. Their confrontation in Synave's rendering suggests Pierre's intense feeling and Esther's more casual attention.[108] *Mademoiselle Fifi*, adapted from the novel *Soirées de Médan (Evenings in the Médan)* by Guy de Maupassant, is a manifestation of lingering hostility toward the Germans in France in the aftermath of the Franco-Prussian War. The play involves Prussian military officers in the company of a group of prostitutes. One ill-mannered low-level lieutenant, nicknamed "Mlle. Fifi" by his comrades, insults the French people, particularly French women, when he is drunk, saying they all belong to their conquerors. One of the women retaliates by plunging her knife into his heart.[109] The program image shows the woman just before that moment of rage, with a knife on the table before her, as the lieutenant pours a drink on her head and blows smoke in her face. Synave communicates the emotional quality of both plays in these images.

Symbolist painter Alphonse Osbert created the color lithographic program for the 16 March 1896 performances of Jean Laurenty's and Fernand Hauser's *Inceste d'âmes (Incestuous Souls)* and Jean Malafaÿde's *Mineur et soldat (Miner and Soldier)* (pl. 31). In contrast to the illustrational quality of Synave's lithograph, Osbert's image reflects his idealist and symbolist allegiances.[110] While Osbert's landscape for the theater program is a variant of a composition that appears in some of his paintings, he may have adapted the formula specifically to the content of the play *Inceste d'âmes*.[111] The story

involves Jean, a doctor, and his sister Fée, an intellectual and a painter. Jean is married to Berthe, who is unintelligent and uninteresting but may have brought a substantial dowry. Predictably, their domestic situation soon becomes unbearable, and Jean begins to spend his days and many nights with his sister. Even Berthe and Jean's daughter prefers the company of her Aunt Fée. The two women strongly dislike one another, and when Fée feigns illness, Berthe poisons her with a double dose of the drug belladonna. On her deathbed Fée begs Jean to forgive his wife for the sake of the child.[112]

Osbert's program shows static, draped figures in a dusky, poetic landscape like those found in his paintings, where such figures are often placed before a pond or a lake. Their transcendental character here is communicated in part by the organization of the composition: three horizontal masses of sky, mountain, and land are balanced by three vertical elements defined by two tree trunks and the mass of two joined standing figures. As in much of his work, this quiet image implies a deeper meaning. The seated figure to the right recalls the pose of Gauguin's recurring symbol of female suffering.[113] The separation of the seated figure from the two figures standing at the left suggests two stages of life, or the desolation of possible choices made by these individuals. Osbert's image may evoke Fée and Jean, poised on the precipice of an incestuous relationship, with the sad figure of Berthe slumped to one side. Osbert created two different known states of this print for the theater, varying the color to explore the expressive potential of the landscape at dawn versus dusk. In one state he inked the ground in a peach-tan color, with the sky changing from tan at the horizon to blue at the top (pl. 31). In the second state the ground is rendered in mauve, as is the top of the sky (pl. 32).

The last performance of this first continuous phase of the Théâtre Libre took place on 27 April 1896. It featured Alfred Mortier's *La Fille d'Artaban (The Daughter of Artaban)*, Louis Dumur's *La Nébuleuse (The Nebula)*, and Alfred de Vigny's

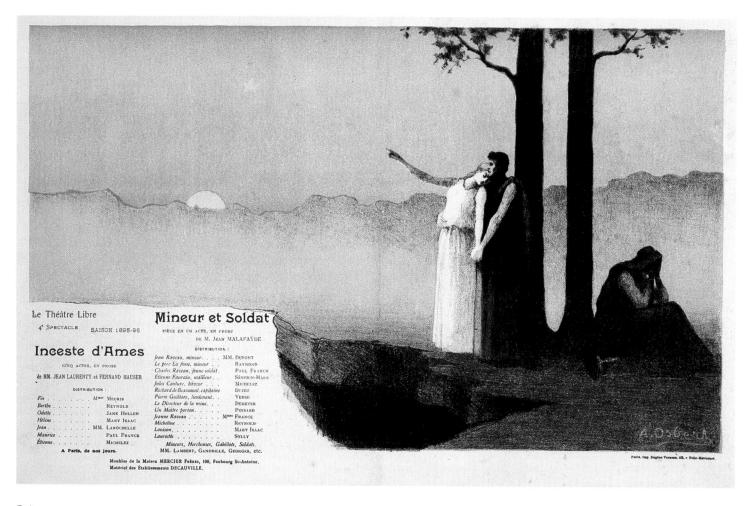

31 Alphonse Osbert, *Inceste d'âmes; Mineur et soldat*, 16 March 1896

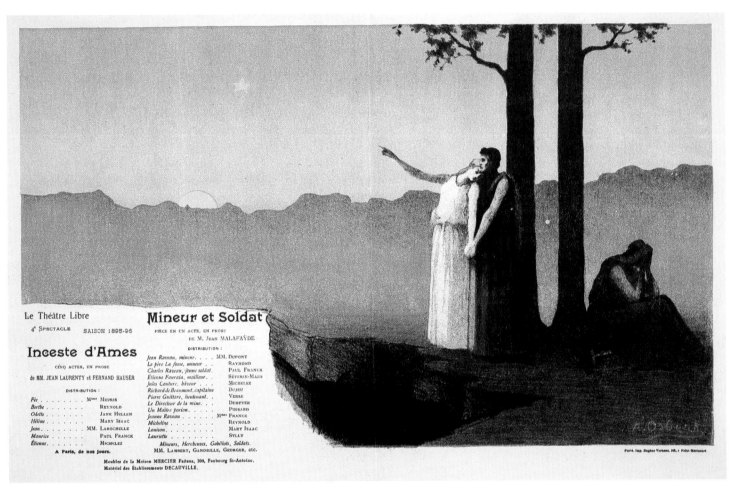

32 Alphonse Osbert, *Inceste d'âmes; Mineur et soldat*, 16 March 1896

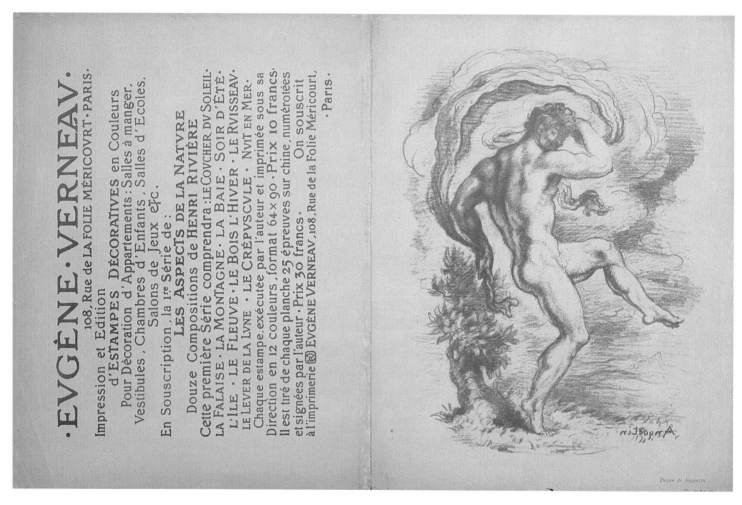

33 Louis Anquetin, *Dancing Nude and Advertisement for Eugène Verneau's "Estampes décoratives"* (verso, 1995.76.84.b)

34 Henri de Toulouse-Lautrec, *Mariage d'argent; Le Fardeau de la liberté; Un Client sérieux* (recto, 1995.76.2.a), 23 December 1897

Dialogue inconnu (Unknown Dialogue). Louis Anquetin, a close associate of Lautrec's and of symbolist writer Edouard Dujardin's, produced a lithograph related to *La Fille d'Artaban* to illustrate the program.[114] In it he depicts the moment when a young woman, Rosella, is stripped of her robes before onlookers at an outdoor fair as a means of attracting viewers to a particular booth. Anquetin used the dramatic potential of lithography, showing the sinister figure who exploits Rosella in tenebrous obscurity, in contrast to the shocking whiteness of the exposed woman as she struggles to cover herself.

When Antoine returned from his stint abroad, he wanted to reestablish the Théâtre Libre, but Larochelle would not allow him to reappropriate the name, which had since become Larochelle's property.[115] Antoine opened a new theater in July 1897, calling it the Théâtre Antoine. He continued the practice of commissioning artists to design programs, and Anquetin, Lautrec, and Rodin and contributed illustrations for the 1897–1898 season. In one particularly interesting example Anquetin and Lautrec collaborated in producing a lithograph for the 23 December 1897 evening of performances benefiting the actor Firmin Gémier, who had performed in *Les Tisserands* at the Théâtre Libre in 1894 and who would interpret the role of Alfred Jarry's Père Ubu at the Théâtre de L'Oeuvre in 1896. The program has the image of a dancing nude by Anquetin on the front cover (pl. 33) and an advertisement for a collection of *Estampes décoratives* by Henri Rivière, serially titled *Les Aspects de la nature*, published by Eugène Verneau on the back. Lautrec drew a portrait of Gémier for the inside of the program (pl. 34).

The Théâtre Antoine existed for nine years, often reviving plays presented earlier at the Théâtre Libre. In 1906 Antoine became director of the Odéon, where he remained until 1914. Certainly his greatest contribution to French culture was being the first to establish an avant-garde theater. At the Théâtre Libre Antoine introduced naturalism and a realistic style of acting. He embraced new works by emerging writers. And of course, his early commissioning of artists to illustrate programs foreshadowed the profound involvement of artist with the Théâtre d'Art and the Théâtre de L'Oeuvre.

NOTES

1. On the state of popular theater prior to the innovations of Antoine see John A. Henderson, *The First Avant-Garde, 1887–1894: Sources of the Modern French Theatre* (London, 1971), 19–26. Declamation as taught at the Conservatoire involved a rhetorical manner of performing one's lines.

2. Earlier Emile Zola had argued for naturalism in the theater. See his *Naturalisme au théâtre* (Paris, 1881).

3. Antoine initiated this convention on the opening night of the 1887–1888 season, in the production of Goncourt's *Soeur Philomène*; see Marvin Carlson, *The French Stage in the Nineteenth Century* (Metuchen, NJ, 1972), 182–183. In May 1890 Antoine published a brochure explaining the methods he encouraged in acting. It is translated and reprinted in Bettina Knapp, *The Reign of the Theatrical Director: French Theatre, 1887–1924* (Troy, NY, 1988), 46–48.

4. On naturalism, and particularly the *comédie rosse* genre, at the Théâtre Libre see Daniel Gerould, "Oscar Méténier and *Comédie Rosse*: From the Théâtre Libre to the Grand Guignol," *Drama Review* 28 (Spring 1984), 15–29.

5. André Antoine, *Memories of the Théâtre Libre* (Coral Gables, FL, 1964), 4–5. Antoine's memoirs were written many years after the events recorded in them, and he colored events to suit his aims. They provide a useful overview of the events of the time, especially of Antoine's thoughts, but must be read with skepticism (see Marvin A. Carlson, "Translator's Preface," xi–xiv).

6. On original printmaking and the revival of decorative art and craft see Patricia Eckert Boyer, "*L'Estampe originale* and the Revival of Decorative Art and Craft in Late Nineteenth-Century France," in Patricia Eckert Boyer and Phillip Dennis Cate, "*L'Estampe originale*": *Artistic Printmaking in France, 1893–1895* [exh. cat., Rijksmuseum Vincent van Gogh] (Amsterdam, 1991), 26–49. See also Debora L. Silverman, *Art Nouveau in Fin-de-Siècle France: Politics, Psychology, and Style* (Berkeley, 1989).

7. Amsterdam 1991, 28.

8. On *La Revue blanche* see Fritz Hermann, *Die Revue Blanche und die Nabis* (Munich, 1959); on *L'Estampe originale* see Amsterdam 1991.

9. See Mariel Oberthür, *Le Chat noir, 1881–1897* [exh. cat., Les Dossiers du Musée d'Orsay] (Paris, 1992); and Phillip Dennis Cate, "Le Chat Noir Cabaret," in Phillip Dennis Cate and Mary Shaw, eds., *The Spirit of Montmartre:*

Cabarets, Humor, and the Avant-Garde, 1875–1905 [exh. cat., Zimmerli Art Museum] (New Brunswick, NJ, 1996), 23–29.

10. Gerould 1984, 15–19.

11. Paul Jeanne, *Les Théâtres d'ombres à Montmartre de 1887 à 1923* (Paris, 1937), 57. For a technical description of the shadow theater see Edouard Sarradin, "Henri Rivière et son oeuvre," *Art et décoration* 3 (1891), 35–37; and Denis Bordat and Francis Boucrot, *Les Théâtres d'ombres histoire et techniques* (Paris, n.d.), 151–173.

12. Bernard and Paul Fort had been friends since childhood, and Bernard married Fort's sister in 1911. See Geneviève Aitken, "Les Nabis, un foyer au théâtre," in *Nabis 1888–1900: Bonnard, Vuillard, Maurice Denis, Vallotton...* [exh. cat., Galeries nationales du Grand Palais] (Paris, 1994), 401. On the influence of the shadow theater on the Nabis see Patricia Eckert Boyer, ed., *The Nabis and the Parisian Avant-Garde* (New Brunswick, NJ, 1988), 53–75. Lautrec's assimilation of silhouettes is obvious in several works, including the lithograph *L'Anglais au Moulin Rouge*, 1892; the poster for the *Moulin Rouge*, 1891; and his program for *L'Argent* at the Théâtre Libre, 1895 (see Wolfgang Wittrock, *Toulouse-Lautrec: The Complete Prints* [London, 1985], 2, P.1, 97). Bernard incorporated a solid black silhouette into the painting *Bridge at Asnières*, 1887 (Museum of Modern Art, New York).

13. For a discussion of the spirit of *fumisme* see New Brunswick 1996, 23–29; and Daniel Grojnowski, "Hydropathes and Company," in New Brunswick 1996, 104.

14. See Antoine 1964 ed., 29–39.

15. Adolphe Thalasso, *Le Théâtre Libre* (Paris, 1909), 44. English translation from Henderson 1971, 135 n. 16.

16. Gerould 1984, 16.

17. Samuel Montefiore Waxman, *Antoine and the Théâtre Libre* (Cambridge, 1926), 74.

18. Antoine 1964, 43. The offices for the Théâtre Libre were at 96 rue Blanche.

19. See letters from Antoine to Darzens in the Atlas Collection, National Gallery of Art, Washington, dated 13 June 1889; 19 June 1889; 28 June 1889; 4 July 1890; 21 July 1891.

20. Biographical information on Darzens published here comes from Jean-Jacques Lefrère, "Les Saisons Littéraires de Rodolphe Darzens (1865–1938)" (Ph.D. diss., L'Université de Paris VIII, 1996). The pages in the manuscript

are unnumbered, and therefore citations here will refer only to chapter number. I am very much indebted to Dr. Lefrère for allowing me to use his excellent manuscript.

21. On Caze see Eugenia W. Herbert, *The Artist and Social Reform: France and Belgium, 1885–1898* (New York, 1971), 70–71.

22. Ajalbert, quoted in Lefrère 1996, chap. 2.

23. Lefrère 1996, chap. 2.

24. On Darzens' introduction of Maeterlinck to Paris see Bettina K. Knapp, *Maurice Maeterlinck* (Boston, 1975), 14, 25–26.

25. Of Signac's paintings, Darzens singled out for particular praise *La Neige au boulevard Clichy*; *L'Abreuvoir d'Asnières*; *La Berge à Asnières*; and *La Passe balisée à Saint-Briac* (in "Chronique artistique," *La Pléiade* [May 1886], 88–89; *Drapeaux* appears on page 75).

26. Darzens 1886, 87–89.

27. Réné Ghil, "Traité du verbe," *La Pléiade* (July 1886), 129–137, and (August 1886), 162–169.

28. Waxman 1926, 80.

29. Daryl Rubenstein, *The Avant-Garde in Theatre and Art: French Playbills of the 1890s* [exh. cat., Smithsonian Institution Traveling Exhibition Service] (Washington, DC, 1972), 23.

30. On Charpentier's medallions see Charles Saunier, "Le Salon de 'La Plume,'" *La Plume* (1 November 1892), 508; and Waxman 1926, 94. Many of these are now in the Musée de la Monnaie, Paris.

31. Lefrère 1996, chap. 13.

32. Lefrère 1996, chap. 6.

33. Henderson 1971, 53.

34. Antoine 1964, 89.

35. James Sanders, *La Correspondance d'André Antoine* (Quebec, 1987). There is not a single letter to an artist in this 418-page volume. Unfortunately, as Sanders points out (p. 27), nearly all of the letters received by Antoine during his tenure at the Théâtre Libre have been lost.

36. "Le blanc Pierrot assassiné / N'est-il pas l'Idéal sans tache / Que la Réalité s'attache / A frapper d'un poing obstiné? / Qu'importe! Pierrot vit encore, / Et du plus que sang de son coeur. / Jaillit toujours d'Espoir vainqueur / Fleur de pourpre que le décore!"

37. Lefrère 1996, chap. 6.

38. Jacques Robichez, *Le Symbolisme au Théâtre: Lugné-Poe et les débuts de L'Oeuvre* (Paris, 1957), 485. Lugné-Poe performed in several productions at the Théâtre Libre between 1888 and 1890, sometimes under the pseudonyms "Philippon," "Delorme," or "Leroy." See also Aurélien François Lugné-Poe, *La Parade I. Le Sot du tremplin. Souvenirs et impressions du théâtre* (Paris, 1930), 144.

39. Lugné-Poe 1930, 119.

40. On Signac and the Chat Noir see Floyd Ratliff, *Paul Signac and Color in Neo-Impressionism* (New York, 1992), 6–7.

41. Robert L. Herbert, *Neo-Impressionism* [exh. cat., Solomon R. Guggenheim Museum] (New York, 1968), 137.

42. See Françoise Cachin, *Paul Signac* (Greenwich, CT, 1971), 32–33.

43. Herbert 1968, 137.

44. Lefrère 1996, chap. 8. Antoine recalled having met Métivet at the home of Mendès in June 1887. See Antoine 1964, 31.

45. Darzens' familiarity with the various night spots in Paris resulted in his receiving the commission to write a book in 1889 titled *Nuits à Paris*. This guide was intended for the visitors who came to Paris to see the Exposition Universelle. Darzens chose Willette to illustrate the text, and the first image in it depicts Willette and Darzens seated together at a café table. Darzens included the most popular haunts found in guidebooks of the period, such as the Chat Noir, the Elysée Montmartre, the Mirliton, and the Rat Mort, but his book stands apart in that it also highlighted such unusual spectacles as the public execution of criminals at the guillotine and a 2:00 a.m. tour of the printing plant of the newspaper *Le Figaro*. See Lefrère 1996, chap. 9.

46. On Charpentier, the Théâtre Libre, and the *gaufrage* technique see Saunier 1892, 508–510; and Gabriel Mourey, "A Decorative Modeller: Alexandre Charpentier," *International Studio* (May 1897), 157–165.

47. In 1860 one concerned official noted that the general clutter was not the only factor that compromised the effectiveness of placards: "Besides, the posters affixed on the public kiosk-urinals cannot be read by a woman, even when she is with her husband." See *Paris la Rue* [exh. cat., La Bibliothèque historique] (Paris, 1976), 39–40.

48. Phillip Dennis Cate, "From Redon to Rivière: Albums of the 1890s," in Pat Gilmour, ed., *Lasting Impressions: Lithography as Art* (Philadelphia, 1988), 128.

49. This group of *Estampes décoratives*—designed by Rivière, printed by Verneau, and titled collectively *Les Aspects de la nature*—was advertised and described in detail on the 23 December 1897 program for the the Théâtre Antoine (see pl. 61). See also Amsterdam 1991, 40.

50. Armond Fields, *George Auriol* (Layton, UT, 1985), 51–52.

51. Quoted in Waxman 1926, 84.

52. Antoine 1964 ed., 129.

53. The identification of individuals is from Jean Chothia, *André Antoine* (Cambridge, 1991), 82.

54. According to Geneviève Aitken, *Artistes et Théâtres d'avant-garde. Programmes de Théâtre illustrés, Paris 1890–1900* (Pully, 1991), 23, busts of dramatic figures sculpted by Alexandre Charpentier were also exhibited in the foyer of the Théâtre Libre.

55. Maurice Denis, *Théories 1890–1910. Du Symbolisme et de Gauguin vers un nouvel ordre classique* (Paris, 1913), 162.

56. Gertrude R. Jasper, *Adventure in the Theatre: Lugné-Poe and the Théâtre de l'Oeuvre to 1899* (New Brunswick, NJ, 1947), 26–35. On the formation of the Nabis and their involvement with the theater see Boyer 1988; and *Nabis 1888–1900* [exh. cat., Musée d'Orsay] (Paris, 1994).

57. I had previously, erroneously, identified this as a depiction of the 1890 *concours*; see Boyer 1988, 33. Documentation in the Archives Salomon clarifies the image as a representation of the 1891 competition and the identification of Marthe Mellot.

58. On Schwabe see Jean-David Jumeau-Lafond, "Carlos Schwabe (1866–1926), illustrateur symboliste," *Bulletin du bibliophile* 2 (1986), 187–206. Among the books Carlos Schwabe illustrated during these years were Stéphane Mallarmé's *Poésies*, in 1887; Catulle Mendès' *L'Evangile de l'enfance de N.S. Jésus-Christ selon St. Pierre*, published as a series in the *Revue illustrée* between 1891 and 1894; and Zola's *Le Rêve* in 1892. Schwabe also created the first poster for the *Salon de la Rose et Croix* in 1892.

59. The first to identify the figure as Monsieur Bute was Geneviève Aitken in "Les Peintres et le Théâtre à Paris autour de 1900" (thesis, Université de la Sorbonne, Paris, 1978), 190. Accordingly, I identified this figure as Monsieur Bute as well in Boyer 1988, 179.

60. Jacques Salomon identified the figure as a peasant bending over vine-stalks in *Vuillard* (Paris, 1945), 23. John Russell, in *Edouard Vuillard, 1868-1940* [exh. cat., Art Gallery of Ontario] (Toronto, 1971), 25, also saw the figure as a peas-ant and remarked that it bore no relationship to the plays presented that evening. The preparatory drawings support this identification.

61. This drawing, located in a private collection, is reproduced in Boyer 1988, 38, fig. 50.

62. Vuillard reworked this image several times, shifting the composition from a horizontal to a vertical orientation, eliminating the carriage wheel, and adding the words "Théâtre Libre" in its place following the coutour of the upper edge of the side of the carriage. For an illustration of one example of the vertical format see Boyer 1988, pl. 39.

63. See John F. Hutchinson, *Champions of Charity: War and the Rise of the Red Cross* (Boulder, CO, 1996), 101–125.

64. Lugné-Poe 1930, 195.

65. There is a second, very closely related study for this program in the collection of the Galerie Berès, Paris. I am grateful to Anisabelle Berès for sharing it with me. Both Bonnard and Vuillard created numerous program designs in their attempt to receive a commission. For additional examples see Boyer 1988, nos. 144–146; and Geneviève Aitken in *Nabis 1888–1900* [exh. cat., Kunsthaus] (Zurich, 1993), nos. 220, 223.

66. Lugné-Poe 1930, 256.

67. Documentation in the Archives Salomon, Paris, states that Mallet also performed at Bruant's café at this time.

68. E. Noël and E. Stoullig, *Annales du Théâtre et de la musique* (Paris, 1890), 337. This is a multi-year publication, and subsequent volumes are cited below by the year in which they were published. On mime and its importance in the formation of the avant-garde theater see Henderson 1971, 120–122.

69. Lugné-Poe 1930, 257. I previously misidentified some drawings of Félicia Mallet in this role as designs for programs for the Théâtre Libre; Boyer 1988, nos. 147 and 148 (and the design for a fan with the image of Pierrot, no. 147) should logically be seen as part of the group of drawings of Mallet.

70. Lugné-Poe 1930, 189.

71. This information is from the Archives Salomon. Maurice Denis wrote to Lugné-Poe, informing him of Hugounet's intention to publish Vuillard's watercolors of Mallet in *L'Enfant prodigue*; see Lugné-Poe 1930, 250. A notice advertising *Pierrot et Pierrots* appeared in a list of "oeuvres funambulesques" in the beginning of P. Hugounet and G. Villeneuve, *Doctoresse* (Paris, 1891).

72. On Biana Duhamel and Miss Helyett see Boyer 1988, no. 158, pl. 43. Duhamel also acted at the Théâtre Libre; see Waxman 1926, 237.

73. Lugné-Poe 1930, 260; also 265–266.

74. William Rothenstein, *Men and Memories: Recollections of William Rothenstein, 1872–1900* (New York, 1931), 90.

75. The identification of Coquelin *cadet*'s roles is from the register of performances at the Comédie-Française and documentation in the Archives Salomon.

76. Noël and Stoullig 1892, 69–70. For other watercolors from this series see Russell, 1971, pls. 15–25; Boyer 1988, nos. 150–153.

77. Letter from Denis in Lugné-Poe 1930, 255. Information on Coquelin *cadet*'s own collection is from *Succession Coquelin cadet*, sales cat., Hôtel Drouot, Paris (26 May 1909), and from the Archives Salomon.

78. Lugné-Poe 1930, 261.

79. *Phonographie éditeur Darzens* and a third watercolor by Vuillard relating to Darzens' phonograph project are reproduced in Boyer 1988, pls. 36, 37. Unfortunately, neither Darzens' book on the subject nor Vuillard's designs were ever published.

80. Dated 17 January 1891, in Antoine 1964, 166.

81. In the end *Axël* was given by Darzens to the Théâtre de la Rive Gauche, a small avant-garde theater that gave its first performance in February 1894 and another in June under the artistic direction of Paul Larochelle, who later took over Antoine's Théâtre Libre. See Henderson 1971, 105. Information on Darzens' involvement is from Lefrère 1996, chap. 12.

82. Antoine 1964 ed., 168–170. Georges Ohnet was a popular novelist who was very successful in adapting his novels to the stage. See Carlson 1972, 198.

83. Gabriel Mourey, "Les Directeurs de Théâtres Parisiens: Théâtre-Libre Antoine," *Le Courrier français* (1 March 1891), 10; and Gabriel Mourey, "Au Théâtre-Libre: A. Antoine," *Le Courrier français* (5 July 1891), 2–3. The journal also published a lengthy interview with Antoine the following year, 3 July 1892, 10–11.

84. Antoine 1964 ed., 182.

85. See Cate in Gilmour 1988, 127–128.

86. Félix Fénéon, "Au Théâtre Libre," *Le Chat noir* (5 December 1891), 1864.

87. Henri-Gabriel Ibels, "La Carrière d'Antoine," *Je sais tout* (15 May 1914), 649.

88. Charles Saunier, "Henri-Gabriel Ibels," *La Plume* (15 January 1893), 35.

89. On Ibels' Théâtre Libre programs and his illustrations for the press see Patricia Eckert Boyer, "The Artist as Illustrator in Fin-de-Siècle Paris," in Phillip Dennis Cate, ed., *The Graphic Arts and French Society 1871–1914* (New Brunswick, 1988), 145–158.

90. See Boyer in Cate 1988, 145–146. I remarked that the beach setting in one act of the play related to Ibels' image in the lithograph. Since then, Ibels' statement of 1914 in *Je sais tout* has come to my attention, suggesting that the beach imagery may be more coincidental.

91. Saunier 1893, 35.

92. Georges Renault and Gustave Le Rouge, *Le Quartier latin* (Paris, 1899), 107; reproduced by Boyer in Cate 1988, 150.

93. Antoine 1964 ed., 219.

94. *L'Echo de Paris* (3 May 1893), 2. In July a miners' strike inspired Ibels' brother André, a poet and an anarchist, to write a poem, which was published in 1894 in the book *Les Chansons colorées (Colorful Songs)*, with a cover illustration by Ibels that depicted miners trudging through a desolate landscape, carrying their picks as though they were crucifixes.

95. *La Plume* (1 May 1893), 199.

96. Wittrock 1985, 84, 43.

97. Henri Albert, "Théâtres," *Mercure de France* (December 1893), 358. On Rivière's decors for the Théâtre Libre see also Sarradin 1891, 37.

98. Mourey, July 1891, 3.

99. See Jean Chothia, *André Antoine* (Cambridge, 1991), 90–91.

100. Wittrock 1985, 86.

101. See Patricia Eckert Boyer, "Charles Condor," in Phillip Dennis Cate, ed., *The Circle of Toulouse-Lautrec* (New Brunswick, 1985), 96–100.

102. Antoine 1964 ed., 226–227. Steinlen never made a program for the Théâtre Libre, although he did create a lithograph for a conference on Lucien Descaves' *La Cage* at the Théâtre Antoine on 20 February 1898. Furthermore,

Lautrec's lithograph was originally published in 1893 and republished in a second edition in 1894 to be used as the program cover for the Théâtre Libre. Therefore, he did not design it specifically for *Le Missionnaire*. This is one of many suspicious deviations from fact in Antoine's memoirs, encouraging the suspicion that his recollections were compiled late and edited to suit his objectives.

103. Antoine 1964 ed., 219.

104. Letter from A. Remacle to Vallette, *Mercure de France* (December 1895), 405–406.

105. Noël and Stoullig 1895, 325–326.

106. Phillip Dennis Cate, "Paris Seen Through Artists' Eyes," in Cate 1988, 36.

107. For a synopsis and review see Camille Mauclair, "Le Cuivre," *La Revue encyclopédique* 6, no. 122 (1896): 7–8; and B. de Courrière, "Théâtre Libre," *Mercure de France* (January 1896), 127–128.

108. Gaston Danville, "Théâtre Libre," *Mercure de France* (March 1896), 413–414.

109. Noël and Stoullig 1896, 405.

110. Osbert was an admirer of Puvis de Chavannes, who devoted his art to the exploration of "states of the soul," placing his figures in ethereal arcadian landscapes. He was associated with many of the leading avant-garde artists of the day. He participated in the Rosicrucian exhibitions between 1892 and 1897; the "Symbolistes et Impressionnistes" exhibitions put on by the Barc de Boutteville, which began in 1891 and included the work of the Nabis and Lautrec; and the Salon des Cent, organized by the journal *La Plume*, which supported the symbolist cause. See Neil Blumstein, "Alphonse Osbert: Le peintre symboliste et son monde," *L'Oeil* (April 1989), 51. After 1894 Osbert's studio became a meeting place for fellow symbolists, attracting the founder of the symbolist Théâtre d'Art, poet Paul Fort; the founder of the symbolist periodical *L'Ermitage*, writer Henri Mazel; poet and writer Alfred Jarry; and artists Charpentier, Vibert, Charles Filiger, Daniel de Montfreid, and Alexandre Séon. See Taube G. Greenspan, "*Les Nostalgiques* Re-Examined: The Idyllic Landscape in France, 1890–1905" (Ph.D. diss., City University of New York, 1981), 194.

111. Among the painted compositions that are similar are *Les Chants de la nuit*, 1896, private collection, Paris; and *Le Soir sur l'étang*, 1895, private collection, Paris.

112. Noël and Stoullig 1896, 406–407.

113. Among the works by Gauguin that include variations of this figure are *Human Misery*, 1888, oil on canvas (Ordrupgaard Collection, Copenhagen); *Human Misery*, 1889, zincograph from the Volpini Suite; *Eve*, 1889, pastel (Marion Koogler McNay Art Museum, San Antonio); and *Life and Death*, 1889, oil on canvas (Mahmoud Khalil Museum, Cairo).

114. For a description of the play in relation to Anquetin's lithograph see Aitken 1991, 38.

115. Thalasso 1909, 98.

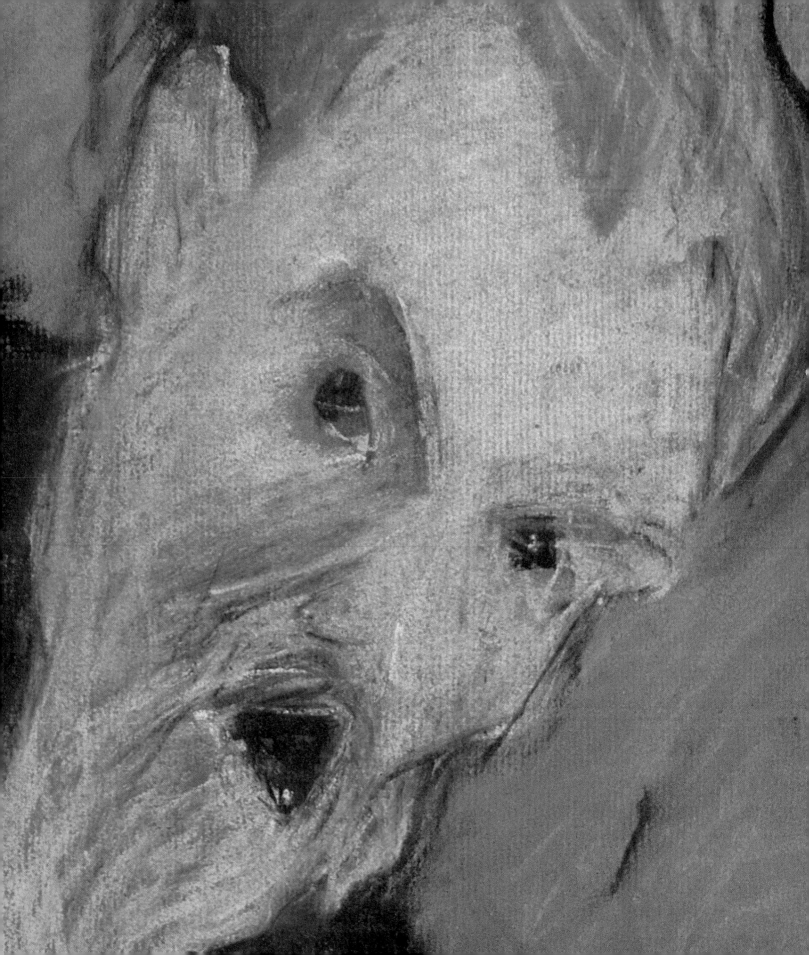

Beginning in 1887 André Antoine established naturalism as a style for drama. Within a few years of his revolution the symbolist poets, led at first by Paul Fort (1872–1960) (fig. 35), appropriated drama as a vehicle for their style of expression. In November 1890, when the Théâtre d'Art presented its first production, the naturalist Théâtre Libre was just reaching its zenith, staging *Monsieur Bute, L'Amant de sa femme,* and *La Belle Opération.* Ironically, the program for that evening at the Théâtre Libre was illustrated by the emerging symbolist artist Edouard Vuillard.

The symbolist movement in literature was fully in place by the mid-1880s. An early manifestation of its principles is found in Charles Baudelaire's poem "Correspondances," published in 1857. The correspondences it describes link the senses and the spirit:

Nature is a temple in which living pillars
Sometimes emit confused words;
Man crosses it through forests of symbols
That observe him with familiar glances.

Like long echoes that mingle in the distance
In a profound tenebrous unity,
Vast as the night, and vast as light,
Perfumes, sounds, and colors respond to one another.

Some perfumes are as fresh as the flesh of children,
Sweet as the sound of oboes, green as pastures
—And others corrupt, rich, and triumphant,

Having the expanse of things infinite,
Such as amber, musk, benzoin, and incense,
That sing of the flight of spirit and the senses.[1]

The theoretical basis of literary symbolism was further developed in Téodor de Wyzéwa's writings about the aesthetics of Richard Wagner. In his "Notes on Wagnerian Painting," published in 1886, de Wyzéwa reiterated Wagner's notion that art should be "an aesthetic reconstruction" of "sensation, thought, and emotion":

Art must consciously re-create, by means of *signs,* the total life of the universe, that is to say the soul....
In the beginning, our soul experiences sensations—phenomena causing pleasure or pain. These consist of the diverse colors, resistances, smells, or sonorities, all of which we believe are external qualities, though all are inner states of the mind. At a later stage, our sensations become linked, and their number, through repetition, lessens. Groups form, abstracted from the initial set; words now give them permanence. The sensations become thoughts; the soul thinks after having felt. Finally, beneath the level of thoughts an even more refined mode comes into being: the sensations become enmeshed in dense breath and there arises in the soul something akin to an immense flow, whose waves lose themselves in confusion. The sensations and thoughts thin out, multiply themselves so that they become imprecise in the overall flow. This is the stage of emotions, passionate anxiety, and feverish joy—supreme and rare states of the spirit; they are still a confused vortex of colors, sonorities, and ideas: and one is dazzled by this vertigo.

These three modes, sensation, thought, and emotion, constitute the whole life of our soul. As a result, art, the deliberate and disinterested re-creation of life, has always attempted—indeed must attempt—an aesthetic reconstitution of these three vital modes.[2]

The symbolist poet Jean Moréas, an associate of Rodolphe Darzens, drafted an important manifesto of the new literary movement for the journal *Le Figaro* in 1886:

An enemy of didactic pursuits, of "declamation, of false sensitivity, of objective description," symbolist poetry endeavors to clothe the Idea in a form perceptible to the senses that nevertheless does not constitute an ultimate goal in itself, but, while helping to convey the Idea, remains subordinate.

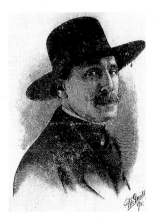

35. Portrait of Paul Fort, wood-engraving on paper, Bibliothèque de L'Arsenal, Paris.

Detail of pl. 35.

The Idea, in turn, must not allow itself to be deprived of the sumptuous trappings of external analogies; for the essential character of symbolic art is never to reach the Idea itself. Accordingly, in this art, the depictions of nature, the actions of human beings, all the concrete phenomena would not manifest themselves; these are but appearances perceptible to the senses destined to represent their esoteric affinities with primordial ideas.[3]

Moréas' manifesto—and his emphasis on the expression of the "Idea" and its evocation through the senses—though derivative of the Baudelairean notion of correspondences, was particularly influential to the new generation of poets and artists and, by extension, to the symbolist theater.

The concept of correspondences among the senses, of eliciting meaning through the arrangement of lines, forms, and colors, was explored in the visual arts by Paul Gauguin in 1888 and was passed from him, through Paul Sérusier, to other members of the Nabis who would be integrally involved in the symbolist theater. In January 1890 Aurélien Lugné-Poe urged his friend Maurice Denis to write an article on the Nabi theories for one of the "petites revues" published by his acquaintance Jean Jullien, whose plays *La Sérénade* and *L'Echéance* had been performed at the Théâtre Libre: "If you have some observations on art that are sufficiently lively and current, bring them or send them to Jullien. You'll get a nice bundle for them."[4] Thus in August 1890, under the pseudonym "Pierre Louis," Denis wrote his seminal article on symbolism in painting, "Définition du Neo-Traditionnisme." It began with the famous dictum: "Remember that a painting—before it is a horse in battle, a female nude, or a story of any king—is basically a flat surface covered with colors put down in no discernible order."[5] Denis went on to stress the importance of "the state of the soul" or "mood" of the artist, from which comes all of the feeling in a work of art. He mentioned musicality and its importance and claimed that

the arrangement of lines, forms, and colors on the surface of a painting can communicate the emotion of the work. He urged the avoidance of direct reproduction of nature and literal illustration of texts, advocating instead decoration, or "accompaniment," through the use of expressive lines.

Denis' statement is clearly indebted to Baudelaire's literary theory of correspondences, and it emphasizes the Nabis' interest in the decorative potential of art: a painting is first a decorative surface covered with colors, which may go beyond its formal nature to evoke ideas. The article brought about even closer ties between the Nabi painters and the literary symbolists, and it may even have helped Gauguin. As Denis wrote to Lugné-Poe in 1891: "You know what we were saying the other day? All in all, it's Lugné who holds the key to Gauguin's success. Remember what happened in a year: the article in *Art et critique*, the relationships with the symbolists, the number of people you got interested in painting."[6]

Vuillard had recorded his thoughts on the importance of mood and the expressive potential of line and color in his journal even before Denis' article was published. On 25 April 1890 he wrote:

Necessity of being aware of the emotional subject, the emotion arising from the lines, spots, and colors, the *painting* regarded with calmness in order to grasp it, but this calmness independent of the emotion coming from the painting, that is, do not believe that the lines or colors give an impression of calmness, [as] this can come into conflict with the motifs *corresponding* to the feelings of noise and movement; emphasize all these words; otherwise, working on the portrait of Mimi I would confuse the mood I'm in and the emotional expression of my work and thus with what was in my head [I] could not understand or at least *admit* into my conception any but things with a character corresponding to impressions of calmness.[7]

These ideas were immediately reflected in Vuillard's art: for example, in his theater drawings

from 1890–1891 of Biana Duhamel and Coquelin *cadet*, and in his drawings for Darzens relating to phonography (see figs. 19–21, 24). Expressive distortion is also apparent in his pastel portrait of an actor who was probably performing in a symbolist production at this time (pl. 35).[8] Just as the poets created correspondences and evocations of ideas and emotions in their writing, and as Gauguin and the Nabis used formal means—color, line, form— to evoke meaning in their painting, so the theater began to appropriate symbolism to create dramas in which meaning was evoked through a combination of movement, staging, and vocal effects rather than being conveyed directly.

Lugné-Poe wrote in his memoirs that it was his artist friends who enriched his spirit and led him to look beyond the Conservatoire and the Théâtre Libre, "where I carried out my first campaign more real to me than those of Reims, but whose complete lack of imagination had made me restive. Life, reading, good friends had led me to burn what I had loved; we read Rimbaud, Gide at the beginning of his career, Verlaine, etc...then Maeterlinck, Ibsen...."[9] Denis wrote to Lugné-Poe early in 1891 during his military service in Reims, urging him to hurry back "to the Théâtre d'Art, which requires your presence in Paris."[10]

The first evidence of the burgeoning symbolist theater was an article published by another young poet, Louis Germain, on 19 April 1890 in *Art et critique*, predicting that naturalism in the theater would die and that the theater of the future would be that of the "Dream." He announced his creation of the Théâtre Idéaliste, which would exist alongside the Théâtre Libre, one complementing the other. He planned to stage texts by Paul Verlaine, Catulle Mendès, and anyone who had talent and desired a better state for humanity. "Naturalism," he wrote, "is the recording of human suffering, just as idealism is pity for it. The latter logically succeeds the former. And to have pity, is that not to be, potentially, a poet?" Germain also mentioned that all of the works

produced at the Théâtre Idéaliste were to be accompanied by music.[11]

Before the Théâtre Idéaliste had actually produced anything, Paul Fort founded the Théâtre Mixte—when he was eighteen years old and still a student at the Lycée Louis le Grand. In an article published in September 1890 in *La Revue indépendente*, a symbolist literary journal, Fort outlined his plans for the theater, which included having young actors and writers work together and staging previously unpublished or unproduced dramas of young writers as well as forgotten works from the past. In the fall of 1890 the Théâtre Idéaliste and the Théâtre Mixte merged, and by November the new entity was renamed the Théâtre d'Art and was operating under the sole direction of Fort.[12] The Théâtre d'Art published its programs and reproductions of related drawings in a journal-like document called *Théâtre d'art*. This publication does not have the aesthetic value of the programs for the Théâtre Libre and Théâtre de L'Oeuvre and is not represented in the Atlas Collection, but it provides a wealth of information about artists' contributions to stage decor and about the staging of symbolist productions at the Théâtre d'Art. And since many of the practices and techniques employed by Lugné-Poe at the Théâtre de L'Oeuvre were a direct continuation of those pioneered at the Théâtre d'Art, my discussion of symbolist theater continues with the contributions of Fort.

The first evening of performances at the Théâtre d'Art took place in November 1890, the same month in which Lugné-Poe began his five-month absence from Paris to fulfill his military service. One of the short plays given was by the female novelist Rachilde, whose *La Voix du sang* (*The Voice of Blood*), ironically, was not symbolist but was of the *comédie rosse* genre often performed at the Théâtre Libre. What is important is that with his initial venture Fort gained the support of this influential writer and her husband, Alfred Vallette, who published *Mercure de France* and would collaborate with Fort in the selection of

35 Edouard Vuillard,
Portrait of an Actor,
c. 1891–1892,
pastel on paper,
30.5 x 22 (12 x 8 ⅝),
Martin and Liane W.
Atlas

plays beginning in January 1891. Saint-Pol-Roux was also on the selection committee.

The Théâtre d'Art's second evening, in January 1891, featured Percy Bysshe Shelley's *Les Cenci*, a play written in Shakespearean blank verse, which had the reputation of being an unplayable masterpiece. The *Théâtre d'art* journal also seems to have made its debut at this time. Fort called it his "combat vehicle."[13] Like the short-lived and contemporary *Théâtre Libre illustré* edited by Darzens, it provided illustrations and information on the writers and dramas performed. The first issue announced upcoming performances that reveal Fort's close affiliation with symbolists: Maurice Maeterlinck's *L'Intruse* (*The Intruder*), Stéphane Mallarmé's *L'Après-midi d'une faune* (*Afternoon of a Faun*), Rachilde's *Madame la Mort* (*Madame Death*), and Verlaine's *Les Fêtes galantes* (*Elegant Festivals*). This issue also disclosed Fort's early intention to include multiple forms of new artistic expression as a complement to symbolist drama. In addition to his plans to publish a new journal, the *Livre d'art*, each issue of which would be dedicated to an up-and-coming poet or painter, he intended to create the Salon d'Art, where works by new painters, sculptors, and architects would be exhibited; Auditions d'Art, in which both modern and historical poetry would be presented with pictorial and musical accompaniment; and Concerts d'Art, in which the works of new composers would be "interpreted." Admission to each of these was to be limited to subscribers to the Théâtre d'Art and members of the press. Yet with the exception of the *Livre d'art*, which first appeared in May 1892, there is no evidence that the other projects materialized.

Fort announced specific methods he intended to use in creating symbolist theater in the 30 January issue of *L'Echo de Paris*. He planned not only to feature new plays but to incorporate new paintings as well as the theory of correpondences into his performances: "Beginning in March, the presentations at the Théâtre d'Art will be concluded with the *staging of a painting*—unknown to the public or still in progress—by a painter of the new school. The curtain will be raised for three minutes to display the scene. Actors and models will impersonate the immobile and silent figures.... A *musical accompaniment* and a *concoction of scents* corresponding to the represented painting will set the scene and then perfect the impression. As Baudelaire said, scents, colors, and sounds all work in concert."[14] While these intentions are equally fascinating, no evidence yet confirms that Fort's plans were ever fully realized. The following month, on 24 February, Fort published a letter to the editor of the same journal, reaffirming that "the Théâtre d'Art was going to become absolutely symbolist."[15]

March 1891 was an important month for symbolism: Lugné-Poe returned to Paris; the Théâtre d'Art presented its first truly symbolist drama, Pierre Quillard's *La Fille aux mains coupées* (*Girl with the Cut-Off Hands*), which had first been published by Darzens in *La Pléiade* in 1886; and G.-Albert Aurier published a groundbreaking article in *Mercure de France* on "Le Symbolisme en peinture: Paul Gauguin," identifying Gauguin as the leader in the new school of pictorial symbolism. In this article Aurier, like Moréas, focused in part on the Idea: "The goal of painting, as of all the arts...cannot be the direct representation of objects. Its end purpose is to express ideas as it translates them into a special language." In summation Aurier wrote:

The work of art, as I have evoked it logically, is:
1. *Ideist*, since its unique ideal is the expression of the idea;
2. *Symbolist*, since it expresses the idea by means of forms;
3. *Synthetic*, since it writes out those forms, these signs, according to a mode susceptible to general comprehension;
4. *Subjective*, since the object depicted is not considered as an object, but as a sign of an idea perceived by the subject;

36. Edouard Vuillard, *Young Girl with Burned Hands*, from *La Fille aux mains coupées*, 1891, pastel on paper, 40.0 x 17.0 (15 3/4 x 6 3/4), location unknown.

5. And (as a consequence) *decorative* —inasmuch as decorative painting...is only a manifestation of an art that is at once subjective, synthetic, symbolist, and ideist.

Aurier also gave particular emphasis to the superiority of decorative painting: "decorative painting is, properly speaking, true painting. Painting can have been created only to *decorate* the bare walls of human edifices with thoughts, dreams, and ideas. Easel painting is an illogical refinement invented to satisfy the commercial spirit of decadent civilizations."[16] It may not be coincidental that beginning with the performance of *La Fille aux mains coupées* in March the Nabis began their long collaboration with avant-garde theater in the painting of stage decor. At the same time, decoration, or the application of their art to functional purposes, was becoming increasingly important to the Nabis. Bonnard designed his first poster in 1891, and Vuillard received his first commission for an interior decorative scheme in 1892. During the 1890s all of the Nabis created designs for book covers, song sheets, folding screens, and other functional objects.

Quillard's *La Fille aux mains coupées* was performed along with other dramas on 19 and 20 March 1891. It was described as a "passion play" that takes place "anywhere, preferably during the Middle Ages." The acting on stage was distanced from modern reality by the use of a gauze curtain, a technique that had been used to suggest certain textures in Henri Rivière's shadow theater at the Chat Noir cabaret and one that would be employed as well by Lugné-Poe at the Théâtre de L'Oeuvre. The decor painted by Sérusier consisted of a gold backdrop, with praying angels painted in what was described as a "primitive" style. In front of this background, and behind the gauze curtain, the actors appeared like silhouettes that moved and spoke slowly, rhythmically "chanting (singing) their souls."[17]

The play consisted of both prose and verse. The prose sections, giving background and explanations, were spoken in monotone by a narrator in a long blue tunic, who leaned against a lectern to the side of the stage.[18] The verse was spoken by actors, and a choir created a "music of words, the Voice of the Invisible." Words were as important to Quillard as was decor in establishing the scene for the drama. The play opens with a girl who has ordered that her hands be cut off by a servant because they have been "burned" by the incestuous kisses of her father. This scene seems to have inspired a drawing by Vuillard of a naked girl, with bright orange hands, seated in a posture of shame (fig. 36). When the father learns what his daughter has done, he orders that she be sent out to sea in a boat with neither oars nor sails (thereby condemning her to death). This episode is depicted by Sérusier in the drawing reproduced as an illustration for the journal *Le Théâtre d'art* (fig. 37).[19] But the girl does not die, and when she awakens she finds that her hands have grown back. She disembarks from the boat in a distant land, where children form a triumphal procession for her wedding to the Poet King. She ascends stairs guarded by motionless female sphinxes toward a marble palace rising toward the clouds. There, although she is conflicted by a desire to remain chaste, she surrenders herself to the "voluptuousness of caresses of the Poet King."[20] It may be entirely coincidental, but it is interesting to note, given Quillard's emphasis on hands, that Sérusier used a linear pattern to suggest the swirling ocean water in his drawing for *Le Théâtre d'art* that looks very much like fingerprints. Fingerprinting had become a scientific method for identification only in the 1880s, and Sérusier may have had this recent advance in mind as he reflected on *La Fille aux mains coupées*.

In a letter published in the *Revue d'art dramatique* in May 1891, titled "De L'Inutilité absolue de la mise en scène exacte," Quillard explained the fundamental differences between the realistic staging at the Théâtre Libre and the staging of

37. Paul Sérusier, *La Fille aux mains coupées*, illustration from *Théâtre d'art*, 1891–1892, Josefowitz Collection.

symbolist plays, stressing the importance of synthesis: "Every dramatic work is above all a synthesis.... *The spoken word creates the scenery along with everything else....The stage scenery must be an ornamental pure fiction that perfects the illusion through analogies of color and lines with the drama.* Most often, a backdrop and a few drop curtains suffice to give the impression of the infinite multiplicity of time and place....the theater would be what it should be: *a pretext for dreaming.*"[21] This article, advocating a synthesis of spoken words, decor, acting, and so on, became gospel to Fort and the artists with whom he worked.[22] The idea of diverse elements retaining

their inherent individual character, on the one hand, but together forming a harmony that evokes the ideas expressed in the drama, on the other hand, is essentially the same concept Denis had expressed about painting the year before. In both arenas the goal was to *evoke* content or meaning—not to *describe* it—through the combination of all expressive and formal means available. Just as the idea that form and color were expressive independent of the subject depicted in a painting became known as synthetism, so the simplified symbolist stage design became known as "synthetic decor."

Also on the evening of 19 and 20 March Fort presented Rachilde's *Madame la Mort*, identified by its author as a "cerebral drama."[23] In the first of three acts a young artist named Paul Dartigny commits suicide in his study by smoking a poisoned cigar. The second act takes place entirely in his mind, although for staging purposes, Rachilde indicated that it should be set in a spring garden, in a "gentle and troubling light."[24] Here two figures, one representing Life and the other Death, each claim ownership of Dartigny. The third act takes place in the study, where the artist's mistress and friends mourn his death and discuss the arrangements that must be made. The second act was recognized as belonging to the new type of symbolist drama, in that it revealed the "state of [Dartigny's] soul." The

actress Georgette Camée played Death, dressed in a costume that included a long gray veil. A few years later she would be one of Lugné-Poe's muses of symbolism at the Théâtre de L'Oeuvre. Suzanne Gay played Dartigny's mistress, and also Life, wearing a rose-colored dress with flowers and diamonds.[25]

Invited to create an illustration of *Madame la Mort*, Gauguin wrote to Rachilde expressing his difficulty in translating her idea into an image:

In reading your drama *Madam Death*, I find myself truly perplexed. How can I express your idea with a mere pencil, when to put it across the footlights you require powerful aids—the actress herself, words, gesture.

I would therefore ask you to excuse me for falling short of your ideas in the feeble sketch which I send you—and if I send you two instead of one, it is because by putting them together (which is possible, is it not?) that one will supplement the other.

Be kind enough to regard my two bad sketches as a well-meaning effort.[26]

Rachilde must not have found the drawings too disagreeable: one of them, depicting the figure of death in her long gray veil, with the suggestion of a skull behind, was reproduced along with Sérusier's drawing of *La Fille aux mains coupées* in the issue of *Théâtre d'art* that corresponds to these performances. The second was used as the frontispiece to Rachilde's book *Théâtre* (fig. 38), also published in 1891.

On 21 May the Théâtre d'Art presented an evening of many plays, intended as a benefit for Gauguin and Verlaine. The authors whose works were performed included Verlaine, Baudelaire, Maeterlinck, Mendès, Théodore de Banville, Victor Hugo, Charles Morice, and Edgar Allen Poe. Just as Darzens had been the first to publish works by Maeterlinck in Paris, Fort was the first to produce them in the theater. *L'Intruse*, one of Maeterlinck's death dramas, concerns a father, his three daughters, their uncle, and their blind

38. Paul Gauguin, *Madame la Mort*, 1891, charcoal on paper, 23.5 x 29.3 (9 1/4 x 11 1/2), Musée du Louvre, Paris, Département des Arts Graphiques, fonds Orsay.

grandfather, who await the mother's recuperation after childbirth. The father and uncle are convinced that she will recover, but the grandfather senses impending doom. He feels a chill and insists someone is coming, although the sighted relatives see nothing. The intruder who finally arrives is Death, and a lamp on a table goes out, symbolizing the death of the mother. Lugné-Poe's acting debut at the Théâtre d'Art was in the role of the blind grandfather. And since Fort was occupied with the staging of the entire benefit, he asked Lugné-Poe, Denis, and Paul Percheron to take responsibility for staging Maeterlinck's work. At the outset Fort may not have realized the importance of the play. As Lugné-Poe wrote in his memoirs:

During the rehearsals Maeterlinck and his actors were treated like poor relations of the theater. We did not even know whether we would perform or not. They put us at the end of the program so that in case the evening was too long they could cut us off.... We were restricted to rehearse on the zinc roof of the Vaudeville Theater....The performance of *The Intruder* began before an indifferent audience. It woke up the drowsy theater and became a triumph. The next day all Paris was talking about the astonishing and tragic Flemish author.[27]

Quillard, reviewing the play for *Mercure de France*, noticed that the effect created by the smoky gray decor, designed "with great intelligence" by Vuillard, was similar to the distinctive and mystical style of a contemporary artist, Eugène Carrière.[28] Actors performed in a static manner, with few and very restrained gestures to express the growing terror in the drama. Sérusier made a drawing of the blind grandfather and the girls that was reproduced in *Théâtre d'art*. Other members of the Nabis were also inspired to make drawings of the drama. Denis depicted the three sisters with the father and uncle to the right and the grandfather seated in the background with the lamp behind him to his right (fig. 39). Denis' image conveys the hopeful suspense of

39. Maurice Denis, *L'Intruse*, 1891, pencil and charcoal on paper, 20.0 x 13.3 (7 7/8 x 5 1/4), Private Collection.

the girls and something of the stillness of the grandfather, who senses what lies ahead.[29] Vuillard created a more literally descriptive sketch of the characters as they appeared in his stage design, with the lamp in the center (fig. 40).

By approximately this time Lugné-Poe was sharing a studio in Montmartre with Bonnard, Vuillard, and Denis. Bonnard and Vuillard made numerous sketches of him and of the theater, one of which (fig. 41) might depict Lugné-Poe as the blind grandfather in *L'Intruse*, showing an elderly man entering a room occupied by figures that could be the three sisters, their father, and uncle. As in the stage directions, the only source of illumination is the light on the table (although in the drawing it is a candle, whereas the stage directions and other drawings of the set clearly indicate a lamp). This drawing was made on a special kind of

40. Edouard Vuillard, *L'Intruse*, 1891, oil on board, 28.0 x 60.5 (11 x 23 $^{7}/_{8}$), location unknown.

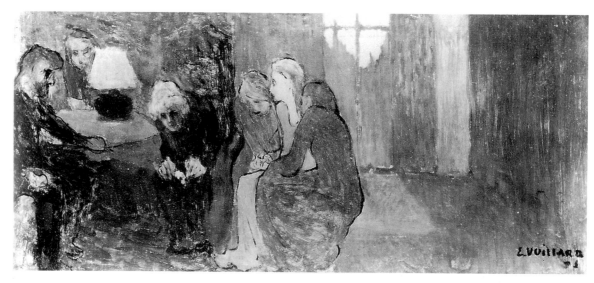

striated paper, named Gillot paper after its inventor, and it reveals the Nabis' receptiveness to new vehicles for exposure for their art. The paper facilitated the creation of halftones in early photorelief printing, and Charles Gillot, owner of a photomechanical printing firm, was proposing by November 1891 to create an album of reproductions of paintings by the Nabis.[30]

For the evening of 11 December 1891 Fort offered fragments of ancient French poems from *La Geste du roi* (*The King's Deed*), Jules Laforgue's *Le Concile féerique* (*The Fairy Council*), Maeterlinck's *Les Aveugles* (*The Blind*), Remy de Gourmont's *Théodat*, and Paul Napoleon Roinard's adaptation of Solomon's *Le Cantique des cantiques* (*Song of Songs*). By now the recitation or performance of poems by actors in costume against a background of symbolist decor was standard practice at the Théâtre d'Art, and according to the program published by the theater, Bonnard, Sérusier, Vuillard, and Henri-Gabriel Ibels created different sets for each part of *La Geste du roi*, while Sérusier designed all of the costumes. A reviewer for *Le Gaulois*, who identified himself only as "a symbolist," wrote that "the spectators had before their eyes symbolist canvases. The first was of an orange tonality, the second violet with violet

stones and gold rain, the third green with gold warriors painted in that adorably awkward manner with the character and charm of the primitives."[31] A drawing by Bonnard that was published in the theater's journal, now retitled the *Livre d'art*, is indicative of this awkwardness (fig. 42). It reflects the Nabis' belief at this time that the simplification of form and a gauche, caricatural style of drawing were the most effective ways to create expressive and evocative images.

For *Le Concile féerique*, which could be described as a dialogue poem, Laforgue recast five previously written poems into a conversation involving three characters—Le Monsieur, La Dame, and An Echo—as well as a Chorus. The staging, with sets designed by Ibels, was described in an unappreciative review by the conservative drama critic Francisque Sarcey: "It's night. On the right a man is standing in the frame of a doorway. On the left, a young man and a young woman are leaning on their elbows on a window....They all begin speaking. Is it in verse? It seems to me that they are speaking in verse since it is a continuous noise of bizarre rhymes as if one had mixed half a dozen sonnets by chance. Anyhow it is impossible to understand one word. I'm unable to figure out what the three people are talking about."[32]

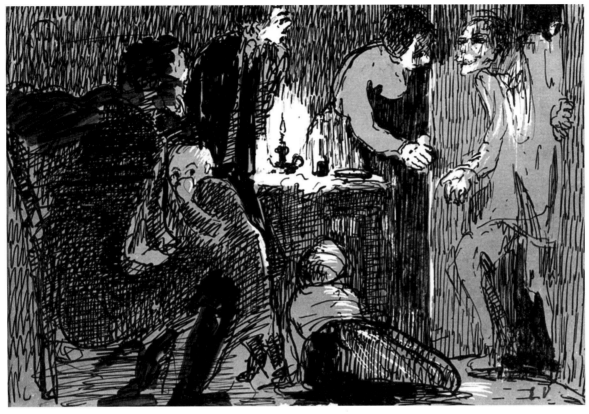

41. Edouard Vuillard, *Theater Scene*, c. 1891, pen and ink with watercolor on Gillot paper, 12.0 x 16.7 (4 ³⁄₄ x 6 ⁵⁄₈), Private Collection.

Laforgue's poem consisted of the nocturnal musings of a man and a woman before and after making love. A drawing by Vuillard for *Le Concile féerique* that was published in the *Livre d'art* seems to depict the couple in the window (fig. 43). Reinterpreting an image he had considered using on a program for the Théâtre Libre in 1890 or 1891 (see fig. 16), Vuillard surrounded the figures with more tightly coiled linear arabesques, perhaps to suggest the sound of several voices speaking at once, as described in Sarcey's review.

Roinard's *Le Cantique de cantiques* was based entirely on the theory of correspondences, according to the program information published by the Théâtre d'Art. The play is divided into eight "devices," or sections, each of which has its own orchestration of speech, music, color, and scent. For the first device, titled "Présentation," Roinard specified:

Speech: in *I* illuminated with *o* (white)
Music: in C
Color: pale purple
Scent: frankincense

Thus the vowels "i" and "o" were stressed by the actors speaking the verses in the first device, the music was performed in the key of C, the lighting had a purple cast, and the scent of frankincense was sprayed over the audience. The remaining seven devices and three "paraphrases" that made up the other scenes of the play were composed of different combinations. In the second, titled "Songe" (Dream), Roinard outlined a different set of evocative analogies:

Speech: in *i-e* illuminated with *o* (white)
Music: in "ré"
Color: in bright orange
Scent: white violet[33]

42. Pierre Bonnard, *La Geste du roi*, illustration from *Le Livre d'art*, 1891–1892, Josefowitz Collection.

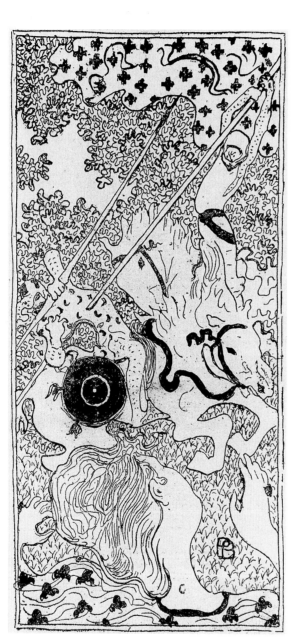

43. Edouard Vuillard, *Le Concile féerique*, illustration from *Le Livre d'art*, 1891–1892, Josefowitz Collection.

In this way the concept of synesthesia, or correspondences between sounds, colors, and scents, was vividly and literally applied to the theater.[34]

Forerunners of Roinard's symbolist drama include not only Baudelaire's "Correspondances" but also Arthur Rimbaud's famous poem "Voyelles," written in 1871 or 1872. Rimbaud too establishes correspondences between vowels and colors: "A black, E white, I red, U green, O blue—I'll tell one day, you vowels, how you come to be and whence...." Roinard's organized application of the theory also strongly recalls the article "Traité du verbe," which Darzens' friend Réné Ghil published in two parts in *La Pléiade* in 1886.[35] Roinard designed and built the stage set himself to evoke a dreamlike atmosphere, and he used the now familiar gauze curtain—here of "metallic color"—to separate the audience from the actors and make them seem more like abstract silhouettes than individuals.

The next performances, on 5 February 1892, included the staging of Rimbaud's poem *Le Bateau ivre (The Drunken Boat)* and Van Lerberghe's *Les Flaireurs (The Trackers)*. For *Le Bateau ivre* the Nabi artist Paul Ranson drew the illustration that accompanied the text of the poem in the theater's journal (fig. 44) and also created the stage decor. The latter consisted of a four-panel folding screen that depicted an underwater garden in a Japanese style.[36] Ranson adhered so well to the theory that decor for the symbolist stage should be extremely simplified and stylized, with the goal of being in complete harmony with costumes, that no one noticed when his screen was hung upside down.[37] For *Les Flaireurs* an illustration by Sérusier appeared in the program to accompany an article by Maeterlinck. Like the Théâtre Libre, the Théâtre d'Art was without sound economic backing and finally succumbed to financial pressures, giving its last performance on 30 March 1892.[38]

In May 1892 Fort began to publish the short-lived *Livre d'art*. Whereas the earlier publication had been a program/magazine related to performances of the theater, the new version was more of a magazine/album of art. Remy de Gourmont served as the guest editor for the first issue; and Emile Bernard and Paul Roinard, respectively, filled the post for the second and third issues. It included literary pieces and reproductions of unpublished drawings by many artists, including Honoré Daumier, Vincent van Gogh, Henri de Groux, and Odilon Redon; the Pont-Aven artists Emile Bernard and Charles Filiger; and the Nabis artists Bonnard, Denis, Ranson, Sérusier, Vuillard, Ker-Xavier Roussel, and Jan Verkade. Each of these (except Bernard, Filiger, van Gogh, Verkade, and of course Daumier, who had died in 1879) would go on to create programs for the Théâtre de L'Oeuvre.

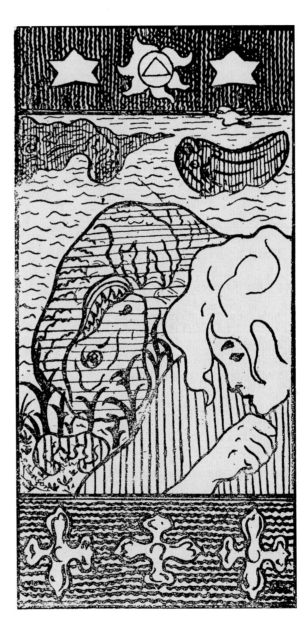

44. Paul Ranson, *Le Bateau ivre*, illustration from *Théâtre d'art*, 1891–1892, Josefowitz Collection.

NOTES

1. Translation and discussion of *Correspondances* are found in Henri Dorra, *Symbolist Art Theories: A Critical Anthology* (Berkeley, 1994), 8–11.

2. Téodor de Wyzéwa, "Notes sur la peinture wagnériene et le Salon de 1886," *La Revue wagnérienne* (8 May 1886), 110–113, translated and discussed in Dorra 1994, 147–149.

3. Jean Moréas, "Le Symbolisme," *Le Figaro*, supplément littéraire (18 September 1886), 150, translated and discussed in Dorra 1994, 150–152.

4. Quoted in Jacques Robichez, *Lugné-Poe et les débuts de L'Oeuvre* (Paris, 1957), 107.

5. Pierre Louis (pseud. Maurice Denis), "Définition du Neo-Traditionnisme," *Art et critique* (23 and 30 August 1890), reprinted in Maurice Denis, *Du Symbolisme au classicisme. Théories* (Paris, 1964), 33.

6. Lugné-Poe 1930, 248.

7. Edouard Vuillard, journal entry for 25 April 1890, Bibliothèque de L'Institut de France.

8. This pastel has traditionally been identified as a portrait of Félix Fénéon, but records in the Archives Salomon identify it as the portrait of an actor.

9. Lugné-Poe 1930, 193–194.

10. Lugné-Poe 1930, 249.

11. Louis Germain, "Le Théâtre Idéaliste," *Art et critique* (19 April 1890), 263–264. Four excellent books have greatly aided this discussion of symbolist theater. They are Robichez 1957; Dorothy Knowles, *La Réaction idéaliste au théâtre depuis 1890* (Paris, 1934); Gertrude Jasper, *Adventure in the Theatre: Lugné-Poe and the Théâtre de L'Oeuvre to 1899* (New Brunswick, NJ, 1947); and Frantisek Deak, *Symbolist Theater: The Formation of an Avant-Garde* (Baltimore, 1993).

12. For an excellent study of the formation and repertoire of the Théâtre d'Art see Deak 1993, 138–162.

13. Paul Fort, *Mes Mémoires, toute la vie d'un poète 1872–1943* (Paris, 1944), 48. The 15 January 1891 issue of the journal *Théâtre d'art* is also identified as "troisième année no. 1," although to my knowledge it is the inaugural issue.

14. Paul Fort, *L'Echo de Paris* (30 January 1891), 4.

15. *L'Echo de Paris* (24 February 1891), 4.

16. G.-Albert Aurier, "Le Symbolisme en peinture: Paul Gauguin," *Mercure de France* (March 1891), 155–164; translation and discussion from Dorra 1994, 192–203.

17. For a description of Sérusier's decor and the staging in general see Alfred Vallette, "Théâtre d'Art," *Mercure de France* (May 1891), 301.

18. Deak 1993, 143.

19. For an illustrated listing and discussion of all of the performances at the Théâtre d'Art see Aitken 1991, 41–50.

20. For a discussion and English translation of the text see Pierre Quillard, *La Fille aux mains coupées*, trans. Jacques F. Hovis, in Frantisek Deak, "Symbolist Staging at the Théâtre d'Art," *Drama Review* (Spring 1984), 117–122.

21. Pierre Quillard, "De L'Inutilité absolue de la mise en scène exacte," *Revue d'art dramatique* (1 May 1891), 181–182.

22. Fort 1944, 31.

23. Rachilde, *Théâtre* (Paris, 1891).

24. Rachilde 1891, 79.

25. Alfred Vallette, "Théâtre d'Art," *Mercure de France* (May 1891), 302–305.

26. Maurice Malingue, ed., *Paul Gauguin: Letters to His Wife and Friends* (Cleveland, 1949), 156.

27. Lugné-Poe 1930, 200–201; English translation from Deak 1993, 160.

28. Pierre Quillard, "Théâtre d'Art," *Mercure de France* (July 1891), 48.

29. A variant of this drawing was reproduced in *La Plume* (1 September 1891) and on the cover of *L'Art littéraire* (October 1893). The two sisters to the right reappear in the painting *Les Deux Soeurs*, 1891 (Rijksmuseum Vincent van Gogh, Amsterdam); see Ursula Perucchi-Petri, "Les Deux Soeurs," in exh. cat. Zurich 1993, 152–153.

30. George L. Mauner, *The Nabis: Their History and Their Art, 1888–1896* (New York, 1978), 69. Perhaps there was discussion about including drawings in the album, leading Vuillard to experiment with Gillot paper. It may also be worth noting that many of the drawings Lucien Métivet had been making since 1889 as illustrations for Darzens' *Théâtre Libre illustré*, were on Gillot paper; perhaps Vuillard's drawing relates to this as well.

31. Un Symboliste, "Mise en scène symboliste," *Le Gaulois* (14 December 1891).

32. Deak 1993, 151–152.

33. *Le Livre d'art, organe du Théâtre d'Art*, program for the 1891–1892 season. Louis Anquetin created the illustration for the program.

34. See *Le Livre d'art, organe du Théâtre d'Art*, program for the first performance of the 1891–1892 season, for a description of the devices. For an excellent analysis of this production see Deak 1984, 120–122, and Deak 1993, 153–156.

35. Réné Ghil, "Traité du verbe," *La Pléiade* (July 1886), 129–137, and (August 1886), 162–169.

36. Knowles 1934, 244.

37. Fort 1944, 31. Fort remembered Bonnard's creating the decor, but it was Ranson who did it.

38. Maurice Maeterlinck, "Les Flaireurs," *Théâtre d'Art*, program for the second performance of the 1891–1892 season, n.p.

Décors du peintre LOUIS HAYET

L'ŒUVRE ADMINISTRATION 23 RUE TURGOT

AURÉLIEN LUGNÉ-POE AND THE THÉÂTRE DE L'OEUVRE, 1893–1900

n November 1892, after the closing of the Théâtre d'Art, Aurélien Lugné-Poe (1869–1940) (fig. 45) staged Henrik Ibsen's *La Dame de la mer* (*The Lady from the Sea*) with an amateur theater group, the Cercle des Escholiers, that he had founded in November 1886 with Georges Bourdon, a former classmate at the Lycée Condorcet.[1] Lugné-Poe must have developed an appreciation of Ibsen through the Théâtre Libre, which had been the first to stage the Norwegian playwright in Paris (*Les Revenants* [*Ghosts*] in 1890, *La Canard sauvage* [*The Wild Duck*] in 1891). In 1892 he became the first to attempt to stage Ibsen in a symbolist manner. Although Ibsen was considered a naturalist by his compatriots, *La Dame de la mer* was thought by its French translators to be a play dealing with the psychological concept of freedom, and therefore to be in the vein of the "cerebral drama." The characters were seen as belonging to another world and speaking a mystical language full of hidden meanings.[2]

In the Escholiers production Georgette Camée performed in the lead role of Ellida, whose ancestors had lived for generations by the sea in Norway. She is married to Wangel, a widowed physician played by Lugné-Poe, but she is haunted by the memory of a young sailor she knew before she met her husband. She had promised she would wait for him to return from sea, but she did not, and during her five years of marriage to Wangel she has been psychologically distant from him because of her unfinished business with the sailor. One day the sailor does return, demanding that she choose between him and Wangel. Only when Wangel releases her from her commitment to him and gives her freedom to choose—between him and "the stranger"—*can* she choose; and she chooses Wangel.

Maurice Denis created a lithograph for the program that depicts Ellida looking over her shoulder at the sea and at the boat that brought the "stranger" (fig. 46). Edouard Vuillard seems to have recorded the performance in an evocative pastel drawing in which figures in the audience, rendered as solid black silhouettes, occupy the foreground (fig. 47). Above them the curve of the proscenium arch defines the stage space, where Vuillard shows a scene from the fifth act in which the stranger, having returned for Ellida, enters Wangel's garden to press his case.[3] Vuillard's silhouette effects recall the Chat Noir's shadow theater; he reserved vivid color to depict the figures onstage. The drawing is thus a synthesis of elements from the popular theater and the poets' theater, a synthesis of two simultaneous realities—onstage and offstage.

Paul Fort planned to reopen the Théâtre d'Art in March 1893 with *Pelléas et Mélisande* by Maurice Maeterlinck, a drama about tragic love that is full of symbolic references. Lugné-Poe was to perform in the role of Golaud and to direct the play with the assistance of critic Camille Mauclair. In the end Fort abandoned the project but gave all of the scenery and costumes to Lugné-Poe and Mauclair, who continued the production on their own. It opened on 17 May at the Bouffes Parisiens. Maeterlinck worked closely with Lugné-Poe in staging the play, and the techniques they applied were direct extensions of those used at the Théâtre d'Art. Mauclair wrote several articles in advance of the opening to educate the public about the nature of this performance. In one, published in *Le Journal*, he described their nonrealistic approach to staging the play:

The organizers of the production sought to change the scenic decor by following new principles, eliminating furniture and props unnecessary for the action and attempting to create a set whose composition and detail corresponded with the development of the play....With that in mind, they have tried to devise an ornamental frame around the characters, instead of wasting time making real apartments or actual forests, following the conventional route. They also wished to give the actors costumes that hewed to a

45. Photograph of Lugné-Poe, c. 1893, Bibliothèque de L'Arsenal, Paris. Detail of pl. 51.

46. Maurice Denis, *La Dame de la mer*, 16 November 1892, lithograph on paper, 17.5 x 24.9 (6 7/8 x 9 3/4), Josefowitz Collection.

new aesthetic, looking not for period re-creations but for the nature of the whole, beyond any fashion and any period—in a word, costumes for fairytales and legends.

In that way, the details harmonize with the feeling, like a kind of musical accompaniment: everything, as in the plays of Shakespeare, comes down to a majestic simplicity, and the stage is framed with large ornamentations that complete it without distracting the spectator. For *Pelléas et Mélisande*, whose nature is melancholy and mysterious, the colors of the scenery run from dark blue, mauve, orange, moss green, pale green, sea green to the dull purples and blue grays of the actors' costumes, culminating in that of Mélisande, which is the lightest. Thus, when the curtain rises, the stage looks like a painting.[4]

The set for the production consisted of painted paper flats, a moving curtain on a wire, and a few "stage properties," all designed by painter Paul Vogler. Observers likened the visual effects in *Pelléas et Mélisande* to "stained glass" and spoke of actors on stage appearing like silhouettes. These descriptions bring to mind both *cloisonnisme* in symbolist painting (in which pictures are composed of flat color forms with prominent outlines) and the color and black silhouettes created in the shadow theater at the Chat Noir. Francisque Sarcey reviewed the production: "One had an impression of watching a succession of images projected by a

magic lantern, in faded colors, subdued tones....The beings that we see acting on stage look like shadows. They live, speak, and move in the atmosphere of artifice; they are creatures of a dream."[5] It is logical that the creators of symbolist theater would draw from the visual effects of shadow performances at the Chat Noir in defining a method of staging that distanced characters from reality in order to evoke more abstract ideas. Lugné-Poe's Nabi friends had also been exploring silhouettes as a formal device in their symbolist art for the previous few years.[6]

One of the fortunate outcomes for Lugné-Poe in staging *Pelléas et Mélisande* was that it earned him the respect of Rachilde and her husband Alfred Vallette. When Rachilde learned that he planned to produce the drama, she wrote to him: "I understand through Paul Fort, Monsieur Lugné-Poe, that you are well aware that the production of *Pelléas et Mélisande*, even if the production does not achieve perfection, was for the Théâtre d'Art the door to glory and that you have decided to open it completely for us with the fullest literary disinterestedness. As the most avid admirer of Maeterlinck I thank you, and let us now adopt the motto of our courageous director: Forward!"[7] From this point on, Rachilde and Vallette turned their attention to helping Lugné-Poe succeed with his Théâtre de L'Oeuvre. They reviewed plays and published articles on issues related to his efforts and the artists and playwrights involved with the theater. Rachilde also offered him advice on the choice of texts, as Vallette had done for Fort.

The Founding of the Théâtre de L'Oeuvre

The Théâtre de L'Oeuvre was founded in the summer of 1893 by Lugné-Poe, Camille Mauclair, and Edouard Vuillard. In a letter sent to the press in September, Lugné-Poe stated that their productions would in "every way possible be Works of Art" and would stir up ideas. He planned to dedi-

cate the first season to foreign drama, and he emphasized that his partners would bring their "science and their art" to the productions. And they did: Mauclair regularly published explanatory articles on pieces that were performed at the theater, and Vuillard played a major role in designing programs and stage sets. Lugné-Poe also mentioned their intent to include an element of "fantasy," which would appear in the way they staged plays, and he discussed the possibility of using enlarged silhouettes as well as other types of puppets and pantomime.[8] Obviously, Lugné-Poe's vision for the Théâtre de L'Oeuvre was the culmination of his theatrical experience to date. He selected and developed what he considered to be the most promising and interesting elements of theater, assimilating elements from all innovative and interesting types of performance.

The manifesto for the new theater, written by Mauclair, was published in *Mercure de France* in October 1893:

We are proposing two parallel, but distinct orientations for our theater. The first is to fight, to create currents of ideas, to make controversy, to rebel against certain people's inertia, even if they can at times be refined...to use our youth no longer as an excuse for our literary experiments, but in order to live violently and passionately through our works. And for that we have resolved to create here, in opposition to the anemic and inconsequential comedy of intrigue, the theater of Henrik Ibsen, the master psychologist of crowds, the instigator of energy, the synthesizer of modern expressive beauty. Ibsen has realized with genius the vision of human drama through which one can satisfy one's morality, pleasure in art, libertarian ideas or taste for aestheticism. If we are happy to invite the public to see masterpieces of symbolism like *Rosmersholm* or *The Master Builder*, it is even with greater earnestness that we are preparing the staging of *An Enemy of the People* in order to present free men and to show an anguished crowd shouting the social issues of today from the stage. In

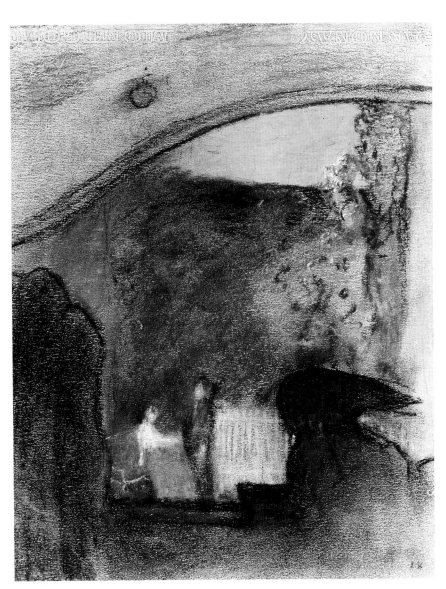

47. Edouard Vuillard, *Scene from "La Dame de la mer,"* 1892, pastel on paper, 30.0 x 25.0 (11 3/4 x 9 7/8), Private Collection.

48. Pierre Bonnard, monogram for the Théâtre de L'Oeuvre, 3.4 (1 ⅜) diameter, Josefowitz Collection.

accordance with our role as artists, we want to serve the cause of individualism which impassions the elite. We are not trying to be impudent, but we will not avoid struggle, whatever form it takes.[9]

Like many other writers and artists of his generation, Mauclair was an anarchist sympathizer and a symbolist at the same time. His manifesto echoes with the general spirit of anarchy and with the sympathy of the artistic avant-garde toward the oppressed working class. Vuillard's proposal of the word "L'Oeuvre" for the name of the theater may reflect this dual identity: *l'oeuvre* means a "work of art," in the sense used by Lugné-Poe in his letter to the press from September, but it also means "work" (as in *labor*). And the latter interpretation seems to be emphasized in a circular seal that Bonnard created for the theater (fig. 48), which depicts a man with a pick-ax working on the cobblestones. At least one contemporary observer, Francis Jourdain, recognized this allusion: "Bonnard designed the seal for L'Oeuvre—a worker facing a pile of paving stones that vividly call to mind a barricade."[10]

Vuillard created all but one of the programs for the first season. The inaugural production was Ibsen's *Rosmersholm,* presented on 6 October 1893, and Vuillard designed the lithograph for the program (pl. 36) and the stage set.[11] The latter consisted of "a room of dark tapestried walls," which was installed with the assistance of Bonnard, Ranson, and Sérusier. The title of the play refers to an old country estate near a small town on a fjord in western Norway, where Pastor Rosmer (played by Lugné-Poe) has lost his wife to suicide. Rebecca West (played by Berthe Bady), the governess for the children, has taken over management of the estate. She is a free-thinking woman, and under her influence, Rosmer is converted into a liberal, which appalls his old friends. Vuillard's program portrays the second act, which Ibsen's stage directions describe as follows: "John Rosmer's study. In the left-hand wall is the entrance door. In the rear wall, a doorway with a curtain drawn aside

from it, leading into his bedroom. Right, a window. In front of it, a desk, covered with books and papers."[12] Rebecca knocks and enters. It is at this point that we learn she is Rosmer's mistress and it was she who somehow convinced his wife to end her life so she and John could marry.

In this psychological drama the characters gradually come to understand themselves, and the audience gradually comes to understand the complexity of their motivations. Rosmer becomes aware that he was not entirely innocent in his wife's suicide. He proposes marriage to Rebecca, but she refuses him, in part due to feelings of guilt for having been the mistress many years earlier of a man she later learned was her father. In the end both Rebecca and Rosmer commit suicide. By appropriating Ibsen to the symbolist theater, Lugné-Poe revealed the symbolist aspects of the playwright's work. As Maeterlinck and others saw it, Ibsen's psychological dramas were compatible with symbolism because "they understood the revelation of hidden psychological life as the revelation of hidden metaphysical principles."[13] In *Rosmersholm* there is also one overt piece of symbolism: a white horse always appears to foreshadow an impending death in the Rosmer family.

Vuillard's lithograph is drawn in the intentionally naive style that characterized his portraits of Coquelin *cadet* and his work for the Théâtre Libre and Théâtre d'Art. The same childlike line traces the forms of actors, stage props, and text, with the result that these elements are woven into a uniform linear texture. This approach is consistent with the symbolist theories the Nabis were exploring about the superiority of awkwardness in art as a more expressive style. The "sameness" of all elements in Vuillard's picture also seems to reflect the visual effects achieved in the staging: Danish actor, director, and novelist Herman Bang, who helped with the production, described a rehearsal of the second act: "The mise-en-scène of *Rosmersholm* is without any firm contours. The actors drift restlessly over the stage, resembling shadows drifting

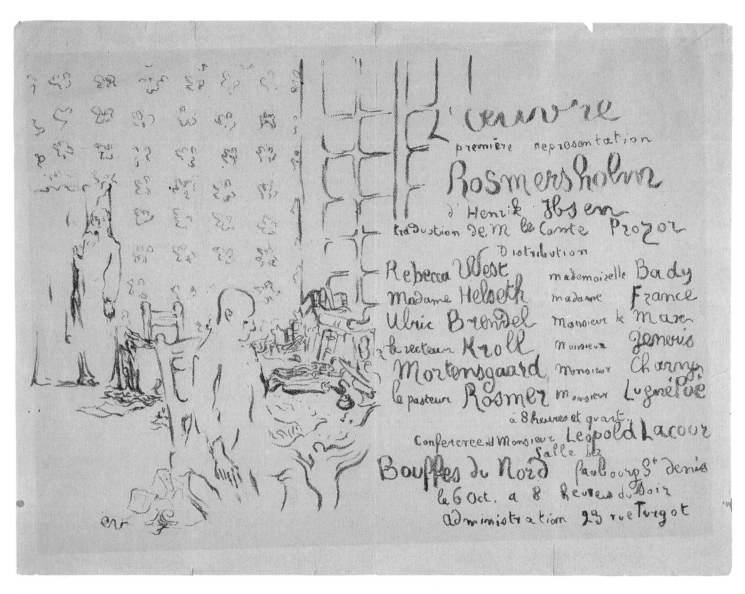

36 Edouard Vuillard, *Rosmersholm*, 6 October 1893

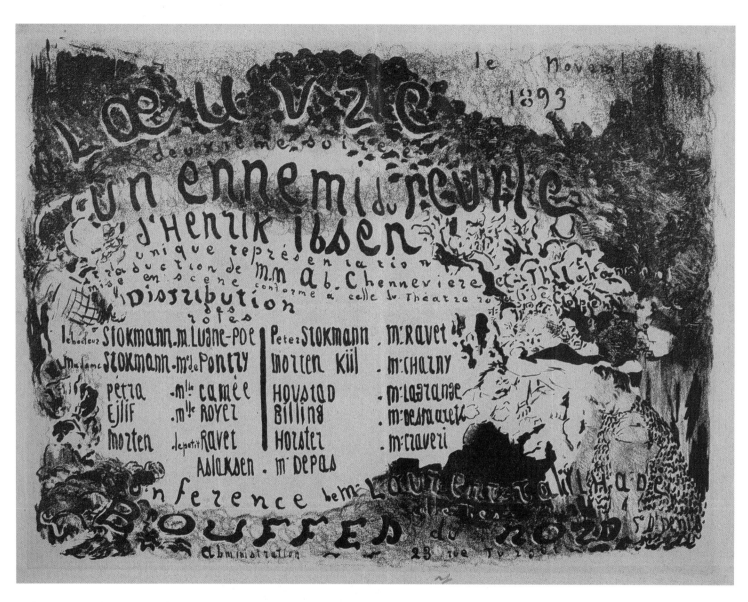

37 Edouard Vuillard, *Un Ennemi du peuple*, 10 November 1893

continuously on the wall....The diction corresponds to this strange appearance. The contours of the lines are erased in an ascending and descending chant that is never-ending in its monotony. Like a Russian hymn, its aim is to create a single ongoing mood."[14]

On opening day Rachilde sent a telegram to Lugné-Poe to wish him luck: "We received word from Camille Mauclair of your triumph yesterday, and we take the liberty, my dear Monsieur Lugné, of congratulating you without having yet had the pleasure of speaking with you....but we are confident that our friend, who is also a discerning critic, cannot be mistaken. So to you and to both of you, in anticipation of our bravos tonight, our best wishes for *the work* and all our congratulations."[15]

Ibsen's *Un Ennemi du peuple (An Enemy of the People)* was the next play the Théâtre de L'Oeuvre produced, on 10 November, and it succeeded brilliantly. Once again Vuillard created the lithograph for the program (pl. 37) and painted the stage sets. The well-known play focuses on an intellectual who is fighting to tell the truth. Dr. Stockman, who is in charge of the public baths, discovers that the water in them is polluted by nearby tanneries. Unfortunately, these baths provide the bulk of the town's income, and if Stockman closes them, it would hurt the entire community. His brother, the mayor, calls him "an enemy of society" for casting "foul aspersions" on the town. Later, at a town meeting, Stockman declares that it is not the baths that are polluted, but rather the politicians: "Majority truths...are the cause of all the moral scurvy that is rotting our society!" Again he is declared an enemy of the people and is encircled by the howling crowd. This is the moment Vuillard has depicted in the program, heightening the caricatural style of the *Rosmersholm* program. The artist takes full advantage of the expressive potential of the lithographic medium. The figures charging at Stockman and the text become a unified, agitated swirl of dark and light, which evokes the anger and energy of the mob. This confrontation intrigued

Vuillard to the extent that he represented it again in the painting *Réunion électorale* (fig. 49). The Théâtre de L'Oeuvre was born at the peak of anarchist activity in Paris, and when *Un Ennemi du peuple* was performed at the theater in 1893 and again in 1899, it was accompanied by anarchist demonstrations.[16] Anarchist writer Laurent Tailhade gave a conference preceding the play in 1893, then lost an eye to a bomb a few months later.

In his ongoing role as promoter of the Théâtre de L'Oeuvre, Mauclair wrote an article about the production for *La Revue encyclopédique*, commenting on the stage decor: "Edouard Vuillard, whom the foremost connoisseurs of modern art consider a master painter of tomorrow, welcomed the numerous intricacies of stage sets." He also noted that among those in the audience were writers Maurice Barrès, Stéphane Mallarmé, Octave Mirbeau, Saint-Pol-Roux, and Rachilde; the influential critic and proponent of the movement to reinvigorate the decorative arts in France, Claude Roger Marx; and artists Denis, Gauguin, Henri de Groux, and Georges Rochegrosse.[17] The significance of the audience was not lost on Vuillard, who continued to make it the subject of such pictures as his watercolor and ink drawing *L'Entracte (Intermission)* done at about this time (fig. 50).

Gerhart Hauptmann's *Ames solitaires (Lonely Souls)* was scheduled to be performed on 13 December 1893, but it was delayed by the police

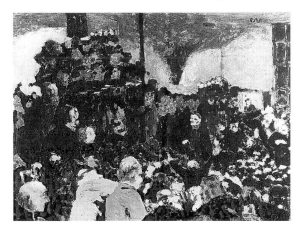

49. Edouard Vuillard, *Réunion électorale*, 1893, oil on board, laid on cradled panel, 36.0 x 44.0 (14 1/8 x 17 3/8), location unknown.

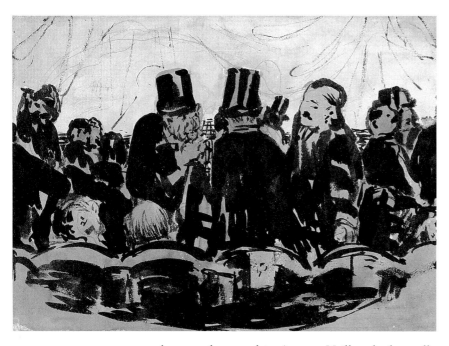

50. Edouard Vuillard, *Intermission*, c. 1893, watercolor and china ink on paper, 20.4 x 30.5 (8 x 12), Private Collection.

because the anarchist Auguste Vaillant had set off a bomb in the Palais Bourbon four days earlier.[18] When the production opened, it was accompanied by Vuillard's program (pl. 38), which records the setting specified by the author for all five acts of the play: "A large room, comfortably furnished to serve both as dining and sitting-room....At the back two bow windows and a glass door look onto a veranda, the garden, lake, and the Müggel Hills beyond."[19] Vuillard shows the principal characters all seated in this room: M. and Mme. Vockerat at the upper left; John Vockerat and Anna Mahr to the right; and Kitty Vockerat, John's wife, in the lower right corner. Kitty is convalescing after the birth of a son, and her health is fragile. She is kind but simple. Her husband, on the other hand, is a frustrated intellectual. He had earned his doctorate but returned to live in the country with his wife and parents (who are dogmatic Christians). One day a student, Anna Mahr, is brought to meet the Vockerats, and she immediately forms a bond with John, who in turn becomes obsessed with her. Kitty feels alienated; she is excluded both physically, because of her infirmity, and intellectually.

Before long she begins to fear for the integrity of her marriage, and she relates her fears to her in-laws, who concur that John is on the brink of adultery. John's mother tells Anna to leave; when she does, John, who insists that his relationship with her was one of the mind and not carnal, commits suicide. Hauptmann's characters address the separation of the life of the mind, or the realm of ideas, from physical life, and they sketch multiple layers of psychological isolation. Vuillard's image reinforces Hauptmann's themes.

Vuillard's program format for *Ames solitaires* is different from the one he used for *Rosmersholm* and *Un Ennemi du peuple*. A sheet of paper is folded in the center, with a lithographed front and back cover. On the front the program information is merged with a scene from the play; on the back a handwritten lithographic announcement for the "transformed" *Revue blanche* is assimilated into the image of an interior with a seated woman reading. Vuillard's programs for these three plays, created over the course of only two months in 1893, seem to summarize the evolution of his art from the intentionally awkward distortions of 1890–1891 to a more mature synthesis. The new simplification of features and integration of form, line, and texture have come together in a very sophisticated aesthetic statement in the program for *Ames solitaires,* in which all aspects are fused in an interaction of light and dark that communicates the psychological tension in the play. Vuillard's tendency to weave all formal elements into one harmonious, decorative entity is analogous to the symbolist approach to drama, in which actors, movements, spoken words, and stage decor are melded into an expressive whole and no single element overshadows the others.

Vuillard also designed the set for *Ames solitaires*. In a review for *L'Art littéraire* Alfred Jarry commented on the extraordinary use of color and light to evoke Kitty's state of existence: "The Ideas fly and leap on their padded feet, stimulating actors entirely equal to the intended performance,

38 Edouard Vuillard, *Ames solitaires*, 13 December 1893

51. Henri de Toulouse-Lautrec, *La Revue blanche*, 1895, color lithographic poster, 125.5 x 91.2 (49 3/8 x 35 7/8), Museum of Modern Art, New York.

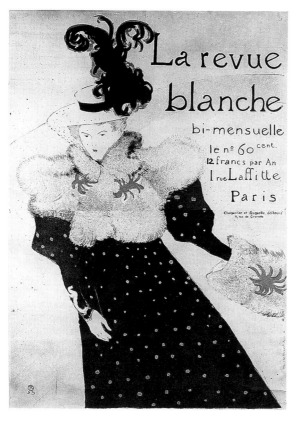

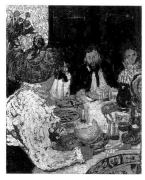

52. Edouard Vuillard, *The Luncheon*, 1895–1897, oil on cardboard, 40.0 x 35.1 (15 3/4 x 13 3/4), Yale University Art Gallery, The Katherine Ordway Collection.

in the half gloom surrounding the green lamp on the red tables, where Vuillard illuminated the vegetative life that renders Kitty's hands so pale."[20] Vuillard's use of a lamp to suggest meaning in the play recalls Paul Fort's extinguishing of the lamp in *L'Intruse* in 1891 to symbolize the death of the mother.

The inclusion of publicity for *La Revue blanche* on this program and several that follow it reflects the intensity of the journal's involvement in the artistic and theatrical activities of Vuillard and his friends. The Paris office for this literary and artistic review was established at 19 rue des Martyrs in the fall of 1891. Alfred and Thadée Natanson were members of the editorial committee, while their older brother Alexandre became the director, and Lucien Muhlfield, the editorial secretary. Like Lugné-Poe and the Nabi artists Bonnard, Denis, Roussel, Sérusier, and Vuillard, the younger two

Natansons had attended the Lycée Condorcet; they would also have known Lugné-Poe through the Cercle des Escholiers. Like many of the artists and writers of the day, the Natansons attended Mallarmé's *mardis* (Tuesday receptions) on the rue de Rome. When Thadée married Misia Godebski in April 1893, their apartment became another meeting place for young artists, writers, and intellectuals. The Natansons were important patrons for the Nabis and Lautrec; Vuillard was especially close to them from the beginning. The latter received the first of many decorative commissions for the family in June 1892, creating six overdoor panels for Paul Desmarais and his wife, who was a cousin of the Natansons; and in 1894 he was commissioned by Alexandre Natanson to paint a decorative cycle of his choice for Natanson's home. In 1893 Vuillard was the first artist to create a lithographic frontispiece for *La Revue blanche* and the first to have a solo exhibition in the offices of the journal.

The publishers of *La Revue blanche* supported the efforts of Lugné-Poe in many ways, and the worlds of the Théâtre de L'Oeuvre and the magazine were intertwined throughout the 1890s. Thadée and Misia attended dress rehearsals; *La Revue blanche* reviewed performances given at the Théâtre de L'Oeuvre and published articles by and about authors whose works were performed; the core group of artists participating in both the theater and the magazine were the Nabis and Lautrec. Bonnard created a poster for the publication in 1894, and Lautrec created one the following year that depicted Misia as an ice skater (fig. 51). Vuillard made several paintings of Thadée and Misia in their home, such as *Le Déjeuner (The Luncheon)* (fig. 52). He also introduced Alfred Natanson, the drama critic for *La Revue blanche*, to one of Lugné-Poe's symbolist actresses, Marthe Mellot, whom Alfred later married.[21]

Publicity for *La Revue blanche* is a prominent element in Vuillard's program for the 13 February 1894 performance at the Théâtre de L'Oeuvre

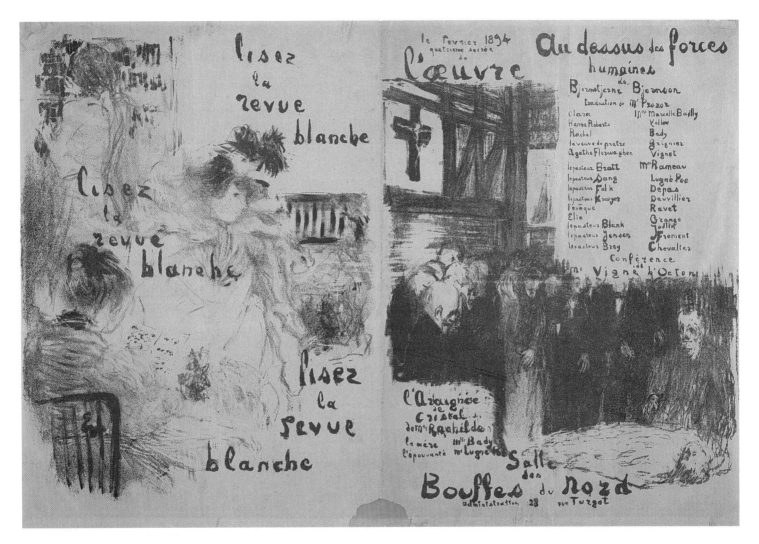

39 Edouard Vuillard, *Au dessus des forces humaines; L'Araignée de cristal*, 13 February 1894

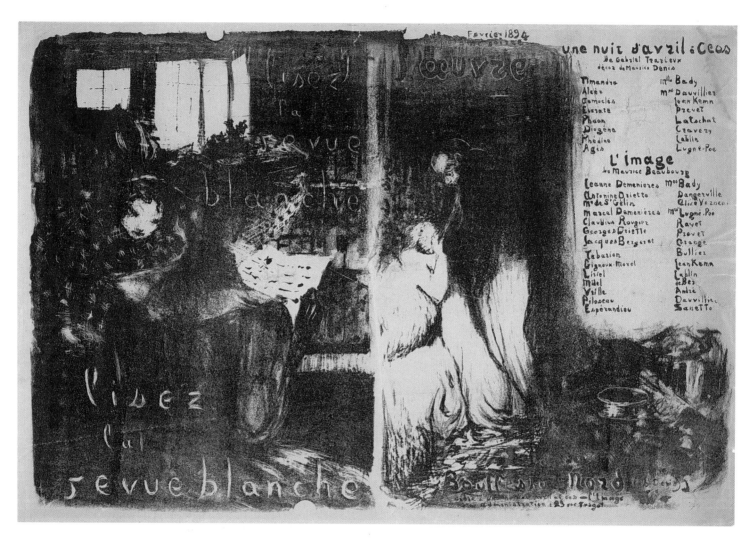

40 Edouard Vuillard, *Une Nuit d'Avril à Céos; L'Image*, 27 February 1894

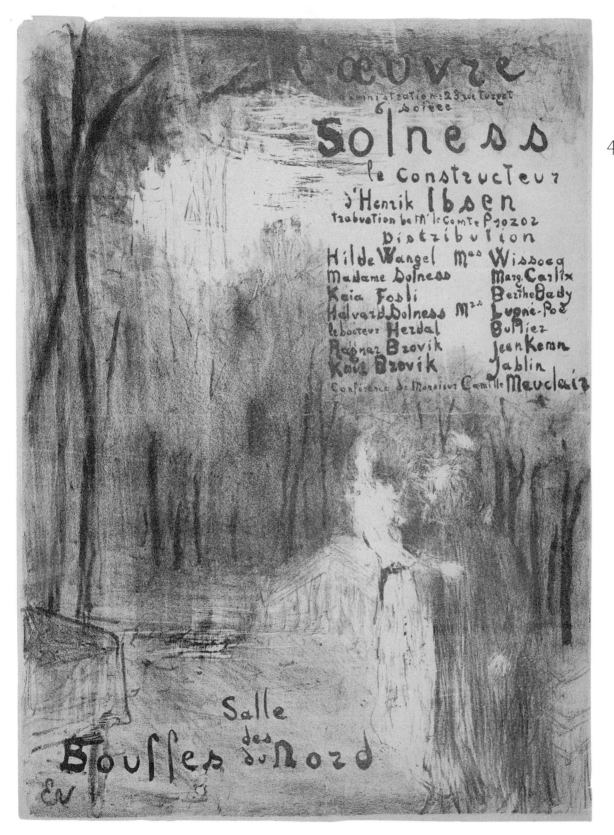

41 Edouard Vuillard,
*Solness, le construc-
teur*, 3 April 1894

53. Sir Edward Coley Burne-Jones, *La Belle au bois dormant*, 24 May 1894, collotype on paper, 17.1 x 54.8 (6 ¾ x 21 ⅝), National Gallery of Art, Washington, Gift of The Atlas Foundation, 1995.76.11.

(pl. 39), which included Björnstjerne Björnson's *Au dessus des forces humaines (Beyond Human Power)* and Rachilde's one-act play, *L'Araignée de cristal (The Crystal Spider)*. He employed the folded format for the program once again, and the lithograph on the front depicts the dramatic finale of Björnson's play. In this story Pastor Sang believes in miracles and has cured people through prayer. All of his parishioners believe in his ability to heal, but his wife, Clara, who has long suffered from insomnia and ill health, has doubts. Sang prays for her healing, but she dies nonetheless. In Vuillard's earthbound image Sang kneels beside her body, which is clothed in white, while his congregation stands in the background.[22] The same month that Lugné-Poe was staging this play, André Antoine was presenting Hauptmann's dream poem *L'Assomption de Hannele Mattern*, with the program by Sérusier, Vuillard's fellow Nabi. In other words, at this moment the Théâtre de L'Oeuvre's activities paralleled those at the Théâtre Libre.

Later in February Lugné-Poe staged *L'Image* by Maurice Beaubourg and *Une Nuit d'Avril à Céos (An April Night at Chios)* by Gabriel Trarieux. Denis created the stage decor for the latter, and Vuillard illustrated the program for the evening, choosing to depict a scene from Beaubourg's play (pl. 40).[23] Beaubourg's writing was appreciated by the editors of both *La Revue blanche*, which had published his book *Les Nouvelles passionnées* in 1893 with a lithographic frontispiece by Vuillard, and of *Mercure de France*, where Mauclair had published a glowing article on Beaubourg in

October 1893. All had great hopes for him as an emerging French symbolist playwright, which, in the end, did not come to fruition. Beaubourg's play, intended as a cerebral drama, is about an idealist writer, Marcel Demenière, who wants to write a play based on ideas and images, not literal reality. He admires Villiers de l'Isle Adam's story *L'Eve future*, which presents the idea of extracting from a woman the qualities one likes most and creating in one's mind an ideal "image" of her, thereby reconstituting a new lover, which one loves more than the real woman. In Villiers de l'Isle Adam's story the illusion became reality, and Marcel's wife fears that he might want to detach *her* best qualities and reconstitute them. In fact, Marcel does kill her, finds that "image," the idealized version of her, when holding her dead body, and kisses it. In his lithograph Vuillard took full advantage of the dramatic potential afforded by lithography to create expressive dark and light contrasts. Marcel emerges from the tenebrous background, his demonic face highlighted against the blackness as he strangles his wife's pale, limp body.

Vuillard also designed the program for Ibsen's *Solness, le constructeur (The Master Builder)*, performed on 3 April 1894 (pl. 41). Ibsen had intended his play to be a realist drama and urged Lugné-Poe to stage it as such; but the director chose to extract from it aspects related to symbolist interests and received advice in symbolist staging from Maeterlinck.[24] The play is about the sexual passion between Solness, a mature married man and head builder of a Scandinavian town, and Hilde, a much younger woman who idolizes him and fantasizes about his building her a castle in the sky. Although Solness is afraid of heights, Hilde encourages him to climb the scaffolding on a new building he has designed and hang a wreath on it. She becomes very excited by his climbing the tall tower, from which he falls and dies. On the program Vuillard has depicted Solness and Hilde, on a garden veranda in front of a bridge described in the play. The artist has scratched away the litho-

graphic crayon to render Hilde's body and hands white. Her form seems solid and substantial in contrast to the dark figure of Solness, dissolving into the murky background, as if to suggest the power she holds over him and his submissive character. Behind them is the scaffold-covered tower.

Berthe Bady, one of Lugné-Poe's best symbolist actresses, played the role of Hilde in *Solness*. She also took the lead in the theater's 24 May production of *La Belle au bois dormant* (*Sleeping Beauty*), a dramatic adaptation written by Robert d'Humières and Henry Bataille (who would also illustrate a program for the theater in 1897). The program for *La Belle au bois dormant* is the only one from the inaugural season not designed by Vuillard; instead a collotype reproduction of a drawing by British artist Sir Edward Burne-Jones adorned the cover (fig. 53). The image relates to Burne-Jones' paintings of *Sleeping Beauty*, made 1868–1890 and exhibited in London and Whitechapel in 1890.[25]

The program indicates that the stage sets were designed by painters Rochegrosse and de Auburtin and executed by M. L. de la Quininte and that the costumes were designed by Rochegrosse and Burne-Jones. The sets were luxurious and expensive, and Rachilde paid them special notice: "As to the sets, [which were] superb, they benefited from being executed following the precise directions of Rochegrosse, that is, in *colored glass*."[26]

The final presentation of the 1893–1894 season at the Théâtre de L'Oeuvre took place on 21 June and included *Frères* (*Brothers*) by Herman Bang, *Créanciers* (*Creditors*) by Auguste Strindberg, and the poem *La Gardienne*, taken from *Tel qu'en songe* (*Such as One Imagines*) by symbolist poet Henri de Régnier. Aware by this time that Antoine had turned over management of the Théâtre Libre to Larochelle, Rachilde urged Lugné-Poe to stage Régnier's poem: "Yes, my dear Lugné, I think I actually may have been on the right track! (and is anyone entirely right in this world?) and I am anxious since L'Oeuvre, which since the death of TL has become the only remaining theater of art that

54. Edouard Vuillard, *Frères*; *La Gardienne*; *Créanciers*, 21 June 1894, lithograph on paper, 48.0 x 32.4 (18 7/8 x 12 3/4), National Gallery of Art, Washington, Gift of The Atlas Foundation, 1995.76.101.

we have, to take a perfect revenge with *you* of the play in question, and this revenge will be, I am positive: *La Gardienne* by Régnier."[27] Vuillard created the stage decor and the program (fig. 54). In the latter, he experimented with a horizontal format. The lithograph on the front relates to Régnier's poem, evoking the apparition of the Guardian, who symbolizes the human soul and conscience. On the back is an advertisement for *La Revue blanche*. The poem was staged in a manner descending directly from that pioneered at the Théâtre d'Art. Some actors chanted the text from offstage, while others moved onstage as if in a dream state, behind a screen of greenish gauze and in front of a background consisting of "a dream landscape of blue trees, violet earth, and a mauve palace." One witness compared the whole effect to that found in symbolist paintings: "You have seen

these portraits by painters of the new school, in which the faces have no contours, where all is blurred, like in a fog."[28] Years later, recalling Vuillard's contribution to the staging of his piece, Régnier composed a *Sonnet à Vuillard:*

Vuillard, remember! La Gardienne was the show
At the Théâtre de L'Oeuvre where you plied your brush,
An artist whose name was not yet heard much,
For the decor that expressed the background of its soul.

Those times are far away, and yet you must recall
Vuillard! The dialogue had barely broken the hush,
Then hisses, laughing, catcalls. The cadenced verse
Found no favor, nor the actress, nor you...

O rare evenings of youth and daring. Rare evening
Where you return, leaving the lighted Hall,
More confident of your effort and your destiny,

And of your hissers, not one had the wit to foresee,
Behind the scenery of painted cloth,
That on the horizon of art your star was about to ascend.[29]

1894–1895 Season: Bataille, Vuillard, Vallotton, Lautrec, Roussel, Dumont, Dethomas, Sattler

For the second season, beginning in the fall of 1894, Lugné-Poe extended the repertoire beyond Ibsen, Strindberg, Björnson, and recent French symbolist fare to include a play from the English Renaissance and even Hindu drama. Mauclair ended his official affiliation with the theater (although he continued to write long, descriptive articles for *La Revue encyclopédique* on the pieces staged by L'Oeuvre), and Maurice Maeterlinck temporarily assumed the role of advisor to Lugné-Poe on literary matters. Mauclair published an article outlining the program goals for the new season, which included turning its attention more to the past and exploring "variations of human sad-

ness."[30] The opening presentation was John Ford's *Annabella*, which had been written in 1633 and originally titled '*Tis Pity She's a Whore*. This tragedy of ambition and rivalry, expressed in sexual terms, was performed in London the year it was written and regularly thereafter (except following the Puritan Parliament's temporary closing of all theaters in 1642) up until 1663. Because of its scandalously sympathetic view of incest, the play disappeared from the stage until Maeterlinck adapted it for the Théâtre de L'Oeuvre, with the title *Annabella*, in 1894. It is now one of Ford's most famous plays.

The principal plot is the story of Giovanni and Annabella, the children of an Italian nobleman from Parma, whose love for one another is both spiritual and carnal. This duality, along with the characters' awareness that submission to their overwhelming passion for one another will ultimately precipitate their demise, must have interested the symbolists. As Maeterlinck wrote: "*Annabella* is a terrifying, bold and bloody poem of ruthless love. This is carnal love in all its power, all its beauty, and all its almost supernatural horror."[31] Giovanni confesses his love for his sister to the friar who educated him and remained his loyal friend. The friar, of course, advises him to turn away from such feelings. But Giovanni expresses his love to Annabella, who, despite many other suitors, accepts her brother's overtures and proclaims her equal love for him. Soon Annabella becomes pregnant, and her father, misreading her malaise, arranges her marriage to Soranzo. When Soranzo realizes that she has been pregnant from the outset and that her brother is the father, he vows to kill them both. Giovanni learns of the plot and kills Annabella himself, stabbing her in the heart. Then, in a macabre gesture of victory for having foiled his rival's plans and retained his command over Annabella's heart, he literally removes it from her body and displays it on his dagger, professing his eternal love for her before the crowd attending a birthday feast for

42 Henri Bataille, *Annabella ('Tis Pity She's a Whore)*, 6 November 1894

Soranzo. He then kills Soranzo and is in return killed by Soranzo's men. The Cardinal intones the closing lines: "We shall have time / To talk at large of all; but never yet / Incest and murder have so strangely met. / Of one so young, so rich in Nature's store / Who could not say, 'Tis pity she's a whore?"[32]

Henry Bataille's lithograph for the program (pl. 42) seems to depict the second scene in the first act, in which Giovanni and Annabella proclaim their love. The cross at the upper left and the encroaching black cloud (perhaps suggesting death) that begins to envelop the figures recalls the first scene of this act, in which Giovanni has confided in the friar, who warns: "O Giovanni! Hast thou left the schools / Of knowledge, to converse with lust and death? For death waits on thy lust."[33] Bataille began his career as an artist, studying at the Académie Julien in Paris between 1889 and 1894 along with Denis, Ibels, Ranson, and Sérusier (also students there in 1889), and following Vuillard (who had studied there in 1886–1887).[34] The Théâtre de L'Oeuvre would later perform Bataille's own plays as well, including his first, La Lépreuse (The Leper), in 1896, which was a poem, with a program illustrated by Lautrec, and Ton Sang (Your Blood) in 1897 with a program the author illustrated himself.

Louis Anquetin painted two backdrops for Annabella. One, a view of Parma, was described by Mauclair as "airy and bright, with its floating turrets and exquisite bell towers, and an enormous tapestry on which golden knights, amid trumpets and banners, are accompanied by nude women and garlands: a Veronese as eloquent as drama."[35] Although Anquetin never created a program for the Théâtre de L'Oeuvre, he later designed one for the Théâtre Libre just before it closed in 1896, and he produced two lithographs for the Théâtre Antoine in 1897 and 1898 (see pl. 33).

On 27 November 1894 Lugné-Poe presented La Vie muette (The Silent Life) by Maurice Beaubourg, whose L'Image had been staged the preceding year. Rachilde was enthusiastic about the new play. She urged Lugné-Poe to produce it as a fresh piece of French dramatic literature that, she thought, would stand up well against the Scandinavian pieces: "After L'Image, La Vie muette brings our French dramatist another step forward. ...In this play by Beaubourg, the three characteristics of good drama come to the fore: the human aspect, the intellectual aspect, and the symbolic aspect."[36] Beaubourg did not turn out to be the French equal of Ibsen, but his La Vie muette did inspire Vuillard to create a fine lithograph (pl. 43), which depicts the principal characters, M. and Mme. de Meyrueis and their two children. M. de Meyrueis, who feels alienated from his family, is critical and jealous of his wife's close relationship to the children. He even begins to question her fidelity, convincing himself that neither the boys nor the unborn child his wife carries are his. Withdrawing psychologically, he lives a silent life. Vuillard's lithograph specifically records the sixth scene in the second act: the father has persuaded the boys to go down a path in the forest they have always been forbidden to take, but they sense that he wants to harm them and they run away. At that moment their mother appears and enfolds them in her embrace. The father is rendered in black, his face obscured in shadow, and he is isolated from the unified mass of his wife and children by the great white void of the garden path. At the conclusion of the play Mme. de Meyrueis is certain that someone is going to attempt to hurt the children while they sleep, and she stations herself outside their door. When she hears someone approach in the dark, she swings at them with a weapon and finds she has mortally wounded her husband. As he dies, they forgive one another, at last bridging the gulf that had separated them in life.[37]

The next presentation, which took place on 13 December 1894, featured Père (Father), another work by Strindberg. Between August 1894 and November 1896 Strindberg lived mainly in Paris, working as an artist and pursuing his interests in

43 Edouard Vuillard,
 La Vie muette,
 27 November 1894

alchemy and the occult in the company of others who shared these passions. In 1894–1895 he was closely associated with Gauguin, whose art he admired, and at Gauguin's request wrote an introduction to a catalogue of his paintings sold at the Hôtel Drouot in February 1895. The two were involved with a group of artists that included Alphonse Mucha, Edvard Munch, and Wladyslaw Slewinski as well as the poet Julien Leclercq.[38] In December 1894 Strindberg was the subject of an article in *La Revue blanche* written by Henri Albert. In January 1895 the same journal published an article by Strindberg titled "On the Inferiority of Woman to Man" expressing his misogynist views.

Strindberg's dislike of women, his complicated struggle with his own faith, and his interest in pseudoscience all surface in *Père*, the story of a military captain-turned-scientist. Père's wife is manipulative and guileful and wants to make him appear insane so that she can have him institutionalized. She wants his money and wants absolute control over their daughter's future. She intercepts letters that come to the house regarding his inventions, and he begins to believe that no one is responding because no one recognizes the value of his discoveries. The wife manipulates the family doctor into believing that Père is mad, and his own brother, the pastor, is brought into her scheme.

The commission for this program went to Félix Vallotton (pl. 44), a Swiss artist who had become affiliated with the Nabis in 1892. In the lower left corner Père sits, head in hand, frustrated by the lack of responses concerning his discoveries. Behind him are his wife, "sweetly" attentive but all the while undermining him, and their young daughter. The right half of the sheet advertises "Editions d'Art de L'Estampe originale" and directs the audience to read the *Revue blanche* article on Strindberg. These promotional notices reinforce the degree to which the activities of avant-garde artists were intertwined with theater, publishing, and fine art printing. *L'Estampe originale* is the title of a series of original print albums published and

sold through subscription by André Marty between 1893 and 1895. It included works by Vallotton and nearly every other artist involved in avant-garde theater. Marty had also published Burne-Jones' program for Théâtre de L'Oeuvre's production of *La Belle au bois dormant* in May 1894. Vallotton's image of a printer pulling a proof from a lithographic stone emphasizes the handcrafted, high art aspect of printmaking that was so celebrated in Marty's publication.

Lugné-Poe's eclectic second season continued in January 1895 with the presentation of an Indian Hindu drama, *Le Chariot de terre cuite (The Little Clay Cart)*. The Sanskrit text, written about 800 and attributed to King Sūdraka, tells the story of the courtesan Vasantasenā who loves Cārudatta, a good but poor Brahman. The evil Prince Samsthānaka wants Vasantasenā for himself, but when she rejects him, he strangles her and leaves her to die. He then abuses the privileges of his higher caste by accusing Cārudatta of the crime and having him condemned to death. Just before Cārudatta is to be executed before a large crowd, Vasantasenā appears, proving she is alive. Cārudatta is exonerated and chooses to spare Samsthānaka.

The title of the play comes from a scene in which Cārudatta's young son is sad because he has only a little clay cart, while his wealthier friend has a gold one. Vasantasenā comments that it is a shame that even a child is saddened by the fact that other children are better off than he is. She throws her jewels (her entire material worth) into the little clay cart and tells the boy to take them and trade them for a gold cart.[39] This gesture was interpreted by Lugné-Poe and the translator, Victor Barrucand, a writer for *La Revue blanche*, as the tangible sign that she had renounced her former profession and had made a moral transformation.[40]

The play had been performed in Paris in 1850 and in Germany in 1892–1893 before being translated and adapted for the Théâtre de L'Oeuvre.

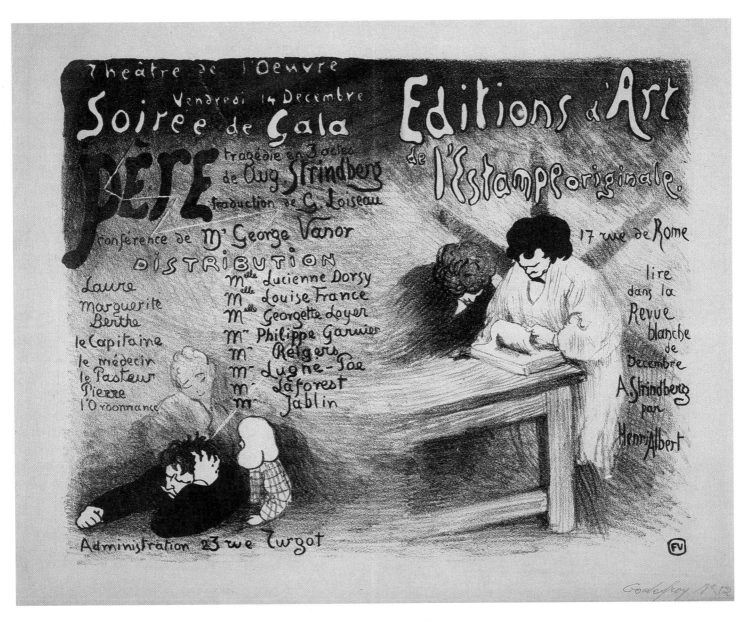

44 Félix Vallotton, *Père*, 13 December 1894

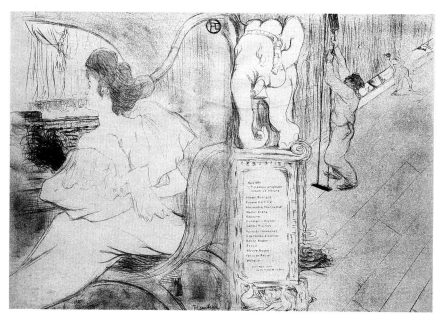

55. Henri de Toulouse-Lautrec, *At the Curtain*, cover and closure album for *L'Estampe originale*, 1895, color lithograph on paper, 58.7 x 82.4 (23 1/8 x 32 3/8), Josefowitz Collection.

It may have appealed to the symbolists because of its portrayal of a prostitute redeemed by true love. But Barrucand was also an anarchist sympathizer, and he emphasized the revolutionary idealism in the text, particularly the anarchist belief that a virtuous person can surmount social injustice. Barrucand was involved with the theater in his personal life as well, living with the anarchist actress Hedwig Moore, who performed at the Théâtre de L'Oeuvre.[41]

Art critic Félix Fénéon was among the friends Lugné-Poe invited to participate in his production of *Le Chariot de terre cuite*. Fénéon had become "literary counselor" and editorial secretary of *La Revue blanche* the same month this play was performed. He was also an anarchist and had been tried in the Trial of Thirty the preceding year because of his sympathetic writing regarding anarchism. Lugné-Poe asked him to recite the prologue to the play, written by Barrucand. In performance Fénéon stepped in front of the curtain dressed as a Hindu priest in a white linen robe—with his bare arms outstretched, his hands gesturing, his fingers spread apart—and chanted words inspired by the original Hindu drama: "May the benediction of

Sambu protect you...." The audience loved it, although not everyone realized who was playing the part.[42] Artist Francis Jourdain recalled that he and a great number of friends participated in the production of this play (undoubtedly in walk-on parts during the great crowd scene surrounding Cārudatta's scheduled execution). Funds were limited, and consequently costumes were improvised—performers wrapped themselves in whatever they could find that would give an Indian effect, including their bedroom curtains—and to look more authentic, they used ocher to dye their skin.[43] Actress Suzanne Després made her debut in *Le Chariot de terre cuite*, soon becoming romantically involved with Lugné-Poe, whom she married in 1898.[44]

Sculptor and stained-glass artist Henry Cros modeled the little clay cart.[45] Lautrec, Albert André, and Louis Valtat collaborated in painting the stage sets, which Mauclair characterized as "violent and gaudy."[46] Late in 1894 Lautrec wrote to his mother, describing his busy participation in this effort: "I have even made my debut in a new line, that of stage-designer. I have to do the stage scenery for a play translated from the Hindustani called *Le Chariot de terre cuite*." In another letter to his mother he wrote, "I'm very much pushed at the moment by my new calling of stage designer. I have to run all over the place, collecting information. And it's quite absorbing."[47] Valtat designed backdrops for the first four acts. For the first and third the setting consisted of a painting of a house and a few trees in the countryside. For the second act, set in Vasantasenā's house, the backdrop was decorative and colorful, intended to evoke the splendor and decadence of a courtesan's home. The fourth act included the use of a transparent rose curtain, with the courtesan appearing behind it. Lautrec painted the backdrop for the fifth act, which included an elephant supporting a building to the left and a flowering cactus on the right.[48] Contemporary observers immediately recognized the elephant as having been inspired by a huge

45 Henri de Toulouse-
Lautrec, *Le Chariot
de terre cuite*,
22 January 1895

56. Attributed to Albert André, *L'Anneau de Çakuntala*, 10 December 1895, lithograph in green on paper, 32.9 x 50.6 (13 x 19 7/8), National Gallery of Art, Washington, Gift of The Atlas Foundation, 1995.76.6.

papier-mâché model in the garden at the Moulin Rouge.[49] Lautrec's program for the play (pl. 45), a lithograph printed in blue on rose-colored paper, clearly relates to his backdrop as well as to the events of the evening. Fénéon is shown in his Hindu robes chanting the prologue. He stands in a pulpit supported by an elephant. To the left, surrounding the program information, are lotus blossoms.

Lautrec's intense involvement with the play spilled over into his concurrent efforts for Marty's *L'Estampe originale*. He had been invited to create a lithograph for the cover of the final installment of prints for 1895, and he chose to depict Misia Natanson, seated in the audience and looking toward the stage, where the curtain is just being lowered following the presentation of *Le Chariot de terre cuite* (fig. 55). Toward the center of the image the familiar elephant stands over a list of the artists who contributed to *L'Estampe originale* in 1895. And at the far right stagehands are shown lowering a curtain. The artist thus portrays multiple views of the same moment, while also connecting the lowering of the curtain at the conclusion of the play to the closing album in Marty's series of print publications.

The Théâtre de L'Oeuvre would stage another Sanskrit drama the next season: *L'Anneau de Çakuntala* (*The Year of Çakuntala*) attributed to Kalisada. Albert André, who participated in creating backdrops for *Le Chariot de terre cuite* and was associated with the Nabis and *La Revue blanche* at this time, most probably created the lithographic program, which is signed with the monogram of an encircled lowercase *a* (fig. 56).[50] Suzanne Després (under the pseudonym Suzanne Auclaire) performed in this play alongside Lugné-Poe.

Ker-Xavier Roussel designed the lithographic program for *Le Volant* (*The Steering Wheel*) by Judith Cladel (fig. 57), which was performed on 28 May 1895. His image conveys the tense relationships among the principal characters, with Marianne Corday seated alone in the foreground and her husband Pierre and friend Rachel together in the middle distance along the garden wall. In the story Rachel, a physician, comes to visit Pierre and Marianne, and they invite her to stay. Before long Pierre and Rachel become attached to one another, and the relationship between Marianne and her husband suffers. Rachel leaves, but by then the harmony between Pierre and Marianne is destroyed. Ultimately, Marianne gives Pierre his freedom to return to Rachel. Roussel's lithograph shows the figures outdoors on a terrace, which relates to a lithographic frontispiece he created the year before for *La Revue blanche* and a series of paintings he completed around 1892–1893, all of which are characterized by the mysterious silence expressed in the image for this theater program.[51]

The avant-garde quality of the plays produced by the Théâtre de L'Oeuvre and its perceived affiliation with the anarchists, which had persisted since the performance of *Un Ennemi du peuple*, kept the number of subscribers lower than hoped; and because of this, the financial situation of the theater was precarious by mid-1895.[52] In June Lugné-Poe received an invitation to perform a very different type of play at a garden party held at the ministry of commerce: a romantic drama by the

famous French author Alfred de Musset, titled *Carmosine*. Profits from this production were used to support the theater's final presentation of the season: Ibsen's *Brand*.

Carmosine, written in 1850, is a sentimental comedy about the daughter of an affluent Sicilian doctor whose family owns a home near the palace of the king. She becomes infatuated with the king, although she realizes that he is happily married and that her love can never be fulfilled. Yet she refuses all other suitors and resolves to die. News of this reaches the royal couple, who feel compassion for her. They meet with her in her family's garden to persuade her not to choose to die, but rather to marry the young lawyer whom her parents had intended for her; then both of them can come to live in the royal palace in the service of the court. The program for the performance(pl. 46) was created by the poet, printmaker, and publisher Maurice Dumont and was produced by his literary and artistic review, *L'Epreuve*. It depicts a young woman, wearing a long gown, in an outdoor setting that recalls Musset's stage directions. Dumont explored this figure in an etching with drypoint as well, which was published in a later edition of *L'Epreuve* (each issue had an original print), but here he has used the medium of glyptography. Like Charpentier's sculpture/prints for the Théâtre Libre programs, Dumont's glyptograph for the Théâtre de L'Oeuvre program had a tactile quality. In this process the image is printed from a relief plate so that the inked areas are pressed deeply into the paper and the unprinted white areas stand in relief. The tangible surface of such a print suggests the symbolist theory of synesthesia—the sensory correspondence of both seeing and touching an image.[53] Dumont also included prints in *L'Epreuve* inspired by other theatrical presentations, such as *L'Intruse* and *Brand*, both from 1895.[54]

Dumont had begun to publish *L'Epreuve* in October 1894 and included the work of many artists, several of whom were associated with avant-garde theater: Bonnard, Denis, Rochegrosse,

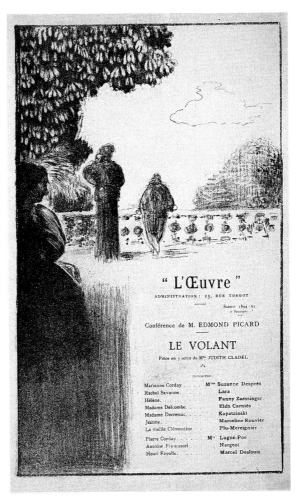

57. Ker-Xavier Roussel, *Le Volant*, 28 May 1895, lithograph on paper, 32.4 x 20.9 (12 3/4 x 8 1/4), National Gallery of Art, Washington, Gift of The Atlas Foundation, 1995.76.68.

Sérusier, and Vuillard. He began to publish *L'Epreuve littéraire* in March 1895, with contributions from many of the symbolist poets who had supported the effort to become integrated with the theater: Paul Fort, André Gide, Mallarmé, Stuart Merrill, and others. And *L'Epreuve littéraire* was offered as a supplement in the newly launched French edition of the German artistic review *PAN*. In March 1896, after *L'Epreuve littéraire* ceased publication, Dumont began a new art journal, *Livre d'art. Revue artistique et littéraire*. Fort, who had used the title *Livre d'art* in 1892, collaborated with Dumont in this effort, serving as the person responsible for its literary content.

46 Maurice Dumont, *Carmosine*, 10 June 1895

Given all of these interconnections, it is not surprising to find publicity for the new French edition of *PAN* featured prominently on the two programs created for performances of Ibsen's *Brand* in June 1895 (pls. 47 and 48). One was designed by German artist Joseph Sattler, and the other by French artist Maxime Dethomas. Ibsen's drama is about a priest in Norway named Brand, who believes in an unforgiving God, a God that demands all or nothing. Brand knowingly allows his young son to die rather than leave his small parish in the North for a warmer climate in which his son might recover. He also loses his wife, Agnes, rather than compromise his harsh religious beliefs to meet her needs. Sattler's image relates to the climactic and hallucinatory scene in act five in which Brand's suffering is symbolized by his wearing an imaginary crown of thorns that causes blood to drip down his face. The spirit of his dead wife has appeared to him and begged him one last time to renounce his extremist beliefs and to be with her in a warm and loving relationship. If he will do that, she and his son will return to life. But he refuses. When he dies in an avalanche soon after, he asks God: "If not by Will, how can Man be redeemed?"[55]

Dethomas' image, on the other hand, seems less an illustration of a specific moment in the play than a general representation of Brand's wife, Agnes, with the ghostly apparition of her dead son. Her left arm encircles a small figure, which pulls away from the ground as if it were not of this world. Marthe Mellot played the role of Agnes. She had met Lugné-Poe in 1890 at the Conservatoire,[56] and she became—like Georgette Camée, Berthe Bady, and Suzanne Després—one of Lugné-Poe's "muses of symbolism," performing frequently with him during the 1890s.[57]

The magazine *PAN* that was advertised on both programs for *Brand*, originally published in German by Julius Meier-Graefe and Otto Julius Bierbaum, appeared in its French edition in the spring of 1895. Joseph Sattler, who designed one

of the programs, also created the poster that advertised the new journal (fig. 58) and the cover of the inaugural issue, which described itself as the first publication of an international artistic and literary society. Like André Marty's *L'Estampe originale*, the new journal was intended to support the printmaking revival of the 1890s and the larger revival of decorative arts and crafts; another goal was to promote German art. The table of contents of the April/May 1895 issue notes that it included reproductions of a painting by Arnold Böcklin and a woodcut by Albrecht Dürer along with an original glyptograph by Dumont and prints by Sattler, Vallotton, James Abbott McNeill Whistler, and several German artists.

There was a strong literary component to *PAN*, and Henri Albert, the French publisher, was in a good position to make such contacts for the magazine in Paris, having reviewed literature and drama for journals such as *La Revue blanche* and *Mercure de France*. The publishers of *PAN* made clear their support for avant-garde theater and art in Paris, offering for sale in their offices the *Livre d'art* published by the Théâtre d'Art in 1892 as well as both lithographic programs for the Théâtre de L'Oeuvre's production of *Brand*. The journal included publicity for both theaters, using Bonnard's seal for L'Oeuvre (see fig. 48). And it offered individual original prints for sale by artists such as Munch (who would illustrate the Théâtre de L'Oeuvre program for *Peer Gynt* in the fall of 1897). *PAN* also published Lautrec's color lithograph of *Marcelle Lender* and Vallotton's *Portrait of Huysmans*.[58]

Sattler's lithograph on the program for *Brand* was used again on a brochure published by Lugné-Poe in 1895, titled *Historique du Théâtre de L'Oeuvre* (pl. 49). A short poem on the cover written by drama critic and writer Henry Bauer evoked the theater's focus: "...truth and dream, poetry and reality, human compassion and the symbol of duty, life in art, death in beauty—such is 'L'Oeuvre' [the work]...." Inside, in decorative black and red

58. Joseph Sattler, color lithographic poster for *PAN*, 1895, published in *Maîtres de L'Affiche*, 35.0 x 28.0 (11 x 14), Bibliothèque Nationale, Paris, Cabinet des estampes.

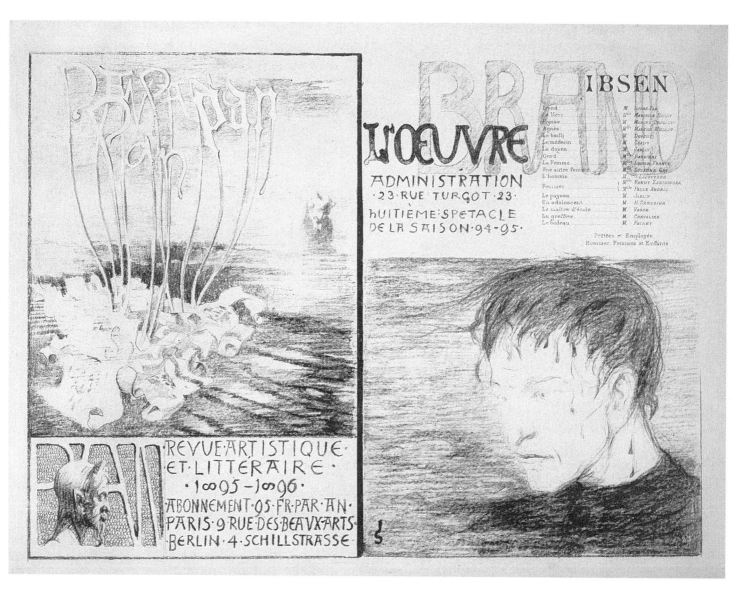

47 Joseph Sattler, *Brand*, 22 June 1895

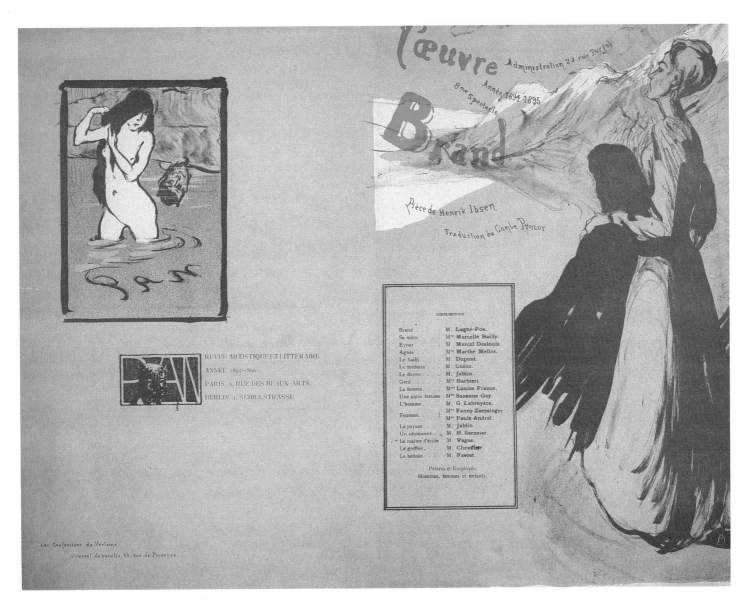

48 Maxime Dethomas, *Brand*, 22 June 1895

.......La vérité et le rêve, la poésie et la réalité,
l'humaine pitié et le symbole du devoir, la vie en art,
la mort en beauté, telle est "L'Œuvre".......

(Henry Bauer)

Historique du Théâtre de "L'Œuvre." Saison 1895-96

49 Joseph Sattler, *Historique du Théâtre de "L'Oeuvre,"* 1895

50 Henri de Toulouse-Lautrec, *Prospectus Programme de l'Oeuvre*, 1895

typography, are listed the plays presented during the theater's first two seasons, both in Paris and abroad.

At around the same time Lugné-Poe published a prospectus for the coming season, 1895–1896 (pl. 50). The text, printed in French, English, and Dutch, announced that the Parisian Théâtre de L'Oeuvre would remain intact and would draw from even more diverse sources: Chinese, English, Greek, Indian, medieval, and Spanish Renaissance drama, as well as contemporary works. In addition, ambitious plans for a new international presence included the establishment of affiliates in Belgium, England, and Holland; and in each of the four venues the theater would sponsor French and foreign drama, musical recitals, exhibitions of decorative art, and a semiannual trilingual periodical of criticism and poetry. The cover for the prospectus, illustrated with a lithograph by Lautrec, shows a sailor navigating his ship. This may refer to Lugné-Poe's efforts to chart a new course for the theater,[59] or it could suggest the crossing of the channel to found an affiliate in London. Unfortunately, these plans were never realized. Other artists who contributed vignettes for the brochure included Denis, Vallotton, Vuillard, M. Dondelet, and Antonio de la Gandara.

1895–1896 Season: Toorop, Lautrec, Sérusier, Bonnard, Hermann-Paul, Vuillard

The initial presentation of the new season was an English Renaissance piece: Thomas Otway's *Venise sauvée* (*Venice Preserved*), first performed in 1682. Dutch artist Jan Toorop received the commission for the program (pl. 51), possibly through Lugné-Poe's efforts to expand the theater into Holland, although Toorop was in contact with the symbolist avant-garde in Brussels and Paris as well. The play was in keeping with the current sympathy for anarchism, and the anarchist Laurent Tailhade, who had given a conference before *Un Ennemi du peuple*

in 1893, spoke before the new presentation. In this drama a group of young men, led by a soldier named Pierre, plan to burn Venice and kill the corrupt senators who monopolize power. Pierre has a mistress, Aquilina, who is a courtesan, and one of her clients is a senator, who is wealthy and can buy her favors as often as he likes. On finding her with the senator, Pierre becomes jealous and attacks his rival. As punishment, he is censured by the senate for "violating something they call 'privilege.'"[60] From that moment he vows revenge. Meanwhile, a co-conspirator, Jaffeir, is married to Belvidera, who is the daughter of a senator, and she persuades him to betray his oath to his friends and reveal their plot to her and to the senate, whereupon the senate condemns all of the conspirators, except Jaffeir, to death. In his last moments Pierre asks to see Jaffeir, who stabs his friend so that he might die an honorable death and then turns the knife on himself. Jaffeir later appears to Belvidera as a ghost and drives her to madness.

Toorop's mysterious image seems to tie into the idea of femmes fatales who corrupt their men's honor and bring them to ruin. The lithograph shows the top half of a phantasmagoric male head, surmounted by two females who gesture with their hands. The flamelike pattern that emanates from the man's head to engulf the female figures might be read as the destructive thoughts and feelings stirred up by women in the minds of men; or it might refer more literally to the plot to burn Venice. At the right Toorop includes theatrical masks, reminiscent of those in Bonnard's watercolor design for a Théâtre Libre program from 1890 (see pl. 8).

In January 1896 Lugné-Poe offered an evening of several short dramas, including Jean Lorrain's *Brocéliande*, which is the subject of Maxime Dethomas' lithographic cover for the program (pl. 52). Printed in ocher, the fluid image depicts Viviane, a water spirit, in the enchanted forest of Brocéliande. Through guile, she discovered the secret of Merlin's magic and bewitched him.[61]

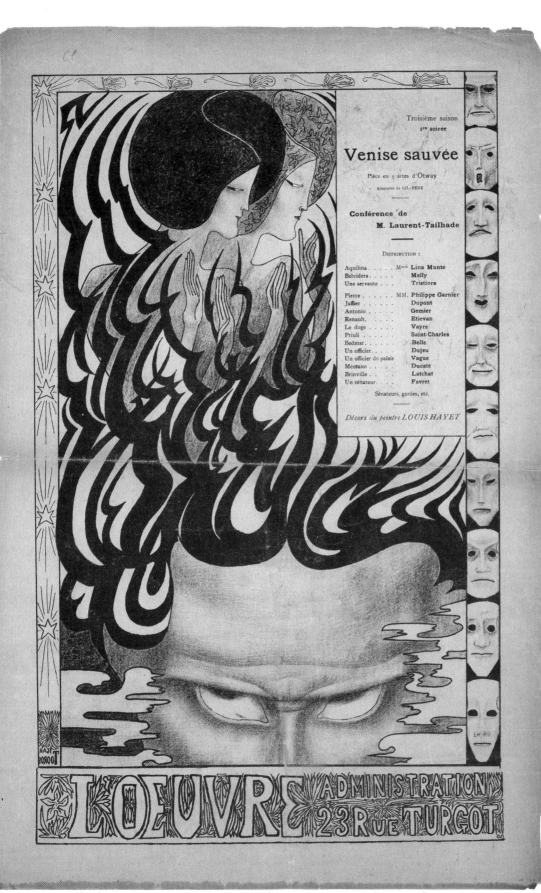

51 Jan Toorop,
Venise sauvée,
8 November 1895

52 Maxime Dethomas, *Une Mère*; *Brocéliande*; *Les Flaireurs*; *Des Mots! Des Mots!*, 6 January 1896

53 Henri de Toulouse-Lautrec, *Raphaël*; *Salomé*, 11 February 1896

To the left (on the back cover) is an advertisement for *La Revue encyclopédique larousse,* which emphasizes its inclusion of original prints. Mauclair's informative articles on productions at the Théâtre de L'Oeuvre appeared regularly in this periodical.

The same publicity is prominent on the next few programs, including the one for 11 February that features *La Revue blanche* writer Romain Coolus' *Raphaël* and Oscar Wilde's *Salomé* (pl. 53). Lautrec illustrated the program with a portrait of each author in his own city: behind Coolus is the Arc de Triomphe, and behind Wilde, Westminster Abbey and the Tower of London. Lautrec and Coolus were good friends, visiting the brothels and various night spots of Paris together and often spending weekends with Thadée and Misia Natanson at their country home. The artist even referred to his friend by the nickname "Coco" or "Cocotte," which means "flirt."[62] The program indicates that props for the play—furniture and art—were lent to the theater by Siegfried Bing's new gallery, L'Art Nouveau, which had opened in Paris the year before. Bing was the first to sell art nouveau—that is, modern decorative art—on a large scale. He commissioned paintings, prints, fur-niture, textiles, jewelry, and all other manner of decorative art from Lautrec, the Nabis, and many other artists, then sold them in his gallery between 1894 and 1904.[63]

Although Lautrec and Wilde were not closely associated, the artist seems to have felt a certain fascination for the writer. When Lautrec was in London just before Wilde was put on trial for sodomy in April 1895, he asked Wilde to sit for a portrait; the request was declined.[64] Back in Paris, Lautrec illustrated an article by Paul Adam in the May 1895 issue of *La Revue blanche* that defended Wilde. *Salomé,* originally written in French in 1891 for the Théâtre d'Art, was first produced by Lugné-Poe at the Théâtre de L'Oeuvre.[65] Wilde was truly grateful, writing from prison to a friend: "How gratified I was at the performance of my play; and have my thanks conveyed to Lugné-Poe; it is something that at a time of disgrace and shame I should be still regarded as an artist....please let Lugné-Poe know that I am sensible of the honor he had done me. He is a poet himself." Wilde's affection for and trust in Lugné-Poe is also evidenced by the fact that he put him in charge of all of his affairs in France in 1897.[66]

Lugné-Poe announced *Salomé*'s inclusion in the program at the last minute to avoid the conflict of opinions that would inevitably arise over the appropriateness of staging the work of such a controversial figure. Indeed during the intermission between the plays, two members of the audience, none other than Rodolphe Darzens and his old friend Maurice Maeterlinck, broke into a heated argument over Wilde, with Darzens defending him and Maeterlinck against him. The two planned to settle the dispute in a duel, but formal combat never took place.[67]

The Théâtre de L'Oeuvre presented a very eclectic mix of plays during the spring of 1896. In March Lugné-Poe staged Auguste Villeroy's *Hérakléa,* with an illustrated program by Paul Sérusier (fig. 59). This zincograph, printed in red brown ink on green paper, depicts the city of

59. Paul Sérusier, *Hérakléa,* 17 March 1896, zincograph in red brown on paper, 32.8 x 50.3 (12 7/8 x 19 3/4), National Gallery of Art, Washington, Gift of The Atlas Foundation, 1995.76.69.

54 Pierre Bonnard, *Dernière croisade; L'Errante; La Fleur Palan enlevée*, 22 April 1896

Chrysopolis in Asia Minor, under siege by the Barbarians, which was the subject of the play. Chrysopolis was full of decadence (inhabited by poets) and lacking in leadership from its aged emperor. Only Hérakléa, guardian of the Faith and of belief in the Ideal, embodied the resistance. In the end the Barbarians infiltrated the palace and enslaved the inhabitants of the city.[68] This play and Sérusier's image might have struck a sympathetic note among the avant-garde in Paris since, like Chrysopolis, Montmartre could be seen as a metaphor for the conflict between a life of art and the crush of common existence.

On 22 April three very different types of drama were on the program, which Bonnard illustrated with a lithograph (pl. 54). This is the only design for a theater program realized by this artist. The image on the left relates to *La Fleur Palan enlevée* (*The Purloined Palan Flower*), a play that Jules Arène adapted from a Chinese model. It shows a young man and woman, who, having slept together one night, decide to marry. Their parents reject the idea and arrange different unions, but the man returns to surprise her, and he lifts a flower from her hair to get her attention. They each tell of their unhappiness but do not reunite. The right side of Bonnard's image relates to Maxime Gray's *Dernière croisade* (*The Last Crusade*), which was not a symbolist play at all but a very modern drama. It concerns the Marquis de Maltaux, who comes from an old Catholic family and has a mistress, Sarah, who is Jewish. No one faults him for having a mistress, but they do question his choice of a Jewish one. His mother decides to persuade Sarah to convert to Catholicism, which she does, along with her husband (who is ignorant of her extramarital liaison). The figures in Bonnard's image represent Sarah and her husband, with the Marquis de Maltaux in the background.[69] All of the figures on the program are rendered with Bonnard's telegraphic simplicity and reliance on a very few elements, with strong contrast between delicate lines and dense masses of pattern. The

third performance of the evening, not illustrated on the program, was *L'Errante* (*The Wanderer*), a dramatic poem by Pierre Quillard. The staging incorporated the familiar symbolist technique of separating the actors onstage from the audience with a transparent green curtain to abstract and generalize them as representations of types and ideas. At the end of the poem this curtain was illuminated by red lights. Rachilde had urged Lugné-Poe to present this piece, and the text was dedicated to her by Quillard.[70]

Hermann-Paul, a well-known Montmartre illustrator whose activities during the 1890s overlapped with those of Lautrec to a large degree, received the commission to illustrate the program and design the scenery for the 29 May 1896 presentation of two comedies: *La Brebis* (*The Sheep*) by Edmond Sée and *Le Tandem* by Léo Trézenik and Pierre Soulaine (pl. 55). Hermann-Paul's specialty in art was satirizing the bourgeiosie,[71] and his depiction here of a fashionable Parisian woman being viewed surreptitiously by a man at a window seems to relate to the theme of adultery, which is the subject of the second play. This is another drama that had nothing to do with symbolism; in fact one reviewer classified it as a *tranche de vie* (slice of life) in the style of the Théâtre Libre.[72] The title alludes to bicycling, because the protagonist Ravinel spends so much time on this sport that he drives his wife to seek the companionship of another man. When he and his wife reconcile, she offers to ride tandem with him!

For the last performance of the 1895–1896 season Lugné-Poe returned to Ibsen, presenting *Les Soutiens de la société* (*Pillars of Society*), and Vuillard returned to do the program illustration (pl. 56) and the stage decor. This was the first time the play was seen in France, and it was the only Scandinavian piece of the season. Vuillard's lithograph, like those he did for the preceding season, was created with a lithographic crayon that he scratched away from the stone in areas to define the forms, printed in black ink with areas of white

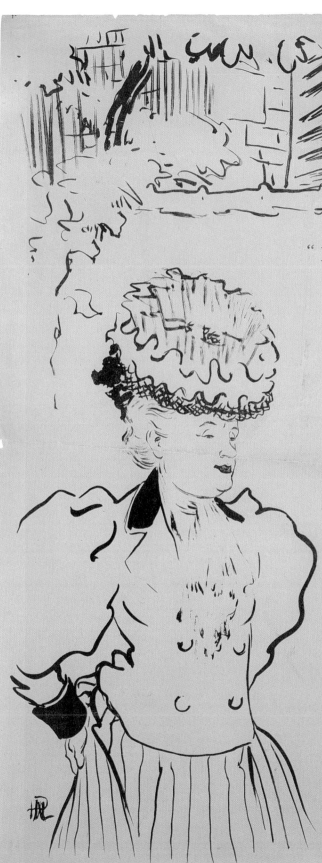

" L'ŒUVRE "

Administration : 23, rue Turgot

ANNÉE MDCCCLXLV-LXLVI
TROISIÈME SAISON
SEPTIÈME SPECTACLE

La Brebis

Comédie en deux actes de M. Edmond Sée

Georges Michiels	MM.	Henri Burguet
Pierre		Gauthier
Flattrin		Lugne-Poe
Latroix		Burguet jeune
Lucienne	M	Dallet
Georgette		Suzanne Auclaire
Louise		Fanny Zaessinger

Le Tandem

Comédie en deux actes de MM. Léo Trézenik et Pierre Soulaine

Ravinel	MM.	Saint-Germain
Désablets		Pons Arlès
Billard		R. Lagrange
Nadur		Dorival
Léontine	M	Ellen Andree
M^{me} Billard		Henriette de Mongey
Une bonne		Sadi

———

La *REVUE ENCYCLOPÉDIQUE LAROUSSE* est désormais hebdomadaire et paraît tous les samedis, en fascicules de 20 pages illustrées, du prix de 50 centimes.

La *REVUE ENCYCLOPÉDIQUE* est la seule revue dont le vaste cadre englobe à la fois les lettres, les arts, les sciences, la politique, la vie pratique, et la seule qui consigne sans partialité toutes les manifestations importantes de l'esprit moderne. Elle est en outre la plus richement illustrée des publications périodiques.

Édition d'amateur

La *REVUE ENCYCLOPÉDIQUE* se publie en tirage spécial exécuté à petit nombre (500 exemplaires) sur papier couché. Cette édition contient, *hors texte*, des reproductions de chefs-d'œuvre de l'art ancien et moderne. 26 planches ont été publiées en 1895. L'année 1896 en comprendra un nombre égal ; mais, toujours soucieuse de progrès et, pour donner à la collection un intérêt plus grand encore, la *Revue Encyclopédique* fera figurer parmi ces vingt-six planches **douze estampes originales** (*lithographies, eaux-fortes, bois, etc.*) signées : Dagnan-Bouveret, Ribot, Fantin-Latour, Jules Chéret, Henri Guérard, Lepère, Maurin, Pierre Roche, Henri Rivière, etc.

Nota. — *L'Édition d'amateur ne se vend pas au numéro.* Prix de l'abonnement d'un an : France, 50 francs ; Étranger, 60 francs.
LIBRAIRIE LAROUSSE, 17, RUE MONTPARNASSE, PARIS

56 Edouard Vuillard, *Les Soutiens de la société*, 23 June 1896

57 Edouard Vuillard, *Les Soutiens de la société*, 23 June 1896 (proof before letters)

where the paper was left untouched. In this program, as in his design for *La Vie muette* in 1893, the figures look away from the viewer, as if they are entirely occupied with their activities. The image is generally descriptive of the setting for the first act, possibly relating to a scene in which a woman draws a curtain aside in response to noise from a nearby circus. Yet it may allude to the final scene and denouement of the drama.[73] The character Bernick, who is admired by all as the leading citizen of his town, once allowed his younger brother-in-law to be punished for something Bernick had done. He also arranged a business deal that benefited him financially, to the detriment of the town and its citizens. In the end he admits his wrongdoings to the public, who have gathered outside his home beyond the garden, and he promises to remedy his errors. In Vuillard's lithograph the woman pulls aside the curtains to reveal a garden and fence. By her side is the figure of a small child. This could be Bernick's wife and son, looking outside to where the crowd will hear Bernick make his confession.

1896–1897 Season: Munch, Jarry, Ranson

Ibsen was featured again for the first performance of the 1896–1897 season, when Lugné-Poe staged *Peer Gynt* on 12 November. Edvard Munch received the commission for the program (pl. 58). For Lugné-Poe's production of this five-act play, written entirely in verse, Suzanne Auclair took the role of Solveig, dancer Jane Avril acted in the role of Anitra, and Alfred Jarry played one of the trolls and also organized the troll scene.[74] Edvard Grieg composed the music. Lugné-Poe recalled in his memoirs that Munch and another Norwegian artist, Fritz Thaulow, helped design the stage sets for the play.[75] Ibsen's drama, based on an old Norwegian folktale, follows the life of Peer, who is a mischievous young peasant in the first act and becomes a weak old man, a dreamer, and a braggart

by the fifth act. It explores his life and dreams, both conscious and subconscious, including an encounter with trolls, who seem to symbolize man's base instincts and desires. Munch's lithograph relates to act two, scene two, in which Peer's long-suffering mother, Aase (played by Mme. Barbieri), and the girl who loves him, Solveig, search for him after he has run away. Ibsen's description reads: "By a mountain lake. The ground is soft and boggy. A storm is brewing. Aase, in despair, is shouting and searching everywhere."[76] In his crayon lithograph Munch shows Aase despairing and Solveig looking out expectantly over a mountain landscape. He employed a pictorial structure that appears in several of his works: restricting the figures to the bottom and side of the composition and allowing the background to assume a significant role in conveying the meaning of the image. The mountainous expanse behind Aase and Solveig suggests the enormous psychological and physical distance between them and Peer Gynt.

Munch had met Lugné-Poe two years earlier. Following the first season of the Théâtre de L'Oeuvre, 1893–1894, which had focused on Scandinavian drama, Lugné-Poe traveled with sixteen actors to bring his French interpretation of Ibsen to the author's native land. They performed in Amsterdam, Anvers, Christiania, Copenhagen, and Stockholm.[77] Munch, who loved the theater, may well have seen these performances. In any case, he first met Lugné-Poe in October 1894, when the director came to the opening of an exhibition of Munch's work in Stockholm.[78]

Munch had studied in Paris on and off since 1889 and spent significant time there between February 1896 and the spring of 1897. His Parisian circle of friends included Mallarmé and Thadée Natanson as well as Strindberg, who wrote a short article on Munch for *La Revue blanche* in June 1896, and Meier-Graefe, one of the publishers of *PAN*, which, as we have seen, was associated with the Théâtre de L'Oeuvre during the spring of 1896. Munch had been affiliated with the German

58 Edvard Munch, *Peer Gynt*, 12 November 1896

periodical since 1893, and its publishers in 1894 encouraged and enabled him to learn how to make prints—etchings and lithographs. In 1895 it was Meier-Graefe who arranged for the French office of the magazine to sell Munch's prints. While in Paris in 1896–1897, Munch furthered his exploration of print media, making color lithographs in the atelier of the printer Auguste Clot, where he would have seen works in this medium by Bonnard, Lautrec, and Vuillard. It was also at this time that Munch began to make color woodcuts. And he participated in exhibitions at the Salon des Indépendants and mounted a one-man show in Siegfried Bing's new L'Art Nouveau gallery.

Munch was very close to Ibsen, whom he had met in Norway in 1893. Ibsen was deeply interested in art, painting pictures himself and collecting the work of others. He visited an exhibition of Munch's work in Oslo in 1895 and asked the artist to accompany him through the show to explain his work.[79] Thadée and Misia Natanson had also seen the exhibition, along with Lugné-Poe, whom they accompanied to Oslo in July 1895 expressly to meet Ibsen. Thadée wrote about the exhibition in the November issue of *La Revue blanche* and reproduced Munch's print *The Scream* in the December issue. Munch later created a lithographic program for Ibsen's *Jean-Gabriel Borkman* at the Théâtre de L'Oeuvre (see pl. 62).[80] In the decades following Ibsen's death in 1906, Munch continually turned to the writer's work for artistic inspiration.[81]

Throughout the 1896–1897 season the Théâtre de L'Oeuvre was linked with the journal *La Critique*. Publicity for the journal appeared on every program, and advertisements for the theater likewise appeared in issues of the journal, using the seal designed by Bonnard. The publishers of *La Critique* printed reviews of the plays and produced all of the lithographic playbills for the season. They also offered subscriptions, costing sixteen francs, for all eight lithographs for the season's programs, printed in the state before letters. And beginning in January, regular subscribers to *La Critique*

received the theater programs for the rest of the season tipped into issues of the journal.

Alfred Jarry, who performed in Ibsen's *Peer Gynt* in November 1896, had been writing for *La Revue blanche* regularly since May and had become the secretary and stage manager for the Théâtre de L'Oeuvre in the summer of that year. From the outset he worked to convince Lugné-Poe to produce his drama *Ubu roi*, and although the director seems to have had doubts, he felt obliged to keep his promise to Jarry and stage the play after the success of *Peer Gynt*. Rachilde, who supported Jarry as she did several of the new young writers, urged Lugné-Poe to go ahead with *Ubu roi*: "This is perhaps not in the vein of a *visionary* success but of a piece of buffoonery that will spectacularly show off your eclecticism, much better than putting on a well-crafted mediocrity."[82] Rachilde's letter, written in November, also urged him give *un guignol* (puppet show).

Two months earlier Jarry had published an article, "De L'Inutilité du théâtre au théâtre," in *Mercure de France* that was essentially a manifesto of his views on theater. Continuing the inquiry into the most effective means of staging drama that Pierre Quillard began earlier with his "De L'Inutilité absolue de la mise-en-scène exacte,"[83] Jarry argued for the elimination of sets and in favor of actors wearing masks, which conveyed "a character's eternal quality."

Lugné-Poe's production of *Ubu roi* involved collaboration with writer, artists, and a musician. Claude Terrasse, Bonnard's brother-in-law, composed music that sounded like the tunes performed at outdoor fairs. Jarry and his friends Lautrec, Ranson, Sérusier, and Vuillard painted a backdrop that seems to have mocked the principle of correspondences so revered in true symbolist productions. To the left it depicted a bed with yellow curtains and a chamber pot next to it; a tree grew out of the bed, and snow fell from a clear sky. In the center there were a pendulum clock (hung from above), a fireplace with a door in it (through

which actors came and went), and an alchemist's crucible. Other elements included a skeleton hanging from a gallows, bats, and a palm tree with a snake wrapped around it. When changing scenery, Jarry announced the new setting with a sign, recalling the practice in Elizabethan theater.[84] He also loosely followed symbolist practices—Ubu, for example, was an abstract, exaggerated character who symbolized injustice and greed. A few actors and actresses who had previously performed at the Théâtre Libre had important roles in Jarry's production: Firmin Gémier appeared as Father Ubu, Louise France as Mother Ubu, and Irma Perrot as King Wenceslas' queen. Jarry had envisioned Ubu being played with marionettes, but performers wore cardboard masks and moved as though they were puppets.

There is nothing mystical about *Ubu roi*. The play is a scatological farce that caricatures royalty and power. The opening word spoken by Ubu was "Merdre" (Jarry added a letter to the word *merde*, but the common translation still applies), and this was enough to ignite the uproar that characterized the rest of the performance. Father Ubu and Mother Ubu decide to assassinate King Wenceslas (for whom Ubu works) and his heirs so that Ubu can take over as king. He and his gang kill all but one of Wenceslas' children, whereupon Ubu crowns himself and begins to murder all of the nobles and judges and to remake the government to suit himself and to benefit him financially. He establishes new taxes, which he eventually collects from the peasants in person, and he massacres anyone who complains that they have already paid. The dialogue is scattered with obscenities, because this is how Ubu and his wife speak.

Jarry's program (pl. 59) is a fairly literal depiction of Ubu, to the right, holding a bag of money and the "pschitt sword" he refers to in the play. The burning house no doubt belongs to a peasant who could not pay his taxes. With its scatological humor and parody of serious traditions (such as symbolism), Jarry's *Ubu roi* was very much in keep-

ing with *fumiste* spirit of humor prevalent in monologues and shadow theater performances in Montmartre cabarets, particularly the Chat Noir.[85] Furthermore, the juxtaposition of incongruous objects on stage and the irreverence that both scandalized and frightened theater-goers made Jarry the idol of the future dadaists and surrealists.

Jarry's collaborative experience with the Nabis and Claude Terrasse contributed to an ongoing exploration of puppet theater by this group. The following year they joined poet Franc-Nohain in organizing a puppet theater, which they would call the Théâtre des Pantins, in Terrasse's apartment on the rue Ballu. Between 1896 and 1898 they put on puppet plays that were attended by an impressive roster of artists and literary figures, including Rachilde and Vallette, Vallotton, and the critics Alphonse Germain and Ferdinand Herold. For the 20 January 1898 performance at the Théâtre des Pantins, which included *Ubu roi*, Jarry designed the program (pl. 60), again depicting the blundering Ubu in an intentially awkward style. Both Bonnard and Vuillard designed stage sets, which were described in *L'Echo de Paris:* "The theater, although small, is charmingly decorated, by Edouard Vuillard in a pyrotechnical range of superb colors and by Bonnard in black and gray silhouettes executed with great virtuosity." The latter seems to have adopted visual effects from the shadow theater at the Chat Noir, as did the directors of the Théâtre d'Art and Théâtre de L'Oeuvre. Bonnard also sculpted the puppets' heads.[86]

In March 1897, after the Théâtre de L'Oeuvre's production of *Ubu roi*, Lugné-Poe staged Gerhart Hauptmann's *La Cloche engloutie* (*The Sunken Bell*), for which Paul Ranson painted the stage decor and designed the program (pl. 61). Ranson's program image—like an ornamental tapestry in the intricacy of its undulating lines and forms—depicts the opening scene of the play.[87] The character Rautendelein, described as an "elfin creature," is seated on the edge of a well, combing her long blond hair. For company she summons up

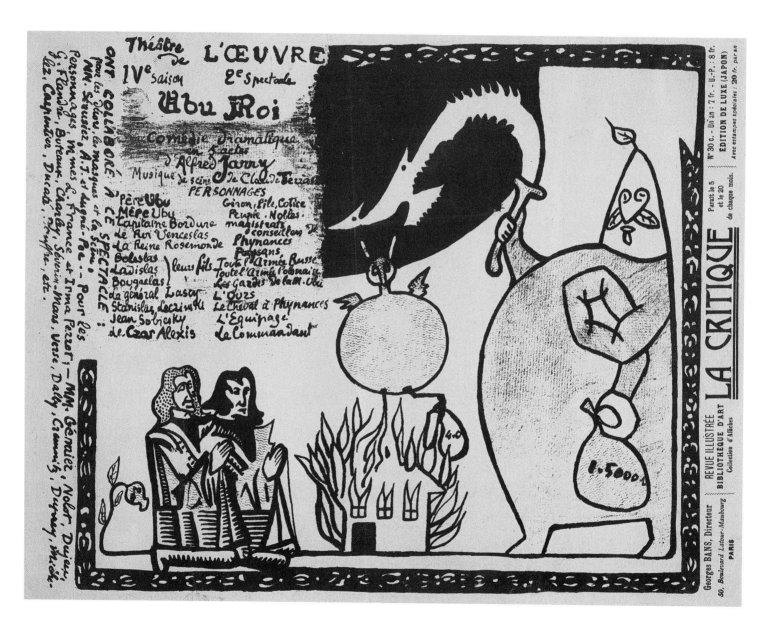

59 Alfred Jarry, *Ubu Roi*, 10 December 1896

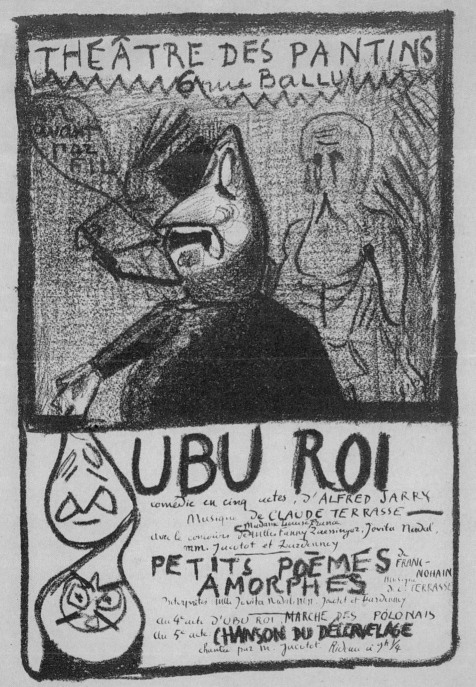

60 Alfred Jarry,
*Ubu Roi; Petits
Poèmes amorphes*,
20 January 1898

61 Paul Ranson,
*La Cloche
engloutie*,
5 March 1897

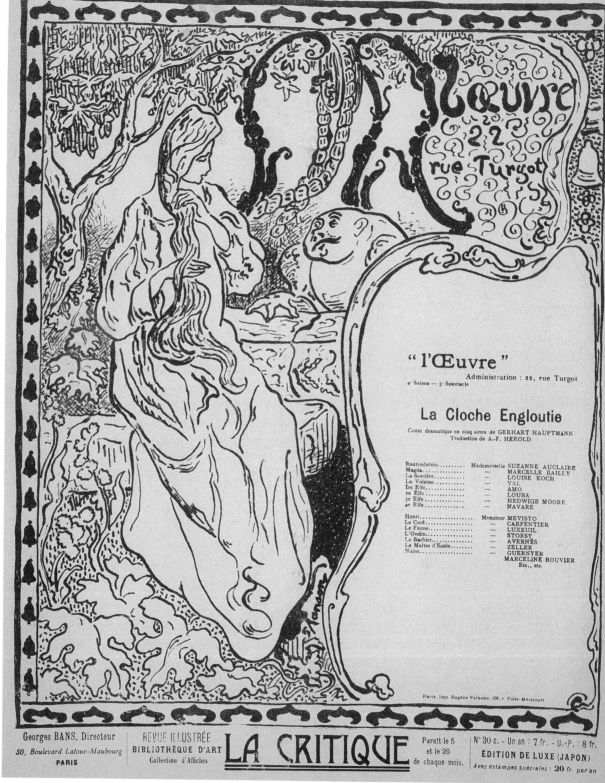

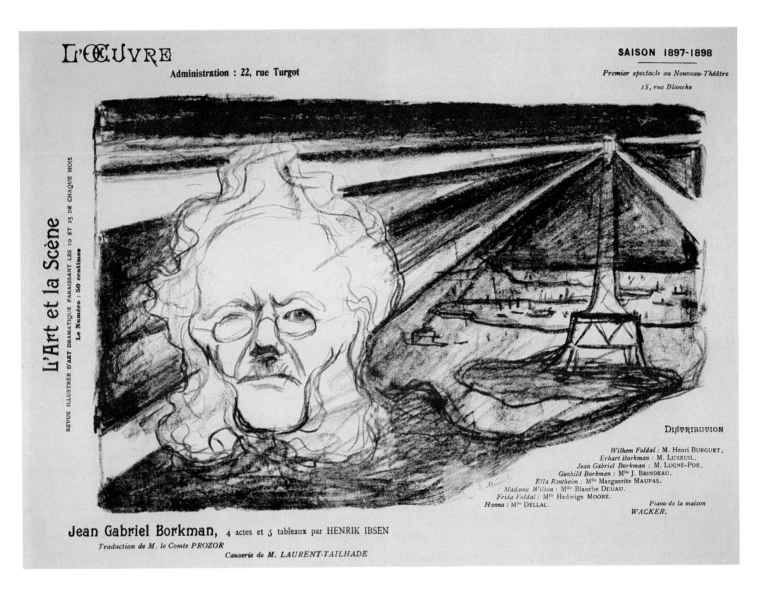

62 Edvard Munch, *Jean-Gabriel Borkman*, 9 November 1897

Nickelmann, "an elemental spirit," who is portrayed here as a frog. The forest creatures, who detest the church bells that disrupt their peace and encroach on their domain, have caused a new bell to come off of its frame and roll down a hill into a lake, where it sinks. In Ranson's image the bell rests inconspicuously at the upper right. Heinrich the bell-maker then leaves his family and the world of humans to live with the beautiful Rautendelein in the forest, newly inspired in his creative endeavors. *La Cloche engloutie* was representative of a new trend in German literature toward themes that reflect the intimate personal life of the writer.[88]

Lugné-Poe's Break with the Symbolists

Lugné-Poe completed the 1896–1897 season with plays by French writers Henry Bataille, Ambroise Herdey, and Tristan Bernard as well as an Ibsen piece, *La Comédie de l'amour (Love's Comedy)*. But the scandalous presentation of *Ubu roi* was the true highlight of the season—and Lugné-Poe's last avant-garde effort. Like André Antoine and Paul Fort, Lugné-Poe had long suffered from a lack of funds, and he reached a point where he wanted to expand his focus beyond symbolist drama and explore new avenues. In the last months of 1896 he had begun to drift away from symbolism, and by spring 1897 he had split with the symbolists, endeavoring to find material of any school or nationality that was fresh and interesting for his theater. Just as the avant-garde period at the Théâtre Libre began to decline when Antoine broadened his already eclectic repertoire to include symbolism, so Lugné-Poe's decline began when he broke with the symbolists. In contrast to Antoine's gradual shift, however, Lugné-Poe's was abrupt. He published an article in June 1897 declaring that the symbolist character of his theater had come about only because the theater had been founded during the heyday of the symbolist movement.

Claiming that the goals of his theater were higher than could be bound by any literary school, he vowed to produce only works that dealt with humanity and life, even if it meant staging only foreign plays.[89] The symbolist literary movement grew increasingly weak after 1897—and Lugné-Poe knew it—but he alienated many of his old supporters among the French avant-garde, including Coolus, Fort, Jarry, Quillard, Rachilde, Régnier, and Saint-Pol-Roux. Unfortunately, no new wave of activity arose to replace symbolism.[90]

For the 1897–1898 season Lugné-Poe emphasized L'Oeuvre's status as an independent theater. The repertoire included Ibsen's *Jean-Gabriel Borkman* in November, with a program by Munch (pl. 62) that featured a portrait of the playwright. Lugné-Poe also produced a Russian play: Nicolai Gogol's *L'Inspecteur Général Revizor*, a satire of the mores of government officials during the reign of Nicholas I. The program was illustrated with a lithograph by Hermann-Paul. The return of *Rosmersholm* in January was paired with *La Gage (The Wager)* by Frantz Jourdain, and Lautrec designed the program (pl. 63), with an image that depicts the principal characters in *La Gage,* a comedy involving adultery and extortion. In February Gustave van Zype's *L'Echelle (The Ladder)* was performed the same evening as Gunnar Heiberg's *Le Balcon (The Balcony)*. Alfredo Muller, an Italian-born artist working in Paris, designed an image for the program depicting a scene from *Le Balcon* (pl. 65). The color lithograph shows the moment when Julie's husband finds her kissing her lover on the balcony. Although the husband Abel is described in the play as being indifferent about his discovery, the moody green tone in Muller's print suggests the emotion of jealousy.[91]

In May Lugné-Poe produced two works by Romain Rolland: *Aërt* and *Morituri*. The latter was retitled *Les Loups (The Wolves)* when it was published that year under the pseudonym "Saint-Juste," referring to a revolutionary who had been put to death alongside Robespierre. Belgian artist

Henri de Groux created similar images for the frontispiece of the book and for the program (fig. 60), which show Death on horseback, dressed as "Commissioner of the Convention," crossing a battlefield littered with cadavers. In the background sky the word "Morituri" is just visible beyond the guillotine and cannon. The play dealt with the condemnation of an innocent man in 1793, but de Groux's image evoked the broader theme of revolutionary massacres.[92]

In May 1899 Lugné-Poe brought back Ibsen's *Un Ennemi du peuple*, with a program designed by Alexandre Steinlen (pl. 66), surprisingly the first one commissioned from this artist who was so closely linked with the Montmartre avant-garde during the 1890s. During the 1899–1900 season L'Oeuvre also presented *Le Cloître (The Cloister)* by Belgian poet Emile Verhaeren, for which the program was designed by another Belgian, the painter Théo van Rysselberghe, who was very much involved in the decorative arts (pl. 67). The image relates to Verhaeren's verse about life in a cloister, derived directly from his own experience during a three-week retreat in a monastery. He first wrote a volume of poetry inspired by his observations and later developed his ideas further in this play. The tragic story is about Dom Balthazar, a respected monk, who had killed his father years earlier and allowed a vagabond to be put to death for it. He hid his crime and entered the monastery, but years later his conscience begins to haunt him and he can find no peace. Since the church maintains a separate exclusive jurisdiction over its own, Balthazar's fellow monks must decide his fate. This play, written in 1899, related to the contemporary Dreyfus Affair, which divided all of France over the guilt or innocence of the Jewish army captain who had been falsely accused and summarily convicted. Verhaeren likens the church's claim to complete control over the handling of legal matters to the similar claim by the military, implying that the church's position is no less harmful to society than the military's.[93] Thus, although by

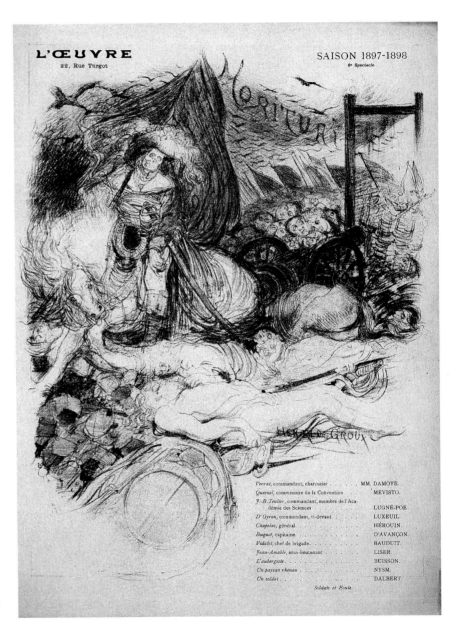

60. Henri de Groux, *Morituri*, 18 May 1898, lithograph in red brown on paper, 38.1 x 28.4 (15 x 11 1/8), National Gallery of Art, Washington, Gift of The Atlas Foundation, 1995.76.18.

63 Henri de Toulouse-
Lautrec, *Rosmersholm*;
Le Gage, 22 January
1898

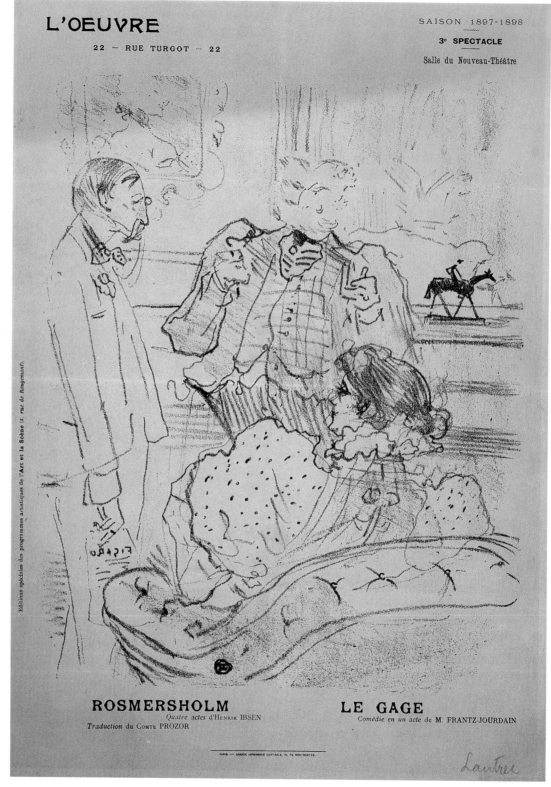

64 Henri de Toulouse-Lautrec, *Rosmersholm*; *Le Gage*, 22 January 1898 (proof before letters)

65 Alfredo Muller,
L'Echelle; Le Balcon,
18 February 1898

L'OEUVRE

RUE TURGOT, 22

SAISON 1897-1898

4ᵉ SPECTACLE

L'ÉCHELLE

Adeline	Mlle Renn
Henriette	Mlle Hedvige More
Sarmol	M. Hardy
Bryois	M. Avernès
Dulac	M. Buisson
Mme Leblanc	Mme Teste
Jeanne	Mlle Radigois
Leblanc	M. Buisson
Edmond Leblanc .	M. Dalbert
Dumont	M. Philipon
Un commis	M. Valin
Trine	Mlle Barbieri
Marie	Mme Teste
Jean	M. Hardy
Reminne	M. Luxeuil

LE BALCON

Julie	Mlle Paule Marsa
Abel	M. Charles Lenormant
Antonio	M. Séverin Mars
Ressmann	M. Philipon
Le Docteur	M. Avernès

Editions spéciales des programmes artistiques de l'Art et la Scène (3, rue de Rougemont).

L'ÉCHELLE
Trois actes de M. Gustave VANZYPE

LE BALCON
Trois actes de M. GUNNAR HEIBERG
(Traduction du Comte PROZOR)

66 Théophile Alexandre Steinlen, *L'Ennemi du peuple*, 18 May 1899

1900 the theater was no longer expressing a particular point of view, Lugné-Poe continued to engage current political and social conflicts, just as he had earlier with dramatic selections that tapped into sensitive anarchist issues.

The avant-garde character of both the Théâtre Libre and the Théâtre de L'Oeuvre, in dramatic terms, was strongest and most productive during the earlier years of each theater, when Antoine and Lugné-Poe each struggled to put forth their passionate views on new directions for drama. For Antoine, this period lasted roughly through 1893 and his major theatrical contribution was to establish naturalism as a style for drama. For Lugné-Poe, his most brilliant period extended through 1896, during which he established symbolism as a style for drama, as opposed to naturalism. While both of these theaters grew less adventurous in dramatic terms, both maintained for some time their important role as patrons for visual artists, commissioning lithographs from leading members of the new school of artists.

The history of these theaters illustrates how a handful of visionaries profoundly influenced a multitude of artists, patrons, and critics. Based in Paris, Antoine, Fort, and Lugné-Poe coordinated the work of authors, publishers, artists, and even musicians from Belgium, China, England, France, Germany, India, Russia, and Scandinavia. Their experiments in the theater brought together a variety of art forms in a single movement—for instance, symbolism in literature, visual art, stage design, and acting style. In this way, the avant-garde theater of the 1880s and 1890s in Paris served as a precursor for those modern movements, such as Dada and expressionism, that would attempt to bring virtually all artistic disciplines under their influence. The theater can be seen as the nexus of the complex and interrelated stream of advances that characterized the fin-de-siècle. And the Atlas Collection provides a remarkable window on the forces that shaped these extraordinary collaborations.

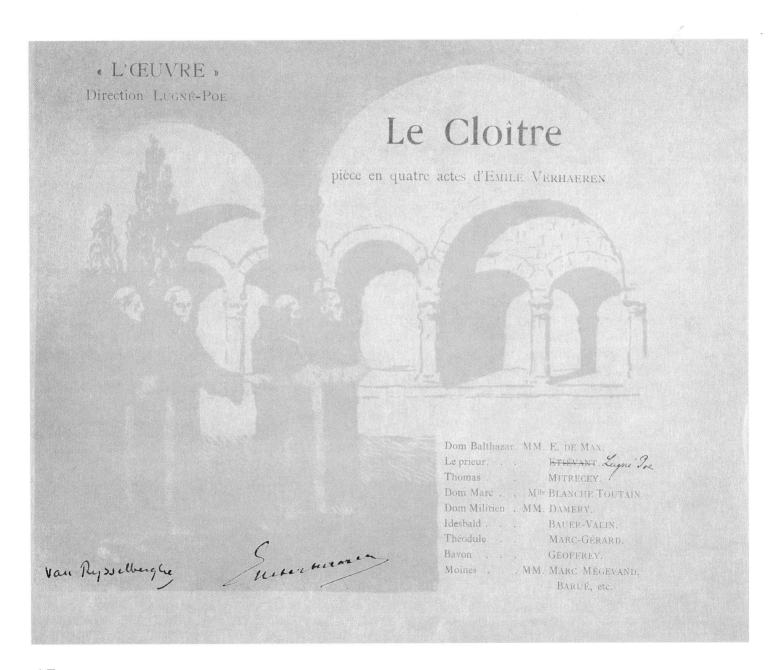

67 Théodore van Rysselberghe, *Le Cloître*, 21 February 1900

NOTES

1. Another former student from the Lycée Condorcet, Alfred Natanson, became treasurer of the Escholiers by October 1887; Alfred's older brother Alexandre was president of the group from March 1887 through 25 February 1889; and a third brother Thadée, also a graduate of the lycée, was involved with the group between October 1889 and July 1891. See Georges Bourdon, *Les Escholiers. Livre d'or* (Paris 1922), cv, and 25–27. Although Lugné-Poe was affiliated with the Escholiers only through 1886, he was given the title "Directeur de la scène" when he returned for a short time in 1892.

2. Deak 1993, 187-188.

3. Henrik Ibsen, *Plays: "Rosmersholm," "The Lady from the Sea," "Little Eyolf,"* vol. 3, trans. and intro. Michael Meyer (London, 1980), 204–205.

4. Camille Mauclair, "Une Première sensationelle," *Le Journal* (17 May 1893), 2.

5. Translated and quoted in Deak 1993, 167 (see 163–167 for a comprehensive discussion of *Pelléas et Mélisande*).

6. Boyer 1988, 53–75. A drawing by Denis for *Pelléas et Mélisande* had been reproduced in Fort's *Livre d'art* for June/July 1892; see Aitken 1991, 56.

7. Letter from Rachilde to Lugné-Poe, 11 February 1893, Bibliothèque de la Société des Auteurs et Compositeurs Dramatiques (SACD), Paris.

8. Aurélien François Lugné-Poe, "Sur Les Soirées de L'Oeuvre," *La Plume* (September 1893), 379–380. Lugné-Poe would have been especially familiar with the theatrical effects produced at the Chat Noir, since he helped Salis at the cabaret from time to time before founding L'Oeuvre; see Lugné-Poe 1930, 213–214.

9. Letter from Camille Mauclair to Vallette, *Mercure de France* (October 1893), 191–192; translation from Deak 1993, 185–186.

10. Francis Jourdain, *Né en '76* (Paris, 1951), 198. Lugné-Poe 1930, 231, says that Vuillard happened upon the word "L'Oeuvre" in a book and proposed it as the name for the theater.

11. "Notes et échos," *L'Art littéraire* (September 1893), 39. Description of set from Deak 1993, 191. Vuillard also apparently learned the technique of painting *à la colle* in the course of painting backdrops for Lugné-Poe's productions at L'Oeuvre. See Geneviève Aitken, *Les Peintres et le théâtre autour de 1900 à Paris* (Paris, 1978), 208.

12. Ibsen 1980, 54.

13. Deak 1993, 206–208.

14. Herman Bang, "Blade I min dagbok," *Bergen Tidene* (18 October 1893), quoted and translated in Frantisek Deak, "Ibsen's Rosmersholm at the Théâtre de L'Oeuvre," *Drama Review* (Spring 1984), 31–32.

15. Telegram from Rachilde and Vallette to Lugné-Poe, 6 October 1893, Bibliothèque de la SACD, Paris.

16. Henrik Ibsen, *Ibsen's Prose Dramas: "An Enemy of the People,"* trans. William Archer, with intro. (London, 1901), xiii.

17. Camille Mauclair, "Le Théâtre," *La Revue encyclopédique* (1 December 1893), 683–686.

18. Robichez 1957, 212.

19. Gerhart Hauptmann, *The Dramatic Works of Gerhart Hauptmann*, ed. Ludwig Lewisohn (New York, 1922), 2:131.

20. Alfred Jarry, "Ames solitaires," *L'Art littéraire* (January-February 1894), 23.

21. Georges Bernier, *La Revue blanche* (Paris, 1991), 79. Bernier does specify the year in which they were married.

22. Raoul Sertat, "Bouffes-du-nord. *Au-dessus des forces humaines,*" *La Revue encyclopédique* (1 March 1894), 67–68.

23. Albert Samain, "Théâtre de L'Oeuvre," *Mercure de France* (April 1894), 361–362.

24. Deak 1993, 206–207.

25. On the Briar Rose Series see, for example, Martin Harrison and Bill Waters, *Burne-Jones* (London, 1979), 100–155. In autumn 1894 Burne-Jones also designed costumes and settings for Comyns Carr's *King Arthur*, produced at London's Lyceum.

26. Rachilde, "Théâtre de L'Oeuvre," *Mercure de France* (July 1894), 281. It is unclear how Lugné-Poe paid for these expensive stage sets.

27. Letter from Rachilde to Lugné-Poe, n.d., Bibliothèque de la SADC, Paris.

28. Quoted in Deak 1994, 225–226. See also Henri Albert, "Théâtre de L'Oeuvre," *Mercure de France* (August 1894), 381.

29. *Vuillard* [exh. cat., Bernheim-Jeune] (Paris, 1953); quoted in George Mauner, *The Nabis: Their History and Their Art, 1888-1896* (New York, 1978), 151–152.

30. Camille Mauclair, *Le Figaro* (24 September 1894); quoted in Deak 1993, 218.

31. Maurice Maeterlinck, "Annabella," *La Revue encyclopédique* (1 December 1894), 518.

32. John Ford, *The Selected Plays of John Ford,* ed. Colin Gibson (Cambridge, 1986), 220.

33. Ford 1986 ed., 127.

34. Catherine Fehrer, *The Julian Academy Paris, 1868–1939* (New York, 1989), n.p. (alphabetical listing of artists and dates of attendance in back of book).

35. Camille Mauclair, "Théâtre," *La Revue encyclopédique* (1 December 1894), 518.

36. Letter from Rachilde to Lugné-Poe, 29 October 1894, Bibliothèque de la SADC, Paris.

37. Maurice Beaubourg, *La Vie muette* (Paris, 1895).

38. August Strindberg, *Strindberg's Letters,* 2 vols., ed. and trans. Michael Robinson (Chicago, 1992), 2:528.

39. Sūdraka, *Mric'Chakatika (The Little Clay Cart),* ed. Arvind Sharma (Albany, 1994). For a discussion of the play see Jasper 1947, 198–205.

40. Camille Mauclair, "Théâtre de L'Oeuvre," *La Revue encyclopédique* (1 February 1895), 42–43.

41. Julia Frey, *Toulouse-Lautrec: A Life* (New York, 1994), 401–402.

42. Mauclair 1895, 43; and Joan Ungersma Halperin, *Félix Fénéon: Aesthete and Anarchist in Fin-de-Siècle Paris* (New Haven, 1988), 303.

43. Jourdain 1951, 204. Jourdain would also design a program for L'Oeuvre for the 9 February 1899 performance of *La Noblesse de la terre (The Nobles of the Earth)* by Maurice de Faramond.

44. Suzanne Després had been acquainted with some of the painters associated with Lugné-Poe, and through them she secured an audition with him. Initially, he told her that she did not have any talent and should give up acting; but she was desperate and he agreed to give her lessons. See Fernand Nozière, "Suzanne Després," *La Revue de L'Oeuvre* (1911–1912), 119–123. She played in many later productions, including Ibsen's *Comédie d'amour; Les Soutiens de la société; Peer Gynt;* and *Solness, le constructeur;* Ambroise Herdey's *Le Fils de l'abess;* and Edmond Sée's *Le Brebis.* When acting alongside Lugné-Poe, she used the pseudonym "Suzanne Auclair."

45. Dom Blasius, "L'Oeuvre—Le Chariot de terre cuite," *Intransigéant* (24 January 1895); clipping from the Collection Rondel, RT 3695, Bibliothèque de L'Arsenal, Paris.

46. Mauclair 1895, 43.

47. Henri de Toulouse-Lautrec, *Unpublished Correspondence of Henri de Toulouse-Lautrec,* ed. Lucien Goldschmidt and Herbert Schimmel (London, 1969), letters 186 and 187.

48. The description of these backdrops comes from Deak 1993. The author incorrectly identified one of the artists as André de Valtal; it was in reality Louis Valtat who collaborated with Lautrec and Albert André. A painted sketch of the backdrop does exist. See Claire Frèches-Thory, "Programme pour *Le Chariot de terre cuite*," in *Toulouse-Lautrec* [exh. cat., Hayward Gallery] (London, 1991), 366, fig. 430.

49. "La soirée Parisienne: *Le Chariot de terre cuite*," *Le Gaulois* (23 January 1895); clipping from the Collection Rondel, RT 3695, Bibliothèque de L'Arsenal, Paris.

50. The program has been attributed to Ranson, Auriol, and "artist unknown"; see Aitken 1991, 72. I propose that Albert André created the program based on the following: 1) he painted a backdrop for *Le Chariot de terre cuite,* the Hindu drama that preceded *L'Anneau de Çakuntala* in 1894, and therefore his involvement with the following Hindu drama could be considered logical; 2) at this time he was a close associate of the Nabis and the *Revue blanche* circle, including Félix Fénéon; 3) a vignette by him, published in *La Revue blanche* (1 July 1896), is signed with the same monogram as the program for *L'Anneau de Çakuntala:* an encircled lower-case "a".

51. See, for example, *Conversation sur la terrasse* (Josefowitz Collection) and *La Terrasse aux Tuileries* (Musée d'Orsay, Paris); reproduced in *Nabis 1888–1900* [exh. cat., Kunsthaus] (Zurich, 1993), 226–227.

52. Jasper 1947, 254.

53. Elizabeth Prelinger, "Pierre Roche and the 'belle gypsographie,'" *Print Quarterly* 10 (1993), 151.

54. On *L'Epreuve* and Dumont's other ventures see Jean-Pierre Seguin, Anne Bonafous-Murat, and Arsène Bonafous-Murat, *Maurice Dumont, 1869–1899. Peintre-graveur, illustrateur, poète et éditeur de L'Epreuve* [exh. cat., Bibliothèque Historique de la Ville de Paris] (Paris, 1991), 17–22 (and 38–39 for prints in *L'Epreuve* that relate to the theater).

55. Henrik Ibsen, *Plays: "Brand," "Emperor," and "Galilean,"* vol. 5, trans. Michael Meyer, with intro. (London, 1986), 112.

56. *La Revue de L'Oeuvre* (1911), 86.

57. She was described as a small, nervous woman with heavy black hair—"the electric prune"—and she was particularly appreciated for her ability to be "picturesque." Robichez 1957, 55.

58. Catherine Krahmer, "PAN and Toulouse-Lautrec," *Print Quarterly* 10 (December 1993), 392–397.

59. Aitken 1991, 70.

60. Thomas Otway, *Venice Preserved*, ed. Malcolm Kelsall (Lincoln, NB, 1969), line 195.

61. Information on the content of the play comes from Aitken 1991, 72; Camille Mauclair, "Théâtre de L'Oeuvre," *La Revue encyclopédique*, no. 122 (1896), 39–40; and Robichez 1957, 524.

62. Frey 1994, 356.

63. For an in-depth study of Bing's enterprise see Gabriel Weisberg, *Art Nouveau Bing: Paris Style 1900* (New York, 1986).

64. Richard Ellmann, *Oscar Wilde* (New York, 1988), 444; see also Frey 1994, 383.

65. Knowles 1934, 142.

66. Letter from Oscar Wilde to Robert Ross, in *The Letters of Oscar Wilde*, ed. Rupert Hart-Davis (New York, 1962), 399; 419–20.

67. Jasper 1947, 209.

68. Synopsis is from Robichez 1957, 525–526.

69. Synopsis is from Robichez 1957, 526–527.

70. M. Geat, "Rachilde e il teatro 'simbolista:' Per una poetica dell'irrappresentabilità," *Micromégas* (March–April 1986), 38–39. For a contemporary description of the content and staging of these three plays, see Henry de Gorsse, "Théâtre de L'Oeuvre," *La Patrie* (22 April 1896); clipping from the Collection Rondel, Bibliothèque de L'Arsenal, Paris.

71. Hermann-Paul illustrated Laurent Tailhade's invective verse in *Au Pays du mufle (In the Land of Mugs)* in 1894, for instance. For a brief discussion of the nature of Hermann-Paul's satire and the scope of his work see Boyer in Cate 1988, 136–144.

72. Anonymous, "Théâtre de L'Oeuvre," *New York Herald*, 30 May 1896; clipping from the Collection Rondel, Bibliothèque de L'Arsenal, Paris.

73. Ibsen's description of the first act reads: "A spacious garden room in Karsten Bernick's house. Downstage left, a door leading to Bernick's room; upstage in the same wall is a similar door. In the center of the opposite wall is a large entrance door. The rear wall is composed almost entirely of fine, clear glass, with an open door giving on to a broad verandah....Steps lead down from the verandah into the garden, part of which can be seen, enclosed by a fence with a small gate. Beyond the fence is a street." See Henrik Ibsen, *Plays: "The Pillars of Society," "John Gabriel Borkman," and "When We Dead Awaken,"* vol. 4, trans. Michael Meyer, with intro. (London, 1991), 23.

74. Lugné-Poe, *La Parade II. Acrobaties* (Paris, 1931), 170.

75. Lugné-Poe 1931, 173.

76. Henrik Ibsen, *Plays: "Peer Gynt," and "The Pretenders,"* vol. 6, ed. and trans. Michael Meyer (London, 1987), 56.

77. Robichez 1957, 269–271.

78. Geneviève Aitken, "Edvard Munch et la scène française," in *Munch et la France* [exh. cat., Musée d'Orsay] (Paris, 1992), 233.

79. Carla Lathe, *Edvard Munch and His Literary Associates* [exh. cat., Hatton Gallery] (Newcastle-upon-Tyne, 1979), 32.

80. Much has been written about Vuillard's influence on Munch; see, for example, Gerhard Gerkens, "Munch und Vuillard," in *Edvard Munch. Probleme, Forschungen, Thesen* (Munich, 1992), 133–146. Munch seems to have turned to the images created for the theater as a general source of inspiration as well; see Aitken 1992, 222–239.

81. Lathe 1979, 32–39. On Munch in Paris see also Bente Torjusen, "The Mirror," in *Edvard Munch: Symbols and Images* [exh. cat., National Gallery of Art] (Washington, 1978), 194–197.

82. Letter from Rachilde to Lugné-Poe, 11 November 1896, Bibliothèque de la SACD, Paris.

83. Alfred Jarry, "De L'Inutilité du théâtre au théâtre," *Mercure de France* (September 1896), 467-473.

84. Excellent studies of *Ubu roi* may be found in Roger Shattuck, *The Banquet Years: The Origins of the Avant-Garde in France, 1885 to World War I* (Salem, NH, 1968),

203–211; and Deak 1993, 227–246 (231 for description of backdrop).

85. Mary Shaw, "All or Nothing? The Literature of Montmartre," in exh. cat. New Brunswick 1996, 147–148.

86. La Cagoule, "Théâtre des Pantins," *L'Echo de Paris* (1 April 1898), 1. These were not the Nabis' first ventures in puppet theater. They had collaborated in creating puppet plays at Ranson's home since the formation of their group. In addition, beginning in 1892 they met on the first Sunday of each month in the home of the Coulon family and presented plays in the children's puppet theater. In March 1892, at the same time they were contributing to Paul Fort's Théâtre d'Art, Denis, Ranson, Sérusier, Verkade, and Vuillard presented *La Farce du Pâté* and Maeterlinck's symbolist drama written expressly for marionettes, *Les Sept Princesses*. They designed backdrops, costumes, and a program for each.

87. See A-Ferdinand Herold, "Théâtre de L'Oeuvre—*La Cloche engloutie*," *Mercure de France* (April 1897), 176–179.

88. On *The Sunken Bell* as a reflection of Hauptmann's personal difficulties see Warren R. Maurer, *Understanding Gerhart Hauptmann* (Columbia, SC, 1992), 74.

89. Jasper 1947, 257–267.

90. Jasper 1947, 267.

91. For a synopsis of the play see Robichez 1957, 539.

92. Aitken 1991, 87.

93. Osman Edwards, intro. to Emile Verhaeren, *The Cloister* (Boston, 1916), v–viii.

(Programs are grouped by theater and listed chronologically by performance date; those included in the exhibition are marked with an asterisk, and a plate number is given following the artist's name and life dates. A figure number is given for works illustrated in the catalogue but not included in the exhibition. If known, technicians involved with photomechanical reproduction are listed in parentheses following this technical designation. Catalogue raisonné numbers are given when they exist.)

THÉÂTRE LIBRE

*1. Willette, Adolphe Léon (French, 1857–1926) [pl. 1]
Chevalerie rustique (Rustic Chivalry) by Giovanni Verga; *L'Amant du Christ (Christ's Lover)* by Rodolphe Darzens; *Marié (Married)* by Georges Porto-Riche; *Les Bouchers (The Butchers)* by Fernand Icres
19 October 1888
color lithograph on wove paper
sheet: 23.9 x 32.1 (9 3/8 x 12 5/8)
Gift of The Atlas Foundation, 1995.76.112

2. Willette, Adolphe Léon (French, 1857–1926)
Rolande by Louise de Gramont
5 November 1888
lithograph on wove paper
sheet (program opened): 24.0 x 32.1
(9 3/8 x 12 5/8)
Gift of The Atlas Foundation, 1995.76.124

*3. Signac, Paul (French, 1863–1935) [pl. 2]
La Chance de Françoise (Françoise's Luck) by Georges Porto-Riche; *La Mort du duc d'Enghien (The Death of the Duke of Enghien)* by Léon Hennique; *Le Cor fleuri (The Flowered Horn)* by Ephraim Mikhaël
10 December 1888
color lithograph on card
sheet: 16.0 x 18.5 (6 1/4 x 7 1/4)
Kornfeld/Wick 1974, 4
Gift of The Atlas Foundation, 1995.76.72

4. Signac, Paul (French, 1863–1935)
La Reine Fiammette (Queen Fiametta) by Catulle Mendès
15 January 1889
color lithograph on card
sheet: 16.2 x 18.5 (6 3/8 x 7 1/4)
Kornfeld/Wick 1974, 4
Gift of The Atlas Foundation, 1995.76.73

5. Signac, Paul (French, 1863–1935)
Les Résignés (The Resigned) by Henri Céard; *L'Échéance (The Day of Reckoning)* by Jean Jullien
31 January 1889
color lithograph on card
sheet: 16.0 x 18.6 (6 1/4 x 7 3/8)
Kornfeld/Wick 1974, 4
Gift of The Atlas Foundation, 1995.76.74

*6. Raffaëlli, Jean-François (French, 1850–1924) [pl. 3]
La Patrie en danger (The Nation in Danger) by Edmond and Jules de Goncourt
19 March 1889
collotype on wove paper
sheet (program opened): 23.5 x 32.9 (9 1/4 x 13)
Gift of The Atlas Foundation, 1995.76.60 and 1995.76.128

7. Maurer, K. (French, active 1890s), after G. Clausse
Gringoire by Théodore de Banville
28 May 1889
lithograph on wove paper
sheet: 18.9 x 12.1 (7 3/8 x 4 3/4)
Gift of The Atlas Foundation, 1995.76.52

8. Charpentier, Alexandre (French, 1856–1909)
Le Père Lebonnard (Father Lebonnard) and *Dans Le Guignol (In the Puppet Show)*, both by Jean Aicard
21 October 1889
embossing on wove paper
sheet: 24.0 x 18.6 (9 7/6 x 7 3/8)
Gift of The Atlas Foundation, 1995.76.129

*9. Charpentier, Alexandre (French, 1856–1909) [pl. 4]
L'École des veufs (School for Widowers) by Georges Ancey; *Au Temps de la ballade (In the Time of Ballads)* by Georges Bois
27 November 1889
embossing on wove paper
sheet: 24.2 x 18.6 (9 1/2 x 7 3/8)
Gift of The Atlas Foundation, 1995.76.13

Detail of pl. 5.

*10. Bonnard, Pierre (French, 1867–1947) [pl. 8]
Program Design for the Théâtre Libre
1890
pen and black ink with watercolor over graphite on
wove paper
inscribed "à mon bon camarade Lugné, P. Bonnard"
sheet: 31.4 x 20.0 (12 $^3/_8$ x 7 $^7/_8$)
Gift of The Atlas Foundation, 1995.76.1

11. Rivière, Henri (French, 1864–1951)
Le Pain d'autrui (The Bread of Others) by Ivan
Turgenev; *En Détresse (In Distress)* by Armand
Ephraim, Henry Fèvre, and Willy Schute
10 January 1890
color lithograph on wove paper
image: 20.1 x 29.7 (7 $^7/_8$ x 11 $^5/_8$);
sheet: 21.7 x 31.1 (8 $^1/_2$ x 12 $^1/_4$)
Gift of The Atlas Foundation, 1995.76.130

12. Rivière, Henri (French, 1864–1951)
Les Frères Zemganno (The Brothers Zemganno) by
Paul Alexis and Oscar Méténier; *Deux Tourtereaux
(Two Turtle Doves)* by Paul Ginisty and Jules Guérin
25 February 1890
color lithograph on wove paper
image: 20.1 x 29.7 (7 $^7/_8$ x 11 $^5/_8$);
sheet: 21.4 x 30.9 (8 $^3/_8$ x 12 $^1/_8$)
Gift of The Atlas Foundation, 1995.76.131

*13. Auriol, George (French, 1863–1938) [pl. 6]
Ménages d'artistes (Artists' Households) by Eugène
Brieux; *Le Maître (The Master)* by Jean Jullien
21 March 1890
color lithograph on wove paper
image: 21.7 x 31.1 (8 $^1/_2$ x 12 $^1/_4$);
sheet: 22.8 x 32.0 (9 x 12 $^5/_8$)
Gift of The Atlas Foundation, 1995.76.7

14. Auriol, George (French, 1863–1938)
Jacques Bouchard by Pierre Wolff; *Une Nouvelle
École (A New School)* by Louis Mullem; *La Tante
Léontine (Aunt Leontine)* by Maurice Boniface and
Edouard Bodin
2 May 1890
color lithograph on wove paper
image: 21.7 x 31.1 (8 $^1/_2$ x 12 $^1/_4$);
sheet: 28.8 x 32.0 (9 x 12 $^5/_8$)
Gift of The Atlas Foundation, 1995.76.132

*15. Rivière, Henri (French, 1864–1951) [pl. 5]
Les Revenants (Ghosts) by Henrik Ibsen; *La Pêche
(Fishing)* by Henri Céard
30 May 1890
color lithograph on wove paper
image: 20.1 x 29.7 (7 $^7/_8$ x 11 $^5/_8$); sheet:
21.7 x 31.1 (8 $^1/_2$ x 12 $^1/_4$)
Gift of The Atlas Foundation, 1995.76.62

16. Auriol, George (French, 1863–1938)
Myrane by Emile Bergerat; *Les Chapons (The
Capons)* by Lucien Descaves and Georges Darien
color lithograph on wove paper
13 June 1890
image: 21.7 x 31.1 (8 $^1/_2$ x 12 $^1/_4$);
sheet: 28.8 x 32.0 (9 x 12 $^5/_8$)
Gift of The Atlas Foundation, 1995.76.133

17. Schwabe, Carlos (French, 1866–1926) [fig. 10]
L'Honneur (The Honor) by Henry Fèvre
22 October 1890
photorelief with watercolor stenciling (*pochoir*)
(Motteroz) on wove paper (recto); photomechani-
cal reproduction (Florian) of drawing by Jean-Louis
Forain (verso); photomechanical reproduction of
a portrait of F. Sarcey by Paul Renouard in *Revue
illustré* (inside)
sheet (program opened): 21.0 x 31.6 (8 $^1/_4$ x 12 $^3/_8$)
Gift of The Atlas Foundation, 1995.76.134 and
1995.76.135

*18. Vuillard, Edouard (French, 1868–1940) [pl. 7]
Monsieur Bute by Maurice Biollay; *L'Amant de sa
femme (His Wife's Lover)* by Aurélien Scholl; *La
Belle Opération (The Fine Operation)* by Jean
Serment
26 November 1890
photorelief with watercolor stenciling (*pochoir*) on
wove paper, with publicity for *Le Théâtre Libre illus-
tré* and *L'Echo de la semaine*
sheet (program opened): 21.5 x 39.6 (8 $^1/_2$ x 15 $^5/_8$)
Gift of The Atlas Foundation, 1995.76.102 and
1995.76.136

19. Chéret, Jules (French, 1836–1932) [fig. 25]
 La Fille Élisa (Elisa the Whore) by Jean Ajalbert
 (after Edmond de Goncourt); *Conte de Noël*
 (Christmas Story) by Louis Linert
 26 December 1890
 lithograph in light brown and red brown on
 wove paper
 sheet (program opened): 26.2 x 34.1
 (10 $^1/_4$ x 13 $^3/_8$)
 Gift of The Atlas Foundation, 1995.76.17

20. Brown, John Lewis (French, 1829–1890)
 La Meule (The Haystack) by Georges Lecomte;
 Jeune premier! (Leading Man!) by Paul Ginisty,
 21 February 1891
 photomechanical reproduction (Charles Decaux)
 on wove paper of a drawing of French cavalry
 officers in *L'Art des deux mondes* (recto); and "La
 Marchande d'oranges"; photomechanical reproduc-
 tion in red (Charles Decaux) of a drawing by
 Auguste Renoir; photomechanical reproduction in
 red of a lithograph depicting people being ground
 between millstones by Maximilien Luce
 sheet (program opened): 25.5 x 40.4 (10 x 15 $^7/_8$)
 Gift of The Atlas Foundation, 1995.76.51.a and b

21. Bac, Ferdinand (French, 1859–1952)
 Le Canard sauvage (The Wild Duck) by Henrik
 Ibsen
 27 April 1891
 photorelief reproduction of a drawing (Rougeron-
 Vignerot) with advertisement for *La Vie parisienne*
 sheet: 23.6 x 15.6 (9 $^1/_4$ x 6 $^1/_8$)
 Gift of The Atlas Foundation, 1995.76.114 and
 1995.76.137

*22. Charpentier, Alexandre (French, 1856–1909) [pl. 9]
 Nell Horn by Léon de Rosny
 25 May 1891
 color lithograph with embossing on wove paper
 sheet: 24.0 x 18.6 (9 $^3/_8$ x 7 $^3/_8$)
 Gift of The Atlas Foundation, 1995.76.15,
 1995.76.16, and 1995.76.138

*23. Rivière, Henri (French, 1864–1951) [pl. 11]
 Leurs Filles (Their Daughters) by Pierre Wolff; *Les
 Fourches caudines (The Caudine Forks)* by Maurice
 Le Corbeiller; *Lidoire* by Georges Courteline
 8 June 1891
 color lithograph on wove paper
 image: 16.5 x 20.6 (6 $^1/_2$ x 8 $^1/_8$);
 sheet: 18.1 x 22.4 (7 $^1/_8$ x 8 $^7/_8$)
 Gift of The Atlas Foundation, 1995.76.63

24. Forain, Jean-Louis (French, 1852–1931)
 Coeurs simples (Simple Hearts) by Sutter Laumann;
 Le Pendu (The Hanged) by Eugène Bourgeois; *Dans
 Le Rêve (In the Dream)* by Louis Mullem
 6 July 1891
 16-page program with 9 photomechanical
 illustrations published by *Le Courrier français*.
 Additional illustrations by Adolphe Léon Willette,
 Oswald Heidbrinck, and Jules Chéret
 sheet (program opened): 28.2 x 45.0
 (11 $^1/_8$ x 17 $^3/_4$); page size (program closed):
 28.2 x 22.4 (11 $^1/_8$ x 8 $^7/_8$)
 Gift of The Atlas Foundation, 1995.76.140

25. Willette, Adolphe Léon (French, 1857–1926)
 La Rançon (The Ransom) by Gaston Salandri;
 L'Abbé Pierre (Father Pierre) by Marcel Prévost;
 Un Beau Soir (One Fine Evening) by Maurice
 Vaucaire
 30 November 1891
 8-page program with 5 photomechanical
 illustrations published by *Le Courrier
 français*; additional illustrations by Jean-Louis
 Forain, Oswald Heidbrinck, and Jules Chéret
 sheet (program opened): 28.0 x 42.7 (11 x 17 $^3/_4$);
 page size (program closed): 28.0 x 22.1 (11 x 8 $^5/_8$)
 Gift of The Atlas Foundation, 1995.76.141

*26. Charpentier, Alexandre (French, 1856–1909) [pl. 10]
 La Dupe (The Dupe) by Georges Ancey; *Son petit
 coeur (The Little Heart)* by Louis Marsolleau
 21 December 1891
 embossing on wove paper
 sheet: 19.8 x 14.7 (7 $^3/_4$ x 5 $^3/_4$)
 Gift of The Atlas Foundation, 1995.76.14

27.　Forain, Jean-Louis (French, 1852–1931)
L'Étoile rouge (The Red Star) by Henry Fèvre; *Seul (Alone)* by Albert Guïnon
7 March 1892
8-page program with 4 photomechanical illustrations published by *Le Courrier français*; additional illustrations by Adolphe Léon Willette, Oswald Heidbrinck, and Louis-Auguste-Matheieu Legrand
sheet (program opened): 28.0 x 44.3 (11 x 7 ³/₈); page size (program closed): 28.0 x 22.4 (11 x 8 ⁷/₈)
Gift of The Atlas Foundation, 1995.76.139

28.　Willette, Adolphe Léon (French, 1857–1926)
Simone by Louis de Gramont; *Les Maris de leurs filles (Their Daughters' Husbands)* by Pierre Wolff
29 April 1892
8-page program with 4 photomechanical illustrations (Charles Decaux) published by *Le Courrier français*; additional illustrations by Oswald Heidbrinck and after Jules Chéret
sheet (program opened): 28.2 x 44.7 (11 ¹/₈ x 17 ⁵/₈); page size (program closed): 28.2 x 22.4 (11 ¹/₈ x 8 ⁷/₈)
Gift of The Atlas Foundation, 1995.76.142

29.　Willette, Adolphe Léon (French, 1857–1926)
Péché d'amour (Love's Sin) by Michel Carré *fils* and Georges Louiseau; *Les Fenêtres (The Windows)* by Jules Perrin and Claude Couturier; *Mélie* by Georges Docquois
27 June 1892
8-page program with 4 photomechanical illustrations published by *Le Courrier français*; additional illustrations by Jean-Louis Forain, Henri-Gabriel Ibels, and Oswald Heidbrinck
sheet (program opened): 28.0 x 44.6 (11 x 17 ¹/₂); page size (program closed): 28.0 x 22.4 (11 x 8 ⁷/₈)
Gift of The Atlas Foundation, 1995.76.143

*30.　Ibels, Henri-Gabriel (French, 1867–1936) [pl. 12]
Le Grappin (The Grapnel) by Georges Salandri; *L'Affranchie (The Emancipated)* by Maurice Biollay
3 November 1892
color lithograph on wove paper
sheet: 23.9 x 32.3 (9 ³/₈ x 12 ³/₄)
Gift of The Atlas Foundation, 1995.76.38

*31.　Ibels, Henri-Gabriel (French, 1867–1936) [pl. 13]
Le Grappin (The Grapnel) by Georges Salandri; *L'Affranchie (The Emancipated)* by Maurice Biollay
3 November 1892
color lithograph on laid paper (proof before letters)
image: 22.7 x 31.0 (8 ⁷/₈ x 12 ¹/₄); sheet: 28.8 x 40.4 (11 ³/₈ x 15 ⁷/₈)
Gift of The Atlas Foundation, 1995.76.39

*32.　Ibels, Henri-Gabriel (French, 1867–1936) [pl. 14]
Les Fossiles (The Fossils) by François de Curel
29 November 1892
color lithograph on wove paper
sheet: 23.9 x 32.0 (9 ³/₈ x 12 ⁵/₈)
Gift of The Atlas Foundation, 1995.76.40

*33.　Ibels, Henri-Gabriel (French, 1867–1936) [pl. 15]
A Bas Le Progrès! (Down with Progress!) by Edmond de Goncourt; *Mademoiselle Julie* by Auguste Strindberg; *Le Ménage Brésile (The Brazilian Household)* by Romain Coolus
16 January 1893
color lithograph on wove paper
sheet: 24.1 x 31.9 (9 ¹/₂ x 12 ¹/₂)
Gift of The Atlas Foundation, 1995.76.30

*34.　Ibels, Henri-Gabriel (French, 1867–1936) [pl. 16]
A Bas Le Progrès! (Down with Progress!) by Edmond de Goncourt; *Mademoiselle Julie* by Auguste Strindberg; *Le Ménage Brésile (The Brazilian Household)* by Romain Coolus
16 January 1893
color lithograph on laid paper (proof before letters)
sheet: 29.0 x 40.2 (11 ³/₈ x 15 ⁷/₈)
Gift of The Atlas Foundation, 1995.76.31

*35.　Ibels, Henri-Gabriel (French, 1867–1936) [pl. 17]
Le Devoir (The Duty) by L. Bruyerre
15 February 1893
color lithograph on wove paper
sheet: 23.8 x 31.8 (9 ³/₈ x 12 ¹/₂)
Gift of The Atlas Foundation, 1995.76.36

36.　Ibels, Henri-Gabriel (French, 1867–1936)
Le Devoir (The Duty) by L. Bruyerre
15 February 1893
color lithograph on laid paper (proof before letters)
sheet: 29.2 x 40.1 (11 ¹/₂ x 15 ³/₄)
Gift of The Atlas Foundation, 1995.76.37

*37. Ibels, Henri-Gabriel (French, 1867–1936) [pl. 18]
Mirages by Georges Lecomte
27 March 1893
color lithograph on wove paper
sheet: 23.9 x 31.3 (9 3/8 x 12 3/8)
Gift of The Atlas Foundation, 1995.76.44

*38. Ibels, Henri-Gabriel (French, 1867–1936) [pl. 19]
Mirages by Georges Lecomte
27 March 1893
color lithograph on laid paper (proof before letters)
sheet: 29.2 x 40.6 (11 1/2 x 16)
Gift of The Atlas Foundation, 1995.76.45

*39. Ibels, Henri-Gabriel (French, 1867–1936) [pl. 20]
Boubouroche by Georges Courteline; *Valet de coeur
(Jack of Hearts)* by Maurice Vaucaire
27 April 1893
color lithograph on wove paper
sheet: 24.0 x 31.7 (9 3/8 x 12 1/2)
Gift of The Atlas Foundation, 1995.76.32

*40. Ibels, Henri-Gabriel (French, 1867–1936) [pl. 21]
Boubouroche by Georges Courteline; *Valet de coeur
(Jack of Hearts)* by Maurice Vaucaire
27 April 1893
color lithograph on laid paper (proof before letters)
sheet: 28.9 x 40.5 (11 3/8 x 16)
Gift of The Atlas Foundation, 1995.76.33

*41. Ibels, Henri-Gabriel (French, 1867–1936) [pl. 22]
Les Tisserands (The Weavers) by Gerhart
Hauptmann
29 May 1893
color lithograph on wove paper
sheet: 23.8 x 31.6 (9 3/8 x 12 3/8)
Gift of The Atlas Foundation, 1995.76.41

*42. Ibels, Henri-Gabriel (French, 1867–1936) [pl. 23]
La Belle au bois rêvant (Dreaming Beauty) by
Fernand Mazade; *Mariage d'argent (Moneyed
Marriage)* by Eugène Bourgeois; *Ahasvère
(Ahasuerus)* by H. Heyermans
12 June 1893
color lithograph on wove paper
sheet: 23.7 x 31.7 (9 1/4 x 12 1/2)
Gift of The Atlas Foundation, 1995.76.35

*43. Toulouse-Lautrec, Henri de (French, 1864–1901)
[pl. 24]
Une Faillite (A Bankruptcy) by Björnstjerne
Björnson; *Le Poète et le financier (The Poet and the
Financier)* by Maurice Vaucaire
8 November 1893
color lithograph on wove paper
sheet: 32.2 x 24.0 (12 5/8 x 9 3/8)
Delteil, 14 ii/ii
Gift of The Atlas Foundation, 1995.76.83

*44. Sérusier, Paul (French, 1863–1927) [pl. 25]
*L'Assomption de Hannele Mattern (The Assumption
of Hannele Mattern)* by Gerhart Hauptmann;
En l'attendant (Waiting for Him) by L. Roux
1 February 1894
color lithograph on wove paper
sheet: 31.6 x 23.6 (12 3/8 x 9 1/4)
Gift of The Atlas Foundation, 1995.76.71 and
1995.76.70

45. Forain, Jean-Louis (French, 1852–1931)
Une Journée parlementaire (A Day in Parliament) by
Maurice Barrès
23 February 1894
photolithograph on wove paper
sheet: 29.8 x 22.7 (11 3/4 x 8 7/8)
Gift of The Atlas Foundation, 1995.76.25

*46. Toulouse-Lautrec, Henri de (French, 1864–1901)
[pl. 26]
Le Missionnaire (The Missionary) by Marcel Luguet
25 April 1894
color lithograph on wove paper
sheet: 30.7 x 24.0 (12 1/8 x 9 3/8)
Delteil, 16 ii/ii
Gift of The Atlas Foundation, 1995.76.80

47. Lambert, Maurice de (French, born 1873)
Elën by Villiers de L'Isle Adam
14 February 1895
photorelief on wove paper
sheet: 39.1 x 30.5 (15 3/8 x 12)
Gift of The Atlas Foundation, 1995.76.19

*48. Toulouse-Lautrec, Henri de (French, 1864–1901)
[pl. 27]
L'Argent (Money) by Emile Fabre
5 May 1895
color lithograph on wove paper
sheet: 31.9 x 23.9 (12 $\frac{1}{2}$ x 9 $\frac{3}{8}$)
Delteil, 15 ii/ii
Gift of The Atlas Foundation, 1995.76.79

49. Ibels, Henri-Gabriel (French, 1867–1936)
Grand-Papa by Claude Berton; *Si c'était (If It Were)*
by Paul Lheureux
13 June 1895
lithograph on wove paper
sheet: 24.4 x 31.9 (9 $\frac{5}{8}$ x 12 $\frac{1}{2}$)
Gift of The Atlas Foundation, 1995.76.34

*50. Abel-Truchet (French, 1857–1919) [pl. 28]
La Fumée, puis la flamme (First Smoke, Then Fire) by
Joseph Caraguel
24 October 1895
color lithograph on wove paper
sheet: 24.1 x 30.9 (9 $\frac{1}{2}$ x 12 $\frac{1}{8}$)
Gift of The Atlas Foundation, 1995.76.90

*51. Vibert, Pierre Eugène (Swiss, 1875–1937) [pl. 29]
Le Cuivre (Copper) by Paul Adam and André Picard
16 December 1895
lithograph on wove paper
sheet: 24.7 x 32.2 (9 $\frac{3}{4}$ x 12 $\frac{5}{8}$)
Gift of The Atlas Foundation, 1995.76.96 and
1995.76.97

*52. Synave, Tancrède (French, born 1860) [pl. 30]
L'Ame invisible (Invisible Soul) by Claude Berton;
Mademoiselle Fifi by Oscar Méténier, taken from a
novel by Guy de Maupassant
10 February 1896
color lithograph on wove paper
sheet: 32.1 x 48.8 (12 $\frac{5}{8}$ x 19 $\frac{1}{4}$)
Gift of The Atlas Foundation, 1995.76.76

*53. Osbert, Alphonse (French, 1857–1939) [pl. 31]
Inceste d'âmes (Incestuous Souls) by Jean Laurenty
and Fernand Hauser; *Mineur et soldat (Miner and
Soldier)* by Jean Malafäyde
16 March 1896
color lithograph on wove paper
sheet: 31.1 x 48.5 (12 $\frac{1}{4}$ x 19 $\frac{1}{8}$)
Gift of The Atlas Foundation, 1995.76.57

*54. Osbert, Alphonse (French, 1857–1939) [pl. 32]
Inceste d'âmes (Incestuous Souls) by Jean Laurenty
and Fernand Hauser; *Mineur et soldat (Miner and
Soldier)* by Jean Malafäyde
16 March 1896
color lithograph on wove paper
sheet: 31.8 x 48.7 (12 $\frac{1}{2}$ x 19 $\frac{1}{8}$)
Gift of The Atlas Foundation, 1995.76.58

55. Anquetin, Louis (French, 1861–1932)
La Fille d'Artaban (The Daughter of Artaban) by
Alfred Mortier; *La Nébuleuse (The Nebula)* by Louis
Dumur; *Dialogue inconnu (Unknown Dialogue)* by
Alfred de Vigny
27 April 1896
lithograph on wove paper
sheet: 32.0 x 24.8 (12 $\frac{5}{8}$ x 9 $\frac{3}{4}$)
Gift of The Atlas Foundation, 1995.76.4

Materials Related to the Théâtre Libre

56. Ibels, Henri-Gabriel (French, 1867–1936)
A Bas Le Progrès! (Down with Progress!) by Edmond
de Goncourt
25 April 1984
performance given at the home of M. and Mme.
Frantz Jourdain
color lithograph on wove paper
sheet: 32.5 x 24.9 (12 $\frac{3}{4}$ x 9 $\frac{3}{4}$)
Gift of The Atlas Foundation, 1995.76.29

57. Rodolphe Darzens (editor), *Le Théâtre Libre illustré*,
2 vols., illustrated by Lucien Métivet (Paris, 1891),
with correspondence to Darzens from the authors
included.

58. *Le Théâtre Libre d'Antoine* (scrapbooks compiled by
Rodolphe Darzens), 3 vols.

THÉÂTRE ANTOINE

59. Toulouse-Lautrec, Henri de (French, 1864–1901)
 Le Bien d'autrui (Other People's Property) by Emile
 Fabre; *Hors Les Lois (Outside the Law)* by Louis
 Marsolleau and Arthur Byl
 5 November 1897
 lithograph in green on wove paper
 sheet: 31.8 x 24.5 (12 $\frac{1}{2}$ x 9 $\frac{5}{8}$)
 Delteil, 220 ii/iii
 Gift of The Atlas Foundation, 1995.76.86

60. Rodin, Auguste (French, 1840–1917)
 Le Repas du lion (The Lion's Meal) by François de
 Curel
 26 November 1897
 photolithograph in red on wove paper
 image: 21.3 x 11.5 (8 $\frac{3}{8}$ x 4 $\frac{1}{2}$);
 sheet: 32.0 x 24.7 (12 $\frac{5}{8}$ x 9 $\frac{3}{4}$)
 Gift of The Atlas Foundation, 1995.76.64 and
 1995.76.65

*61a. Toulouse-Lautrec, Henri de (French, 1864–1901)
 [pl. 34]
 Mariage d'argent (Moneyed Marriage) by Eugène
 Bourgeois; *Le Fardeau de la liberté (The Burden of
 Freedom)* by Tristan Bernard; *Un Client sérieux
 (A Serious Client)* by Georges Courteline (recto)
 23 December 1897
 lithograph on wove paper
 sheet: 31.8 x 49.4 (12 $\frac{1}{2}$ x 19 $\frac{1}{2}$)
 Delteil, 221 ii/ii
 Gift of The Atlas Foundation, 1995.76.2.a and
 1995.76.84.a

*61b. Anquetin, Louis (French, 1861–1932) [pl. 33]
 *Dancing Nude and Advertisement for Eugène
 Verneau's "Estampes décoratives"* (verso)
 transfer lithograph in brown on wove paper
 sheet: 31.9 x 49.5 (12 $\frac{1}{2}$ x 19 $\frac{1}{2}$)
 Gift of The Atlas Foundation, 1995.76.84.b and
 1995.76.2.b

62. Toulouse-Lautrec, Henri de (French, 1864–1901)
 Portrait of the Actor Firmin Gémier for *Mariage
 d'argent (Moneyed Marriage)* by Eugène Bourgeois;
 Le Fardeau de la liberté (The Burden of Freedom) by
 Tristan Bernard; *Un Client sérieux (A Serious Client)*
 by Georges Courteline
 23 December 1897
 lithograph on wove paper
 (proof of no. 61a, recto, before letters)
 sheet: 31.8 x 24.5 (12 $\frac{1}{2}$ x 9 $\frac{5}{8}$)
 Delteil, 221 i/ii
 Gift of The Atlas Foundation, 1995.76.85

63. Anquetin, Louis (French, 1861–1932)
 Dancing Nude
 23 December 1897 .
 transfer lithograph in brown on wove paper (proof
 of no. 61b, verso, before letters)
 sheet: 31.8 x 24.6 (12 $\frac{1}{2}$ x 9 $\frac{5}{8}$)
 Gift of The Atlas Foundation, 1995.76.3

64. Anquetin, Louis (French, 1861–1932)
 Le Talion (The Retaliation) by Michel Provins;
 La Cage (The Cage) by Lucien Descaves; *Ceux qui
 restent (Those Who Remain)* by Ernest Grenet
 Dancourt; *Fortune* by Eugène Bourgeois and A.
 Thiriet
 22 January 1898
 lithograph on wove paper (proof before letters)
 sheet: 32.4 x 25.0 (12 $\frac{3}{4}$ x 9 $\frac{7}{8}$)
 Gift of The Atlas Foundation,
 1995.76.5 and 1995.76.144

Materials Related to the Théâtre Antoine

65. Ibels, Henri-Gabriel (French, 1867–1936)
 *Menu du réveillon offert aux amis du Théâtre Antoine
 (Menu of the Midnight Repast Offered to the Friends
 of Antoine)*
 late 1890s
 lithograph on wove paper
 sheet: 29.7 x 23.0 (11 $\frac{5}{8}$ x 9)
 Gift of The Atlas Foundation, 1995.76.42 and
 1995.76.43

THÉÂTRE DE L'OEUVRE

*66. Vuillard, Edouard (French, 1868–1940) [pl. 36]
Rosmersholm by Henrik Ibsen
6 October 1893
lithograph on wove paper
sheet: 24.4 x 32.6 (9 5/8 x 12 7/8)
Roger-Marx 1948, 16
Gift of The Atlas Foundation, 1995.76.107

*67. Vuillard, Edouard (French, 1868–1940) [pl. 37]
Un Ennemi du peuple (An Enemy of the People) by
Henrik Ibsen
10 November 1893
lithograph on wove paper
sheet: 24.3 x 32.2 (9 1/2 x 12 5/8)
Roger-Marx 1948, 17
Gift of The Atlas Foundation, 1995.76.109

*68. Vuillard, Edouard (French, 1868–1940) [pl. 38]
Ames solitaires (Lonely Souls) by Gerhart
Hauptmann
13 December 1893
lithograph on wove paper
sheet: 32.8 x 48.6 (12 7/8 x 19 1/8)
Roger-Marx 1948, 19
Gift of The Atlas Foundation, 1995.76.98

*69. Vuillard, Edouard (French, 1868–1940) [pl. 39]
*Au dessus des forces humaines (Beyond Human
Power)* by Björnstjerne Björnson; *L'Araignée de
cristal (The Crystal Spider)* by Rachilde
13 February 1894
lithograph on wove paper
sheet: 32.9 x 48.0 (13 x 18 7/8)
Roger-Marx 1948, 18
Gift of The Atlas Foundation, 1995.76.100

*70. Vuillard, Edouard (French, 1868–1940) [pl. 40]
Une Nuit d'Avril à Céos (An April Night at Chios)
by Gabriel Trarieux; *L'Image (The Image)* by
Maurice Beaubourg
27 February 1894
lithograph on wove paper
sheet: 32.4 x 48.1 (12 3/4 x 18 7/8)
Roger-Marx 1948, 22 ii/ii
Gift of The Atlas Foundation, 1995.76.110

*71. Vuillard, Edouard (French, 1868–1940) [pl. 41]
Solness, le constructeur (The Master Builder) by
Henrik Ibsen
3 April 1894
lithograph on wove paper
sheet: 32.5 x 24.2 (12 3/4 x 9 1/2)
Roger-Marx 1948, 21 ii/ii
Gift of The Atlas Foundation, 1995.76.108

72. Burne-Jones, Sir Edward Coley (British, 1833–1898)
[fig. 53]
La Belle au bois dormant (Sleeping Beauty) by Henry
Bataille and Robert d'Humières
24 May 1894
collotype on wove paper
plate: 12.5 x 21.9 (4 7/8 x 8 5/8); sheet
(program opened): 17.1 x 54.8 (6 3/4 x 21 5/8)
Gift of The Atlas Foundation, 1995.76.11

73. Burne-Jones, Sir Edward Coley (British, 1833–1898)
La Belle au bois dormant (Sleeping Beauty) by
Henri Bataille and Robert d'Humières
24 May 1894
collotype on wove paper
plate: 12.5 x 22.2 (4 7/8 x 8 3/4);
sheet (program opened): 17.2 x 55.0 (6 3/4 x 21 5/8)
Gift of Martin and Liane W. Atlas, 1997.96.2

74. Vuillard, Edouard (French, 1868–1940) [fig. 54]
Frères (Brothers) by Herman Bang; *La Gardienne
(The Guardian)*, a poem by Henri de Régnier;
Créanciers (The Creditor) by Auguste Strindberg
21 June 1894
lithograph on wove paper
sheet: 48.0 x 32.4 (18 7/8 x 12 3/4)
Roger-Marx 1948, 23
Gift of The Atlas Foundation, 1995.76.101

*75. Bataille, Henri (French, 1872–1922) [pl. 42]
Annabella ('Tis Pity She's a Whore) by John Ford
6 November 1894
lithograph on wove paper
sheet: 25.0 x 32.7 (9 7/8 x 12 7/8)
Gift of The Atlas Foundation, 1995.76.9

*76. Vuillard, Edouard (French, 1868–1940) [pl. 43]
La Vie muette (The Silent Life) by Maurice
Beaubourg
27 November 1894
lithograph in green black on wove paper
sheet: 32.9 x 25.1 (13 x 9 $^7/_8$)
Roger-Marx 1948, 20
Gift of The Atlas Foundation, 1995.76.104

*77. Vallotton, Félix (Swiss, 1865–1925) [pl. 44]
Père (Father) by Auguste Strindberg
13 December 1894
lithograph on wove paper
sheet: 29.0 x 36.8 (11 $^3/_8$ x 14 $^1/_2$)
Vallotton/Goerg 1972, 52
Gift of The Atlas Foundation, 1995.76.93

78. Toulouse-Lautrec, Henri de (French, 1864–1901)
Le Chariot de terre cuite (The Little Clay Cart)
adapted from the *Mric'Chakatika* (attributed to
Sūdraka) by Victor Barrucand
22 January 1895
offset lithograph in blue on pink wove paper
sheet: 43.8 x 28.1 (17 $^1/_4$ x 11)
Delteil, 77 ii/ii
Gift of The Atlas Foundation, 1995.76.78

*79. Toulouse-Lautrec, Henri de (French, 1864–1901)
[pl. 45]
Le Chariot de terre cuite (The Little Clay Cart)
adapted from the *Mric'Chakatika* (attributed to
Sūdraka) by Victor Barrucand
22 January 1895
lithograph in blue and pink on wove paper
sheet: 55.9 x 37.7 (22 x 14 $^7/_8$)
Delteil, 77 ii/ii
Gift of Martin and Liane W. Atlas, 1996.87.1

80. Denis, Maurice (French, 1870–1943)
La Scène (The Scene) by André Lebey; *La Vérité
dans le vin (Truth in Wine)* by Charles Collé; *Les
Pieds nickelés (Nickeled Feet)* by Tristan Bernard;
Intérieur (Interior) by Maurice Maeterlinck
15 March 1895
lithograph on wove paper
sheet: 24.7 x 32.5 (9 $^3/_4$ x 12 $^3/_4$)
Cailler 1968, 85
Gift of The Atlas Foundation, 1995.76.22

81. Rops, Félicien (Belgian, 1833–1898)
L'Ecole de l'idéal (The School of the Ideal) by Paul
Vérola; *Le Petit Eyolf (Little Eyolf)* by Henrik Ibsen
8 May 1895
photomechanical process on wove paper
sheet: 37.6 x 13.9 (14 $^3/_4$ x 5 $^1/_2$)
Gift of The Atlas Foundation, 1995.76.66 and
1995.76.67

82. Roussel, Ker-Xavier (French, 1867–1944) [fig. 57]
Le Volant (The Steering Wheel) by Judith Cladel
28 May 1895
lithograph on wove paper
sheet: 32.4 x 20.9 (12 $^3/_4$ x 8 $^1/_4$)
Gift of The Atlas Foundation, 1995.76.68

*83. Dumont, Maurice (French, 1869–1899) [pl. 46]
Carmosine by Alfred de Musset
10 June 1895
glyptograph on simili-japon paper
plate: 12.0 x 15.9 (4 $^3/_4$ x 6 $^1/_4$);
sheet: 22.9 x 28.3 (9 x 11 $^1/_8$)
Gift of Martin and Liane W. Atlas, 1997.96.3

*84. Dethomas, Maxime (French, 1867–1929) [pl. 48]
Brand by Henrik Ibsen
22 June 1895
lithograph in green brown and red on wove paper
sheet: 35.4 x 45.8 (13 $^7/_8$ x 18)
Gift of The Atlas Foundation, 1995.76.20

*85. Sattler, Joseph (German, 1867–1931) [pl. 47]
Brand by Henrik Ibsen
22 June 1895
lithograph in green on wove paper
sheet: 32.6 x 43.8 (12 $^7/_8$ x 17 $^1/_4$)
Gift of Martin and Liane W. Atlas, 1997.96.7

*86. Sattler, Joseph (German, 1867–1931) [pl. 49]
*Historique du Théâtre de "L'Oeuvre" (Historical
Account of the Théâtre de L'Oeuvre)*
1895
lithograph in green on wove paper
sheet (program opened): 25.3 x 47.5 (10 x 18 $^3/_4$)
Gift of The Atlas Foundation, 1995.76.113

*87. Toulouse-Lautrec, Henri de (French, 1864–1901)
[pl. 50]
Prospectus Programme de l'Oeuvre
1895
1 sheet folded in thirds with text and 6 lithographs on wove paper: cover by Toulouse-Lautrec; other prints by Maurice Denis, M. Dondelet, Antonio de la Gandara, Félix Vallotton, and Edouard Vuillard; additional illustrations by de la Gandara and Vallotton
sheet (program opened): 24.6 x 100.5
(9 $^5/_8$ x 39 $^1/_2$)
Delteil, 149 ii/ii
Gift of The Atlas Foundation, 1995.76.81.a-b

*88. Toorop, Jan (Dutch, 1858–1928) [pl. 51]
Venise sauvée (Venice Preserved) by Thomas Otway
8 November 1895
lithograph on wove paper
sheet: 49.9 x 32.8 (19 $^5/_8$ x 12 $^7/_8$)
Gift of The Atlas Foundation, 1995.76.77

89. André, Albert (attributed) (French, 1869–1954)
[fig. 56]
L'Anneau de Çakuntala (The Year of Çakuntala) by Kalisada
10 December 1895
lithograph in green on wove paper
sheet: 32.9 x 50.6 (13 x 19 $^7/_8$)
Gift of The Atlas Foundation, 1995.76.6

90. Abel-Truchet (French, 1857–1919)
Des Mots! Des Mots! (Words! Words!) by Charles Quinel and René Dubreuil
6 January 1896
lithograph in brown on green wove paper
sheet: 25.7 x 32.5 (10 $^1/_8$ x 12 $^3/_4$)
Gift of Martin and Liane W. Atlas, 1997.96.1

*91. Dethomas, Maxime (French, 1867–1929) [pl. 52]
Une Mère (A Mother) by Ellin Ameen; *Brocéliande* by Jean Lorrain; *Les Flaireurs (The Sniffers)* by Charles van Lerberghe; *Des Mots! Des Mots! (Words! Words!)* by Charles Quinel and René Dubreuil
6 January 1896
lithograph in orange on wove paper
sheet: 31.5 x 50.5 (12 $^3/_8$ x 19 $^7/_8$)
Gift of The Atlas Foundation, 1995.76.24

*92. Toulouse-Lautrec, Henri de (French, 1864–1901)
[pl. 53]
Raphaël by Romain Coolus; *Salomé* by Oscar Wilde
11 February 1896
lithograph on wove paper
sheet: 32.8 x 50.2 (12 $^7/_8$ x 19 $^3/_4$)
Delteil, 195 iv/iv
Gift of The Atlas Foundation, 1995.76.82

93. Sérusier, Paul (French, 1863–1927) [fig. 59]
Hérakléa by Auguste Villeroy
17 March 1896
zincograph in red brown on wove paper
sheet: 32.8 x 50.3 (12 $^7/_8$ x 19 $^3/_4$)
Gift of The Atlas Foundation, 1995.76.69

*94. Bonnard, Pierre (French, 1867–1947) [pl. 54]
Dernière croisade (The Last Crusade) by Maxime Gray; *L'Errante (The Wanderer)* poem by Pierre Quillard; *La Fleur Palan enlevée (The Purloined Palan Flower)* adapted from the Chinese original by Jules Arène
22 April 1896
lithograph in green on wove paper (proof before letters at upper center)
sheet: 32.1 x 50.2 (12 $^5/_8$ x 19 $^3/_4$)
Roger-Marx 1952, 39
Gift of The Atlas Foundation, 1995.76.10

95. Toulouse-Lautrec, Henri de (French, 1864–1901)
La Lépreuse (The Leper) by Henry Bataille
4 May 1896
lithograph in red brown on wove paper
sheet: 48.7 x 30.7 (19 $^1/_8$ x 12 $^1/_8$)
Delteil, 196 ii/ii
Gift of Martin and Liane W. Atlas, 1996.87.2

*96. Hermann-Paul (French, 1864–1940) [pl. 55]
La Brebis (The Sheep) by Edmond Sée; *Le Tandem (Tandem)* by Léo Trézenik and Pierre Soulaine
29 May 1896
lithograph on wove paper
sheet: 50.3 x 30.2 (19 $^3/_4$ x 11 $^7/_8$)
Gift of The Atlas Foundation, 1995.76.26

*97. Vuillard, Edouard (French, 1868–1940) [pl. 56]
Les Soutiens de la société (Pillars of Society) by
Henrik Ibsen
23 June 1896
lithograph on wove paper
sheet: 32.4 x 49.9 (12 $^3/_4$ x 19 $^5/_8$)
Roger-Marx 1948, 24 iii/iii
Gift of The Atlas Foundation, 1995.76.105

*98. Vuillard, Edouard (French, 1868–1940) [pl. 57]
Les Soutiens de la société (Pillars of Society) by
Henrik Ibsen
23 June 1896
lithograph on wove paper
(proof before letters)
sheet: 38.1 x 56.2 (15 x 22 $^1/_8$)
Roger-Marx 1948, 24 ii/iii
Gift of The Atlas Foundation, 1995.76.106

*99. Munch, Edvard (Norwegian, 1863–1944) [pl. 58]
Peer Gynt by Henrik Ibsen
12 November 1896
lithograph on wove paper
sheet: 25.1 x 31.9 (9 $^7/_8$ x 12 $^1/_2$)
Schiefler 1907, 74c
Gift of The Atlas Foundation, 1995.76.56

*100. Jarry, Alfred (French, 1873–1907) [pl. 59]
Ubu Roi (King Ubu) by Alfred Jarry
10 December 1896
photomechanical process on pink wove paper
sheet: 24.8 x 32.5 (9 $^3/_4$ x 12 $^3/_4$)
Gift of The Atlas Foundation, 1995.76.46

101. Jarry, Alfred (French, 1873–1907)
Ubu Roi (King Ubu) by Alfred Jarry
10 December 1896
photomechanical process on pink wove paper
(proof before letters)
sheet: 24.8 x 32.6 (9 $^3/_4$ x 12 $^7/_8$)
Gift of The Atlas Foundation, 1995.76.47

102. Denis, Maurice (French, 1870–1943)
Au-delà des forces humaines (Beyond Human Power),
part 1, by Björnstjerne Björnson; *La Motte de terre
(Ball of Earth)* by Louis Dumur
14 January 1897
lithograph in green on wove paper
sheet: 24.8 x 32.6 (9 $^3/_4$ x 12 $^7/_8$)
Cailler 1968, 95
Gift of The Atlas Foundation, 1995.76.21

103. Vuillard, Edouard (French, 1868–1940)
Au-delà des forces humaines (Beyond Human Power),
part 2, by Björnstjerne Björnson
26 January 1897
lithograph on wove paper
sheet: 23.9 x 31.9 (9 $^3/_8$ x 12 $^1/_2$)
Roger-Marx 1948, 25 ii/ii
Gift of The Atlas Foundation, 1995.76.99

*104. Ranson, Paul (French, 1864–1909) [pl. 61]
La Cloche engloutie (The Sunken Bell) by
Gerhart Hauptmann
5 March 1897
lithograph on wove paper
sheet: 31.9 x 25.0 (12 $^1/_2$ x 9 $^7/_8$)
Gift of The Atlas Foundation, 1995.76.61

105. Lebasque, Henri (French, 1865–1937)
Le Fils de l'abbesse (The Abbess' Son) by Ambroise
Herdey; *Le Fardeau de la liberté (The Burden of
Liberty)* by Tristan Bernard
15 May 1897
lithograph on wove paper
sheet: 32.1 x 24.4 (12 $^5/_8$ x 9 $^5/_8$)
Gift of The Atlas Foundation, 1995.76.50

106. La Jeunesse, Ernest (French, 1874–1917)
La Comédie de l'amour (Love's Comedy) by
Henrik Ibsen
23 June 1897
collotype in green on simili-japon paper
sheet: 28.0 x 38.2 (11 x 15)
Gift of Martin and Liane W. Atlas, 1997.96.5

*107. Munch, Edvard (Norwegian, 1863–1944) [pl. 62]
Jean-Gabriel Borkman by Henrik Ibsen
9 November 1897
lithograph on wove paper
sheet: 28.1 x 38.4 (11 x 15 $^1/_8$)
Schiefler 1907, 171a
Gift of The Atlas Foundation, 1995.76.55

108. Hermann-Paul (French, 1864–1940)
L'Inspecteur Général Revizor (The Inspector General)
by Nicolai Gogol
8 January 1898
photorelief on wove paper
sheet: 28.3 x 38.4 (11 $^1/_8$ x 15 $^1/_8$)
Gift of The Atlas Foundation, 1995.76.27

*109. Toulouse-Lautrec, Henri de (French, 1864–1901)
[pl. 64]
Rosmersholm by Henrik Ibsen; *Le Gage (The Wager)*
by Frantz Jourdain
22 January 1898
lithograph on wove paper
sheet: 38.6 x 28.0 (15 $^1/_4$ x 11)
Delteil, 212 ii/ii
Gift of The Atlas Foundation, 1995.76.87

*110. Toulouse-Lautrec, Henri de (French, 1864–1901)
[pl. 63]
Rosmersholm by Henrik Ibsen; *Le Gage (The Wager)*
by Frantz Jourdain
22 January 1898
lithograph on china paper (proof before letters)
image: 29.3 x 23.7 (11 $^1/_2$ x 9 $^1/_4$);
sheet: 35.7 x 32.2 (14 x 12 $^5/_8$)
Delteil, 212 i/ii
Gift of The Atlas Foundation, 1995.76.88

*111. Muller, Alfredo (Italian, 1869–1940) [pl. 65]
L'Echelle (The Ladder) by Gustave van Zype; *Le
Balcon (The Balcony)* by Gunnar Heiberg
18 February 1898
lithograph in black and green on wove paper
sheet: 38.0 x 27.5 (15 x 10 $^7/_8$)
Gift of The Atlas Foundation, 1995.76.54

112. Bussy, Simon Albert (French, 1870–1954)
Aërt by Romain Rolland
3 May 1898
lithograph in green on wove paper
sheet: 28.1 x 37.7 (11 x 14 $^7/_8$)
Gift of The Atlas Foundation, 1995.76.12

113. Groux, Henri de (Belgian, 1867–1930) [fig. 60]
Morituri by Romain Rolland
18 May 1898
lithograph in red brown on wove paper
sheet: 38.1 x 28.4 (15 x 11 $^1/_8$)
Gift of The Atlas Foundation, 1995.76.18

114. Dethomas, Maxime (French, 1867–1929)
La Victoire (The Victory) by Saint-Georges de
Bouhélier
20 June 1898
lithograph in brown on wove paper
sheet: 36.4 x 27.4 (14 $^3/_8$ x 10 $^3/_4$)
Gift of The Atlas Foundation, 1995.76.23

115. Hista, Robert (French, active 1890s)
Mesure pour mesure (Measure for Measure) by
William Shakespeare
10 December 1898
photorelief on green wove paper
sheet: 25.6 x 28.3 (10 $^1/_8$ x 11 $^1/_8$)
Gift of The Atlas Foundation, 1995.76.28

116. Jourdain, Francis (French, born 1876)
La Noblesse de la terre (The Nobles of the Earth) by
Maurice de Faramond
9 February 1899
lithograph in green on wove paper
sheet: 24.2 x 37.2 (9 $^1/_2$ x 14 $^5/_8$)
Gift of The Atlas Foundation, 1995.76.91

117. Léandre, Charles-Lucien (French, 1862–1934)
Fausta by Paul Sonniès
16 May 1899
lithograph in brown on wove paper
sheet: 36.7 x 26.8 (14 $^1/_2$ x 10 $^1/_2$)
Gift of Martin and Liane W. Atlas, 1997.96.6

*118. Steinlen, Théophile Alexandre
 (French, 1859–1923) [pl. 66]
 L'Ennemi du peuple (The Enemy of the People)
 by Henrik Ibsen
 18 May 1899
 lithograph on wove paper
 sheet: 50.0 x 32.4 (19 $^5/_8$ x 12 $^3/_4$)
 Gift of The Atlas Foundation, 1995.76.75

119. Peské, Jean (French, 1870–1949)
 *Entretien d'un philosophe avec la maréchale de XXX
 (Conversation between a Philosopher and a Field
 Marshal's Wife)* by Denis Diderot; *La Triomphe de la
 raison (The Triumph of Reason)* by Romain Rolland
 3 June 1899
 lithograph in brown on wove paper
 sheet: 38.0 x 28.2 (15 x 11 $^1/_8$)
 Gift of The Atlas Foundation, 1995.76.59

120. Vibert, Pierre Eugène (Swiss, 1875–1937)
 Le Joug (The Yoke) by Lucien Mayrargue
 6 June 1899
 lithograph in green on wove paper
 sheet: 25.8 x 38.1 (10 $^1/_8$ x 15)
 Gift of The Atlas Foundation, 1995.76.95

*121. Rysselberghe, Théodore van (Belgian, 1862–1926)
 [pl. 67]
 Le Cloître (The Cloister) by Emile Verhaeren
 21 February 1900
 lithograph in yellow brown on wove paper
 sheet: 20.4 x 24.5 (8 x 9 $^5/_8$)
 Gift of The Atlas Foundation, 1995.76.94

122. Guérin, Charles-François-Prosper (French,
 1875–1939)
 Le Roi Candaule (King Candaule) by André Gide
 13 September 1901
 lithograph on wove paper
 sheet: 32.4 x 45.4 (12 $^3/_4$ x 17 $^7/_8$)
 Gift of Martin and Liane W. Atlas, 1997.96.4

123. Vuillard, Edouard (French, 1868–1940)
 *Une répétition à L'Oeuvre (A Rehearsal at the Théâtre
 de L'Oeuvre)*, Program for *L'Oasis* by Jean Jullien
 14 December 1903
 lithograph on wove paper
 sheet: 30.8 x 20.9 (12 $^1/_8$ x 8 $^1/_4$)
 Roger-Marx 1948, 50 iv/iv
 Gift of The Atlas Foundation, 1995.76.111 and
 1995.76.103

124. Jarry, Alfred (French, 1873–1907)
 Ubu Roi (King Ubu) by Alfred Jarry
 image from 1896 reused for the revival of the play
 on 17 February 1922
 photomechanical process on wove paper
 sheet: 32.4 x 25.2 (12 $^3/_4$ x 9 $^7/_8$)
 Gift of The Atlas Foundation, 1995.76.48

THÉÂTRE DES PANTINS

*125. Jarry, Alfred (French, 1873–1907) [pl. 60]
 Ubu Roi (King Ubu) by Alfred Jarry; *Petits Poèmes
 amorphes (Little Amorphous Poems)* by
 Franc-Nohain
 20 January 1898
 photomechanical process in green on wove paper
 sheet: 36.0 x 26.4 (14 $^1/_8$ x 10 $^3/_8$)
 Gift of The Atlas Foundation, 1995.76.49

THEATER UNDETERMINED

126. Abel-Truchet (French, 1857–1919)
 La Muse malade (The Sick Muse)
 c. 1900
 lithograph in brown on wove paper
 sheet: 25.0 x 27.5 (9 $^7/_8$ x 10 $^7/_8$)
 Gift of The Atlas Foundation, 1995.76.89

127. After A. B. (French, 19th century)
 Les Honnêtes femmes (The Honest Women);
 Conférence, Poésies inédites d'Henry Becque;
 La Parisienne
 31 May 1904
 halftone on wove paper
 sheet (program opened): 32.7 x 50.1
 (12 $^7/_8$ x 19 $^3/_4$)
 Gift of The Atlas Foundation, 1995.76.8

SELECT BIBLIOGRAPHY

Aitken, Geneviève (with the collaboration of Samuel Josefowitz). *Artistes et théâtres d'avant-garde. Programmes de théâtre illustrés, Paris 1890–1900.* Pully, 1991.

——. "Les Peintres et le théâtre à Paris autour de 1900." Ph.D diss., Université de la Sorbonne, Paris, 1978.

——. "Les Nabis, un foyer au théâtre." In *Nabis 1888–1900. Bonnard, Vuillard, Maurice Denis, Vallotton....* Exh. cat., Galeries nationales du Grand Palais. Paris, 1994.

——. "Edvard Munch et la scène française." In *Munch et la France.* Exh. cat., Musée d'Orsay. Paris, 1992.

Albright, H. D., ed. *André Antoine's "Memories of the Théâtre Libre."* Trans. Marvin A. Carlson. Coral Gables, FL, 1964.

Antoine, André. *Le Théâtre Libre.* Paris, 1890.

Arnaud, Noël. *Alfred Jarry.* Paris, 1974.

Bablet, Denis. *Esthétique générale du décor de Théâtre de 1870–1914.* Paris, 1989.

——. *La Mise en scène contemporaine.* Paris, 1968.

——. *Les Révolutions scéniques du XXe siècle.* Paris, 1975.

Bapst, Germain. *Essai sur l'histoire du théâtre. La Mise en scène, le décor, le costume, l'architecture, l'eclairage, l'hygiène.* Paris, 1893.

Barrot, Olivier, and Pascal Ory. *"La Revue blanche."* Paris, 1989.

Béarn, Pierre. *Paul Fort.* Paris, 1960.

Bernier, Georges. *"La Revue blanche." Ses Amis, ses artistes.* Paris, 1991.

Bourdon, Georges, and Robert de la Motte de Fleurs. *Les Escholiers. Livre d'or.* Paris, 1922.

Boyer, Patricia Eckert. "The Artist as Illustrator in Fin-de-Siècle Paris." In *The Graphic Arts and French Society, 1871–1914.* Ed. Phillip Dennis Cate. New Brunswick, NJ, 1988.

——, ed. *The Nabis and the Parisian Avant-Garde.* Exh. cat., Zimmerli Art Museum, Rutgers University. New Brunswick, NJ, 1988.

Boyle-Turner, Caroline. *Paul Sérusier.* Ann Arbor, MI, 1983.

Bouvet, Francis. *Bonnard. L'Oeuvre gravé.* Paris, 1981.

Cailler, Pierre. *Catalogue de l'oeuvre gravé et lithographié de Maurice Denis.* Geneva, 1968.

Carlson, Marvin. *The French Stage in the Nineteenth Century.* Metuchen, NJ, 1972.

Cate, Phillip Dennis, and Patricia Eckert Boyer. *The Circle of Toulouse-Lautrec.* Exh. cat., Zimmerli Art Museum, Rutgers University. New Brunswick, NJ, 1986.

Cate, Phillip Dennis, and Mary Shaw, eds. *The Spirit of Montmartre: Cabarets, Humor, and the Avant-Garde, 1875–1905.* Exh. cat., Zimmerli Art Museum, Rutgers University. New Brunswick, NJ, 1996.

Chassé, Charles. *Les Nabis et leur temps.* Paris, 1960.

Ciaffa, Patricia. *The Portraits of Vuillard.* Ann Arbor, MI, 1985.

Clothia, Jean. *André Antoine.* Cambridge, 1991.

Cogniat, Raymond. *Cinquante ans de spectacles en France. Les Décorateurs du théâtre.* Paris, 1955.

Darzens, Rodolphe. *Nuits à Paris.* Paris, 1889.

——, ed. *Le Théâtre Libre illustré.* Paris, 1891.

Deak, Frantisek. "Ibsen's *Rosmersholm* at the Théâtre de L'Oeuvre." *The Drama Review* 28 (Spring 1984), 29–36.

——. "Symbolist Staging at the Théâtre d'Art." *The Drama Review* 28 (Spring 1984), 117–124.

_____. *Symbolist Theater: The Formation of an Avant-Garde.* Baltimore, 1993.

Denis, Maurice. "L'Epoque du symbolisme." *Gazette des Beaux Arts* 76 (March 1934), 165–179.

_____. *Du Symbolisme au classicisme. Théories.* Paris, 1964.

Dickson, Daniel. "The Aesthetic Conception of the Actor/Audience Relationship in the Theatrical Productions of Lugné-Poe 1893–1897." M.A. thesis, University of Alberta. Edmonton, Alberta, Canada, 1990.

Dorra, Henri. *Symbolist Art Theories: A Critical Anthology.* Berkeley, 1994.

Dumas, Ann, and Guy Cogeval. *Vuillard.* Paris, 1990.

Eggum, Arne. *Edvard Munch.* Paris, 1983.

Ellmann, Richard. *Oscar Wilde.* New York, 1988.

Erichsen, Svend. "Percée du réalisme dans le théâtre français du XIXe siècle." *Revue d'histoire du théâtre* 31 (1979), 52–80.

Fabre, Emile. *Le Théâtre.* Paris, 1936.

Forgione, Nancy Ellen. *Edouard Vuillard in the 1890s: "Intimisme," Theater, and Decoration.* Ann Arbor, MI, 1996.

Fort, Paul. *Mes Memoires. Toute la vie d'un poète, 1872–1943.* Paris, 1944.

_____. "Les Temps héroïques du symbolisme, le Théâtre d'Art et les premiers drames de Maurice Maeterlinck." Unpublished conference, given at King's College, Oxford, and Christ Church, London, n.d.

Frèches-Thory, Claire. "Toulouse-Lautrec and the Theater." In *Toulouse-Lautrec.* Exh. cat., Hayward Gallery. London, 1991.

Frey, Julia. *Toulouse-Lautrec: A Life.* New York, 1994.

Gerould, Daniel. "Oscar Méténier and *Comédie Rosse:* From the Théâtre Libre to the Grand Guignol." *The Drama Review* 28 (Spring 1984), 15–28.

Gisèle, Marie. *Le Théâtre symboliste.* Paris, 1973.

Goldwater, Robert. "Symbolist Art and Theater: Vuillard, Bonnard, Maurice Denis." *Magazine of Art* 39 (December 1946), 366–370.

Groom, Gloria Lynn. *Edouard Vuillard: Painter-Decorator.* New Haven, CT, 1993.

Halperin, Joan. *Félix Fénéon: Aesthete and Anarchist in Fin-de-Siècle Paris.* New Haven, 1988.

Hasselt, C. van. "L'Illusion au théâtre." *Revue d'art dramatique* 22 (1891), 170–173.

Hemmings, F.W.J. *The Theatre Industry in Nineteenth-Century France.* Cambridge, 1993.

Henderson, John. *The First Avant-Garde, 1887–1894: Sources of the Modern French Theatre.* London, 1971.

Herbert, Eugenia W. *The Artist and Social Reform: France and Belgium 1885–1898.* New Haven, 1961.

Herbert, Robert, and Eugenia W. Herbert. "Artists and Anarchism." *The Burlington Magazine* 102 (1960), 472–482; 517–522.

L'Heritier, Henri. *La Vie et l'oeuvre d'Henry Bataille.* Paris, 1930.

Herold, A. Ferdinand. "M. Antoine and the Théâtre Libre." *The International Monthly* 111 (May 1901), 511–525.

Hobson, Harold. *French Theatre Since 1830.* London, 1978.

Ibels, Henri-Gabriel. "La Carrière d'Antoine." *Je sais tout* (15 May 1914), 649–653.

Jackson, A. B. *"La Revue blanche" (1889–1903). Origine, influence, bibliographie.* Paris, 1960.

Jarry, Alfred. "De L'Inutilité du théâtre au théâtre." *Mercure de France* (September 1896), 467–473.

Jasper, Gertrude. *Lugné-Poe and the Théâtre de L'Oeuvre.* New Brunswick, NJ, 1947.

Jourdain, Francis. *Né en '76*. Paris, 1951.

Knapp, Bettina. *Maurice Maeterlinck*. Boston, 1975.

_____. *The Reign of the Theatrical Director: French Theatre, 1887–1924*. New York, 1988.

Knowles, Dorothy. *La Réaction idéaliste au théâtre depuis 1890*. Paris, 1934.

Krahmer, Catherine. *"Pan* and Toulouse Lautrec." *Print Quarterly* 10 (December 1993), 392–397.

Lathe, Carla. *Munch and His Literary Associates*. Norwich, 1979.

Lefranc, F. "Le Théâtre naturaliste." *Revue d'art dramatique* 22 (1891), 1–12.

Lefrère, Jean-Jacques. "Les Saisons littéraires de Rodolphe Darzens (1865–1938)." Ph.D. diss., Université de Paris VIII, 1996.

Lemaître, Jules. *Impressions de Théâtre*. Paris, 1889–1900.

Lugné-Poe, Aurélien François. *La Parade I: Le Sot du tremplin: Souvenirs et impressions du théâtre*. Paris, 1930.

_____. *La Parade II: "Acrobaties" souvenirs et impressions du théâtre*. Paris, 1931.

_____. *La Parade III: Sous les étoiles*. Paris, 1933.

_____. "Sur les soirées de L'Oeuvre." *La Plume* 4 (September 1893), 379–380.

Mauclair, Camille. "Notes sur une dramaturgie symbolique." *La Revue indépendante* 22 (March 1892), 305–317.

_____. Letter to A. Vallette. *Mercure de France* (October 1893), 191–192.

_____. "Une Première sensationnelle." *Le Journal* (17 May 1893), 2.

Mauner, George. *The Nabis: Their History and Their Art, 1888–1896*. New York, 1978.

_____. "The Nature of Nabi Symbolism." *Art Journal* 23 (1963–1964), 96–103.

Maurer, Warren R. *Understanding Hauptmann*. Columbia, SC, 1992.

Meyer, Michael. *Ibsen: A Biography*. Garden City, NY, 1971.

_____. *Strindberg*. Oxford, 1985.

Mourey, Gabriel. "Some French Illustrated Theatre Programs." *The Studio* 10 (1897), 237–243.

Morice, Charles. "A Propros du Théâtre d'Art." *Mercure de France* (March 1893), 249–253.

Natanson, Thadée. *Peints à leur tour*. Paris, 1948.

Noël, E., and E. Stoullig. *Annales du théâtre et de la musique*. Paris, 1887–1900.

Pruner, Francis. "La Première Représentation de Strindberg à Paris." *Revue d'histoire du théâtre* 30 (1978), 273–286.

_____. *Les Luttes d'Antoine au Théâtre Libre*. Paris, 1964.

Queant, Gilles. *Encyclopédie du théâtre contemporain. 1850–1914*. Vol. 1. Paris, 1957.

Quillard, Pierre, "De L'Inutilité absolue de la mise en scène exacte." *La Revue d'art dramatique* (1 May 1891), 180–183.

Rachilde. "De La Fondation d'un théâtre d'art." *Théâtre d'art* (March 1891), 10–13.

Recueil factice de programmes, prospectus, invitations, articles de presse concernant le Théâtre Libre, 1888–1890. Bibliothèque de L'Arsenal, Paris. Rt 3615.

Recueil factice d'articles de presse biographiques sur Antoine (1858–1943). 8 vols. Bibliothèque de L'Arsenal, Paris. Rt 3679.

Recueil factice d'articles de presse sur Antoine et le Théâtre Libre (1858–1943). 1 vol. Bibliothèque de L'Arsenal, Paris. Rt 3680.

Recueil factice de presse de référence sur Paul Fort et le Théâtre d'Art. Bibliothèque de L'Arsenal, Paris. Rt 3685.

Recueil factice de presse de critiques des pièces jouées à L'Oeuvre. (October 1893–December 1904). 2 vols. Bibliothèque de L'Arsenal, Paris. Rt 3695.

Recueil factice de presse et de programmes concernant l'activité de L'Oeuvre (1893–1929). vol. 2: programmes et critiques, 1893–1914.

Robichez, Jacques. *Lugné-Poe.* Paris, 1955.

_____. *Romain Rolland et Lugné-Poe, correspondance 1894–1901.* Paris, 1957.

_____. *Le Symbolisme au théâtre. Lugné-Poe et les débuts de L'Oeuvre.* Paris, 1957.

Robinson, Michael, ed. and trans. *Strindberg's Letters.* 2 vols. Chicago, 1992.

Roger Marx, Claude. "Paul Fort et le Théâtre d'Art." *Comédie illustré* (15 July 1912), 874–875.

_____. *L'Oeuvre gravé de Vuillard.* Monte Carlo, 1948.

Rubin, William. "Shadows, Pantomimes, and the Art of the 'Fin de Siècle.'" *Magazine of Art* 46 (March 1953), 114–122.

Rubenstein, Daryl R. *The Avant-Garde in Theatre and Art: French Playbills of the 1890s.* Exh. cat., Smithsonian Institution Traveling Exhibition Service. Washington, DC, 1972.

Salandri, Gaston. "La Pièce bien faite et le Théâtre Libre." *Art et critique* 1 (22 June 1889), 49–51.

Sanders, James B. "Le Théâtre Libre d'Antoine. Berceau de l'art dramatique contemporain." *Revue de L'Université d'Ottawa* 35 (October–December 1965), 420–438.

_____. *La Correspondance d'André Antoine. Le Théâtre Libre.* Longueuil, Quebec, 1987.

Sérusier, Paul. *ABC de la peinture. Correspondance.* Paris, 1950.

Shattuck, Roger. *The Banquet Years: The Origins of Avant-Garde in France, 1885 to World War I.* Rev. ed. New York, 1968.

Silverman, Debora L. *Art Nouveau in Fin-de-Siècle France: Politics, Psychology, and Style.* Berkeley, 1989.

Soederstroem, Goeran. "Strindberg et les cercles d'art Parisiens." *La Revue d'histoire du théâtre à Paris* 3 (1978), 321–333.

Un Symboliste. "La Mise en scène symbolist." *Le Galois* (14 December 1891), 3.

Terrasse, Antoine. *Bonnard, illustrateur.* Paris, 1989.

Thalasso, Adolphe. *Le Théâtre Libre. Essai critique, historique, et documentaire.* Paris, 1909.

Thomé, J. R. "Les Programmes illustrés du Théâtre de L'Oeuvre." *Le Courrier graphique* 32 (September–October 1947), 35–43.

Thomson, Belinda. *Vuillard.* New York, 1988.

Thomson, Richard; Claire Frèches-Thory; Anne Roquebert; and Daniele Devynck. *Toulouse-Lautrec.* New Haven, 1991.

Torjusen, Bente. "The Mirror." In *Edvard Munch: Symbols and Images.* Exh. cat., National Gallery of Art. Washington, 1978.

Van Hoof, Diane Marie-Louise. *Peer Gynt in Performance: Five Models of the Modern Theater.* Ann Arbor, MI, 1988.

Veinstein, André. *Du Théâtre Libre au Théâtre Louis Jouvet.* Paris, 1955.

Vuillard, Edouard. "Souvenirs du peintre." Unpublished journals, 1890–1905. Institut de France, Paris.

Waller, Bret, and Grace Seiberling. *Artists of La Revue Blanche: Bonnard, Toulouse-Lautrec, Vallotton, Vuillard.* Exh. cat., Memorial Art Gallery. Rochester, 1984.

Waxman, Samuel Montefiore. *Antoine and the Théâtre Libre.* Cambridge, 1926.

Weber, Eugen. *France. Fin de siècle.* Cambridge, 1986.

Wittrock, Wolfgang. *Toulouse-Lautrec: The Complete Prints.* London, 1985.

PHOTOGRAPHIC CREDITS

Works in the Atlas Collection have been photographed in the National Gallery of Art's photographic laboratory by Dean Beasom and Lee Ewing. In addition to those mentioned in the acknowledgments, we would like to note Michel Plet, photographer for fig. 6; Photothèque des Musées de la Ville de Paris by SPADEM for fig. 7; © The Board of Trustees of the Victoria and Albert Museum, London, for fig. 9; Jean-Michel Routhier, photographer for figs. 11–14, 17–18, 20, 23–24, 40, 47, 49; Jack Abraham, photographer for figs. 26–27, 29–31, 33–34; and © RMN-SPADEM for fig. 38.